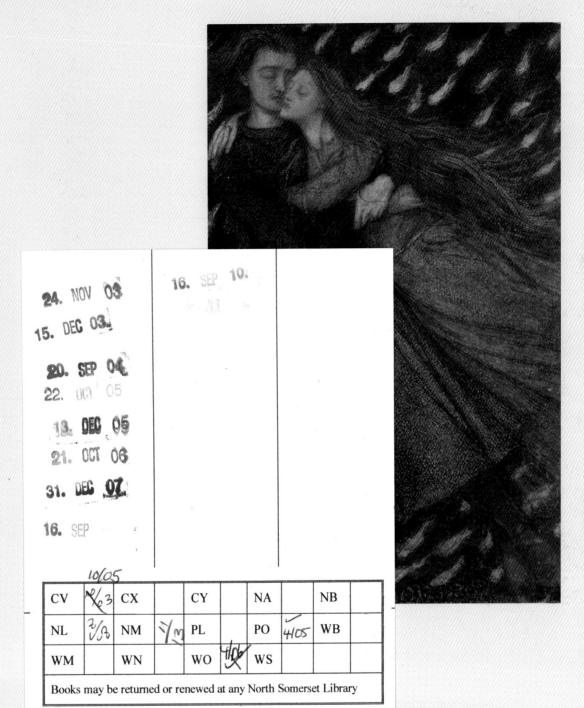

THE PRE-RAPHAELITE DREAM

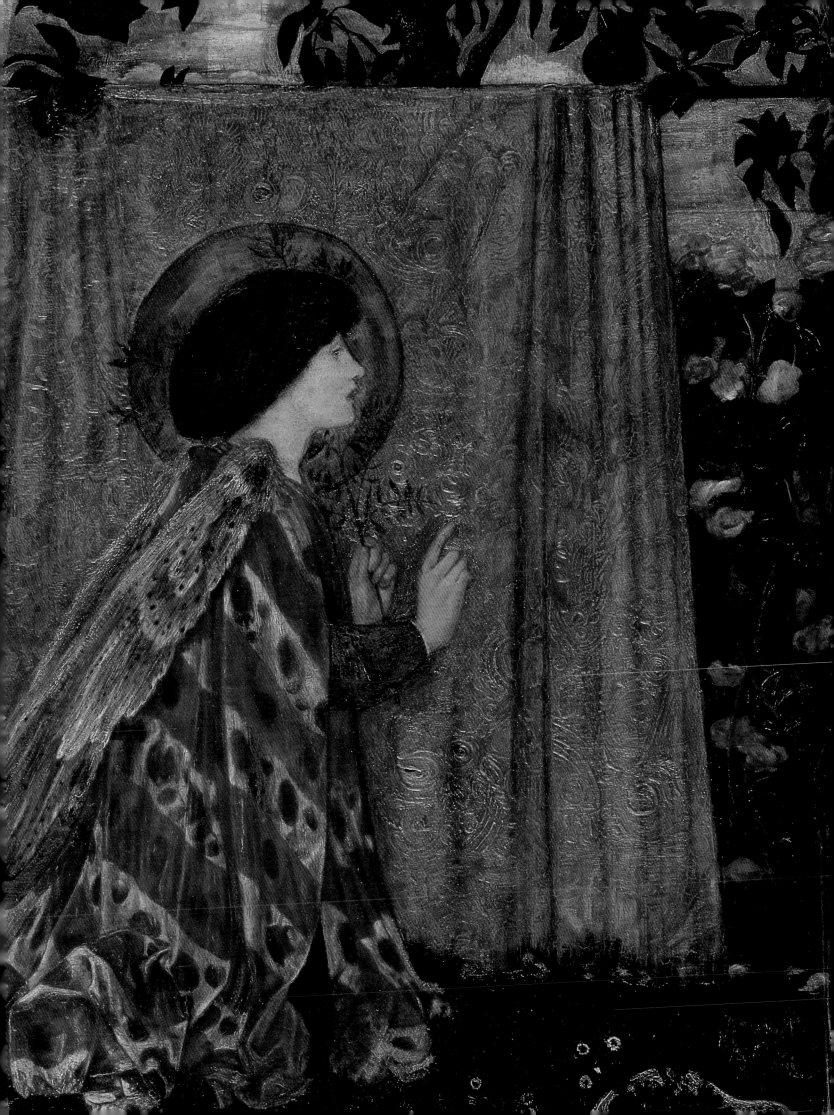

THE PRE-RAPHAELITE DREAM

PAINTINGS AND DRAWINGS FROM THE TATE COLLECTION

Robert Upstone

Art Gallery of Western Australia

Dunedin Public Art Gallery

Frist Center for the Visual Arts

Tate Publishing

Published by order of the Tate Trustees on the occasion
of the exhibition touring to:

Art Gallery of Western Australia, Perth, Australia
12 July – 28 September 2003

Dunedin Public Art Gallery, Dunedin, New Zealand
25 October 2003 – 15 February 2004

Frist Center for the Visual Arts, Nashville, United States
14 May – 15 August 2004

ISBN 1 85437 521 0 (hbk)
ISBN 1 85437 491 5 (pbk)

British Library Cataloguing in Publication Data
A catalogue record for this book is available from the
British Library

Published in 2003 by Tate Publishing, a division of
Tate Enterprises Ltd, Millbank, London SW1P 4RG

www.tate.org.uk

© Tate 2003

Distributed in the United States and Canada by
Harry N. Abrams, Inc., New York

Library of Congress Cataloging in Publication Data
Library of Congress Control Number: 2003107212

Designed by Sarah Praill

Printed in Hong Kong by South Sea International Press

Measurements for works of art are given in centimetres,
height before width, followed by inches in brackets

Front cover:
DANTE GABRIEL ROSSETTI
Proserpine 1874 (no.66, detail)

Frontispiece
DANTE GABRIEL ROSSETTI
Paolo and Francesca da Rimini 1855 (no.18, detail)

Page 2
EDWARD COLEY BURNE-JONES
The Annunciation and the Adoration
of the Magi 1861 (no.40, detail)

CONTENTS

FOREWORD

Three years ago we began to explore the idea of touring an exhibition of Tate's Pre-Raphaelite paintings and drawings to Australia and New Zealand, a proposal that was encouraged by the presence of a wealth of British Victorian art in that region. Indeed, the Art Gallery of South Australia was, we discovered, in the process of organising *Love and Death: Art in the Age of Queen Victoria*, an important exhibition which brought together works from Australia and New Zealand and was to tour to The Art Gallery of New South Wales, Queensland Art Gallery, and Toi o Tāmaki Auckland Art Gallery after its presentation in Adelaide in early 2001. The museums of Australia and New Zealand were collecting British contemporary art two or three decades before any museum existed in Britain for this purpose. The National Gallery of British Art, as Tate was first named, opened only in 1897, and by then several major Pre-Raphaelite paintings had already been acquired by museums in Australasia. Ford Maddox Brown made his first sale to a public collection in 1876 when The Art Gallery of New South Wales purchased his masterpiece *Chaucer at the Court of Edward III* 1856–68, a later version of which is included in this exhibition (no.26). Artists in Britain bemoaned the absence of a national museum for contemporary art, and one of the most well known Pre-Raphaelite painters, John Everett Millais, was the moving spirit behind the establishment of the National Gallery of British Art, founded by his friend and patron, the philanthropist and collector Henry Tate. Though most of the artists in the original Pre-Raphaelite Brotherhood had died by the time the museum opened, Edward Burne-Jones, Holman Hunt, and Frederic Stephens lived to see what would become the home to some of the greatest paintings of their generation.

The immediate success of the Tate Gallery (as it became known), ensured that the original Pre-Raphaelite patrons, or their offspring, bequeathed works to the museum in the first few decades of the twentieth century. We have continued to build upon the strengths of the Collection, most recently with the acquisition of *Mariana* 1851, one of Millais's most important works (no.7). The Pre-Raphaelite paintings and drawings are now among the most cherished for audiences at Tate Britain. The romantic narratives of medieval chivalry and love, the idealised depiction of beauty, the detailed rendering of nature and the moralising tales; the works absorb us in a reverie, both removing us from our everyday life, and prompting us to reflect upon it.

It has been a great pleasure working with all our partners on this exhibition. We thank Alan Dodge,

Director of the Art Gallery of Western Australia, for his contribution to the formation of the exhibition and in particular his request that one of Holman Hunt's greatest paintings, *The Awakening Conscience 1853*, be included in the selection. We also thank Gary Dufour, Deputy Director at the AGWA and Curator Melissa Harpley. Priscilla Pitts, Director of the Dunedin Public Art Gallery, was, like Alan, committed to the project from the earliest stage and we particularly appreciate the energy and creativity she and her staff have brought to the presentation in Dunedin. We are grateful to Chase Rynd, Director of the Frist Center for the Visual Arts in Nashville who responded to a late opportunity to show the exhibition in the USA. The Frist opened in 2001 and has quickly established a dedicated audience. In 2002 the museum hosted *Whistler, Sargent and Steer: Impressionists in London from the Tate Collection*, and we were delighted to work again with Chase, Curator Mark Scala and all the other staff at the Frist.

The idea for the exhibition originated from Robert Upstone, Curator of British Art 1860–1960, who has brought his scholarship and deep knowledge of the Tate Collection to the selection and the writing for this catalogue, which he has undertaken with characteristic enthusiasm and rigour. The project could not have happened without the dedication and skill of Joanne Bernstein, Tate's International Manager, who was ably assisted by Penny Brookes and Renée Pfister of the International Programmes Division, which, until his appointment as Director of the National Portrait Gallery in London, was led by Sandy Nairne. We thank Conservators Stephen Hackney, Susan Breen, Rebecca Hellen, and Rosie Freemantle for preparing the works for exhibition. In Tate Publishing we thank Nicola Bion, Jo Field, and the designer Sarah Praill, who are all responsible for this handsome publication, for which Heather Birchall of the Collections Division has written the excellent artists' biographies. Lastly our thanks go to Stephen Deuchar, Director of Tate Britain, and Chris Stephens, Senior Curator, for accommodating the release of a large number of Tate's finest Pre-Raphaelite works. We are delighted to be able to share them with audiences on the other side of the world, many of whose forefathers came to Australia and New Zealand from Britain when the Pre-Raphaelite movement was at its height.

Nicholas Serota
Director, Tate

DIRECTORS' FOREWORD

Tate's very welcome decision to develop this exhibition for tour offers our three museums – the Art Gallery of Western Australia, Dunedin Public Art Gallery, and the Frist Center for the Visual Arts – a number of significant opportunities.

We are delighted to be able to offer our communities, and indeed audiences from further afield, the wonderful experience of viewing such an impressive selection of art works. Tate has been generous in allowing so many of its splendid Pre-Raphaelite works to travel far from home – works such as Rossetti's *Proserpine* 1874 and *Monna Vanna* 1866, Millais's *Mariana* 1851, and Holman Hunt's *The Awakening Conscience* 1853 are unsurpassed masterpieces and key works in the Pre-Raphaelite oeuvre. As most museums with substantial collections know, it is difficult to display all of their collections and, in *The Pre-Raphaelite Dream*, viewers have the good fortune to see a number of drawings that have seldom been shown even at Tate. Tate's desire to make its collection, in all its depth and variety, more widely available is truly our gain.

Involvement in this project has offered our institutions and our staff the chance to develop a relationship with one of the world's great art museums. Not only does Tate have outstanding collections and impressive sites, it has in recent years proved itself a leader in innovative ways of using those collections and developing exhibitions that excite and challenge the visitor.

Even for those who may be familiar with the work of the Pre-Raphaelite Brotherhood and its associates, this exhibition will reveal new treasures, new images and new ideas. The art of the Pre-Raphaelites is most obviously characterised by glorious colour, richly decorative pattern, a fascination with female beauty, and the intimation of narrative drawn from a variety of sources. Their admiration for medieval art and the work of the Italian Primitives is also well known. Robert Upstone's selection of works and his catalogue essay remind us that these artists were also ardent and often controversial interrogators of contemporary attitudes to women, love, sex and marriage, the family, work, war, and religion. He has skilfully framed this discussion, relevant even today, within the Pre-Raphaelites' belief in the virtue of craft and the saving grace of exceptional beauty.

We are most grateful to Tate for making *The Pre-Raphaelite Dream: Paintings and Drawings from the Tate Collection* available to our three museums. In particular we would like to thank Tate Director Nicholas Serota; Stephen Deuchar, Director of Tate Britain; Joanne Bernstein, Tate's International Manager; Sandy Nairne, formerly Director of National and International Programmes; and Robert Upstone, Curator and author of the catalogue.

ALAN R. DODGE
Director, Art Gallery of Western Australia

PRISCILLA PITTS
Director, Dunedin Public Art Gallery

CHASE W. RYND
Director, Frist Center for the Visual Arts

JOHN EVERETT MILLAIS
Mariana 1851 (no.7, detail)

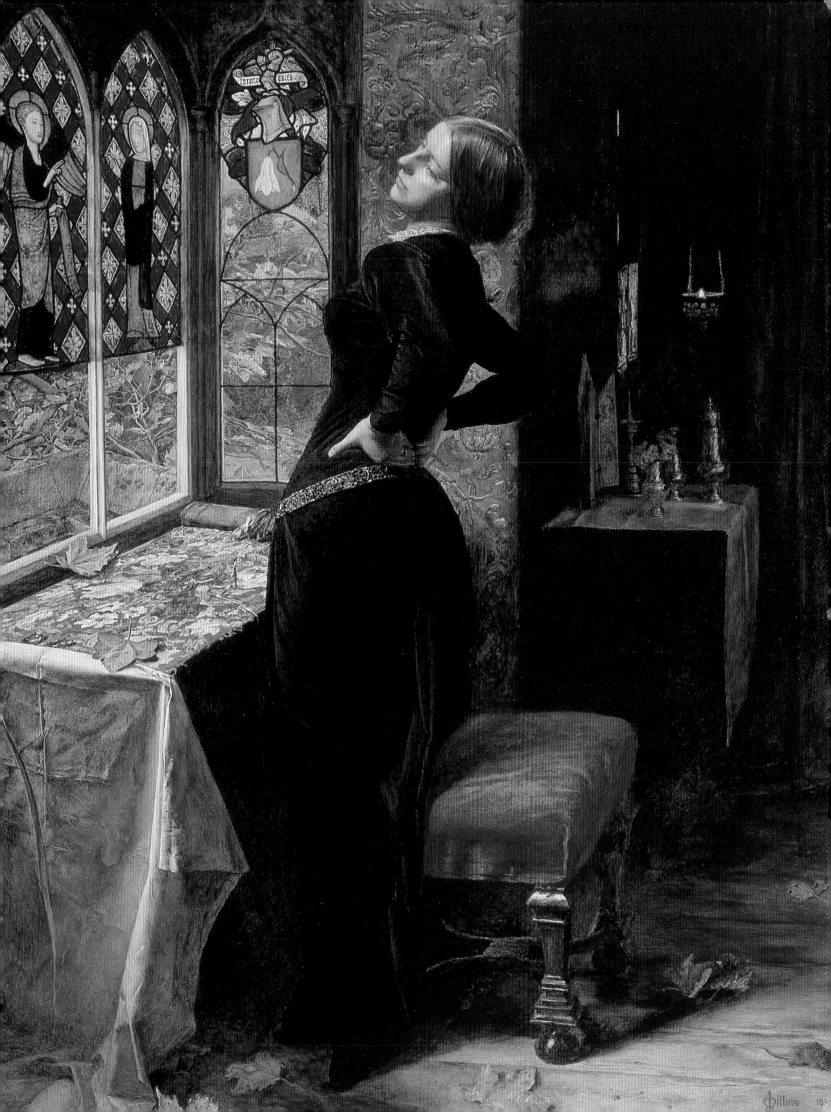

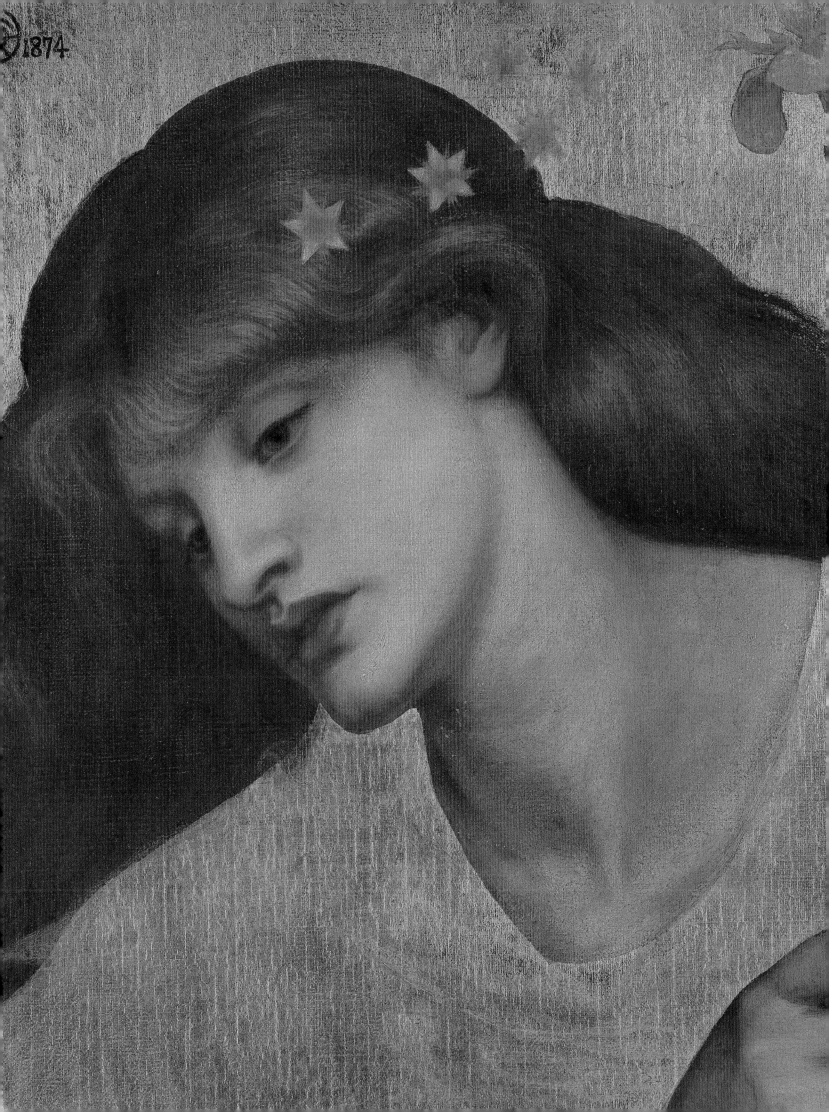

DANTE GABRIEL ROSSETTI
Sancta Lilias 1874 (no.67, detail)

INTRODUCTION

On an evening sometime in September 1848 a group of young men gathered in a room in Gower Street to discuss the future of British art. The nineteen-year-old John Everett Millais invited to his parents' house his friends William Holman Hunt and Dante Gabriel Rossetti, fellow students from the Royal Academy's art school. In considering how the future might be, they looked for inspiration to the past. Together that evening they turned the pages of a volume of line engraving illustrations of the early Italian frescoes in the Campo Santo in Pisa by Benozzo Gozzoli. Admiring the sparcity and simplicity of line and expression, the lack of chiaroscuro shading and complex perspective, they found in them a pervasive sense of humble spirituality. This fitted the trio's belief that modern academic painting was blighted by overblown stylistic hyperbole due to its emulation of the High Renaissance painters who had superseded Gozzoli and his generation. 'The innocent spirit which had directed the invention of the painter was traced point after point', Hunt recalled,

> with the determination that a kindred simplicity should regulate our
> own ambition, and we insisted that the naïve traits of frank
> expression and unaffected grace were what had made Italian art so
> essentially vigorous and progressive, until the showy followers of
> Michael Angelo had grafted their Dead Sea fruit on to the vital tree
> just when it was bearing its choicest autumnal ripeness for the
> reawakened world.[1]

Their enthusiasm for the Early Italian painters was undoubtedly partly encouraged by an exhibition of these painters' work held in the spring of 1848 at the British Institution. It was Raphael, they all agreed, who had led things astray. Viewed by the world as a figure who embodied all the greatness of artistic moral ambition and expression, and whom their teachers told them to revere and emulate, it was Raphael from whom they must free themselves and rebel against the accepted establishment reverence for his qualities. Together they would be 'Pre-Raphaelites'.

Rossetti's brother William, who was himself to enlist in the new group, recalled years later that:

> The British School of Painting was in 1848 wishy washy to the last degree; nothing imagined finely, nor descried keenly, nor executed puissantly ... The three young men hated all this. They hated the cant about Raphael and the Greek Masters, for utter cant it was in the mouths of such underlings of the brush as they saw all around them; and they determined to make a new start on a new basis.[2]

It was Millais and Holman Hunt who invented the term 'Pre-Raphaelite' for this view, but it was Rossetti who added 'Brotherhood', a covenant of shared belief which gave the appearance of holding the status of a secret society or a revolutionary cadre. The Anglo-Italian Rossetti, whilst deeply romantic, knew all about the efficacy of such societies in binding their constituents together, for his own father Gabriele was a political exile who had escaped from Naples. It was his poetry extolling the liberty of the spirit and the flesh that had got him into trouble, and Gabriele Rossetti had discovered that art could have political weight, meaning and transformative power, an experience that could not wholly have been lost upon his son. There were to be seven Brothers – Millais, Hunt, Rossetti, his brother William, the sculptor Thomas Woolner, Frederic Stephens and James Collinson. The first formal meeting was convened on the very the last day of 1848. Thereafter, William Michael Rossetti recalled, they formed a very tight social and artistic group:

> We really were like brothers ... continuously together, and confiding to one another all experiences bearing upon questions of art and literature, and many affecting us as individuals. We dropped using the term 'Esquire' on letters and substituted 'PRB' ... There were monthly meetings, at the houses or studios of the various members; occasionally a moonlight walk or a night on the Thames. Beyond this, very few days can have passed in a year when two or more PRBs did not foregather for one purpose or another.[3]

Their shared disdain for posturing academic mannerism and their rejection of the outmoded hierarchies and techniques that were the inheritance of 'Sir Sloshua' Reynolds were combined now with an agreed devotion to sincerity in art. This was translated into the central Pre-Raphaelite credo of 'truth to nature'. In practice this meant painstakingly detailed observation and drawing of real objects in suitably realistic circumstances; it meant drawing from life rather than lay figures or casts; and if the subject demanded, it meant painting outdoors to catch every subtle gradation of light and colour. Artifice was to be abandoned in favour of an earnest truthfulness, a blurring of the boundaries between art and life, a kind of super realism which might embody a higher truth.

These principles were now to be applied to subjects drawn from the Bible, history or literature, the highest categories of art in the hierarchies that Reynolds had set out in his *Discourses*, and a set of principles and rules still rigidly adhered to at the Royal Academy. Traditionally these subjects had been treated in an idealised, elevated manner divorced from reality and often drawing upon ancient Greek or late Renaissance precedents and sources. Now they would be brought to life by being run through with the observational detail and realist strength of life itself. Similarly 'modern life' could also be the vehicle for serious art. Traditionally, and according to academic principle, such scenes had been reserved for 'genre' painting, a category which took in trite narratives or rustic idylls. Instead, the Pre-Raphaelites proposed, modern life, and particularly urban metropolitan life, could provide material for an art that was relevant and pressing and new. It could range from ruminations on the fallen women of Rossetti's *Found* 1854–81 (see fig.1) or Hunt's *The Awakening Conscience* 1853 (no.12) to the pathos of a newly bereaved Crimean war widow in Stephens's *Mother and Child* c 1854 (no 15), an apparent indictment of the human costs of a pointless war fought with modern weaponry. To these were brought the use of an extended and interlocking symbolism, a practice normally reserved only for high art subjects, and the use of inventive, telling new symbols, again drawn from the everyday – the soiled, discarded glove to represent the lost innocence of Hunt's kept woman, or the precarious doll riding a toy lion in Stephens's Crimea painting to represent the young queen and her army, and the childishness of the war.

This was to be a revolutionary group, through whose example, they hoped, British art would be renewed and revitalised. Evidently the frisson of shared purpose, a great cause and the trappings of a secret society were powerful elements in their formation, but at its centre lay a heartfelt dissatisfaction with both the condition of art and by connection the society from which it sprang. Artistic groups have in the past sometimes been conservatively considered only in isolation, but in their questioning and searching for new meaning the Pre-Raphaelites were far from alone. The year the Pre-Raphaelite Brotherhood was created was in fact a momentous one of turmoil throughout Europe, and its formation took place against a background in Britain of considerable social, political and economic turbulence and instability.

With varying degrees of success revolution came in 1848 to almost every major European capital except London, Brussels and St Petersburg; absolutist kings were replaced with republics or constitutional monarchies, carrying the watchwords of freedom

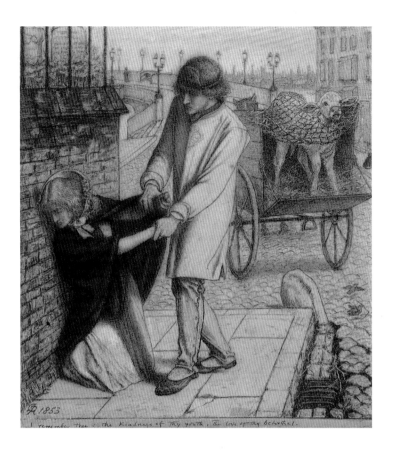

and democracy. The rights of the individual and the pre-eminence of individual expression were subjects that were forcefully addressed. King Louis-Philippe fled France for London, and in Italy Venice declared itself a republic again while Milan rose up and successfully defeated its Austrian occupiers. Naples rebelled against King Ferdinand, and Rossetti's father Gabriele was even invited to return to his homeland. In Britain, as so often, things were a little different. Despite fears that the contagion of full-blown Continental revolt might cross the Channel, the Government had only well behaved Chartists to face down, although they viewed them with equal measures of dread and loathing.

The Chartists were a long-standing political pressure group who wanted the right to vote extended beyond the property-owning middle and upper classes. The movement for a 'People's Charter' had initially been organised by the London Working Men's Association, but the cause gradually found a national following as Chartist branches were formed across the country. By 1840 there was a vibrant Chartist press with newspaper publications in all the main industrial cities of Britain. The Chartists had six demands which they believed would improve both democracy and the quality of British governance universal suffrage for all men (but not women); secret ballots; annual general elections; the abolition of the need for Members of Parliament to be property owners; the payment of a salary to Members of Parliament; and the creation of equal electoral districts throughout the country. Signed by hundreds of thousands, the Charter was presented to Parliament in the form of a petition in 1839 and 1842, and on both occasions it was heavily defeated in a vote in the House of Commons. Discussion of the need to resort to strikes and arms dominated Chartist discussions for the years following 1842, and the last petition of 1848, the year of the Pre-Raphaelites' formation, took place against a dramatic backdrop of growing crisis – in 1846 and the following year there were crop failures which resulted in high food prices and hunger in mainland Britain; and in 1847 there was also a commercial and economic slump which saw a check on the manufacturing industry's expansion and numerous businesses collapse. Continuing famine in Ireland took death by starvation to shocking and catastrophic levels, and was the impetus behind a rapidly crushed nationalist rebellion in 1848 during which a Fenian tricolour flew for the first time. 'The people there have always been listless, improvident, and wretched', an extraordinarily chilling *Times* editorial wrote of the great Irish famine, 'they have not participated in the great progress of mankind ... We do pity them, because they have yet to be civilized'; and, in an echo of Marie-Antoinette, it advised the starving Irish to eat fish instead of potatoes.[4]

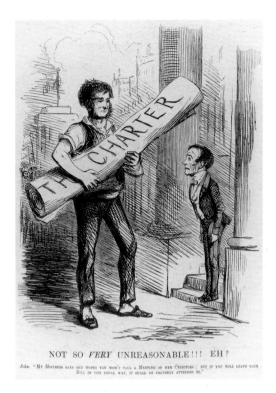

Fig.2
Punch 'The Charter' 1848

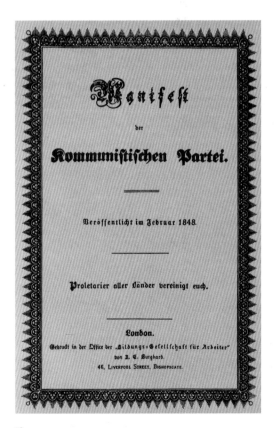

Fig.3
Title page of *Manifest der Kommunistischen Partei*,
London ed., 1848

The wave of rebellion which swept the Continent in March 1848 following Louis-Phillipe's abdication on 24 February filled the British Government with a sense of foreboding about the Chartists. Their planned demonstration in central London on 10 April was outlawed, and troops were mobilised. The Charter that year ran to five million signatures, although some were forged. The gathering that took place on Kennington Common, south of the Thames, was claimed by the Chartists themselves to have been attended by a million people, although the authorities believed it to be a fraction of this figure. A steady, driving rain fell on the demonstrators, and any fears about insurrection or riot rapidly evaporated. Three cabs were needed to present the petition to Parliament, which promptly assigned a Select Committee to consider it; eventually it was rejected, amid allegations of forgery, and as a mass movement Chartism crumbled. In *Punch* an heroically well-built Chartist presents the petition to the diminutive Prime Minister, Lord John Russell, an honest tradesman calling at the backdoor and dealing with the sardonic servant (fig.2). 'My Mistress says she hopes you will not call a meeting of her creditors,' says Russell, 'but if you will leave your Bill in the usual way, it shall be properly attended to', meaning of course that it will be ignored or fudged by the Queen and her Government like all the previous Chartist petitions.

These matters might seem tangential to the context of the Pre-Raphaelite Brotherhood's birth, except that two of its main creators were at Kennington. Holman Hunt gave a gripping account of his and Millais's accompaniment of the demonstrators' march. It captures vividly the sense of their excitement, even at over fifty years' distance, and it is a description which combines sympathy for the protesters with fear of their actions, and an overriding sense of the momentousness of the occasion:

> The first use which Millais and I made of our release from the pressure of work, was on a succeeding morning to accompany the Chartist procession; it marched from Russell Square across Blackfriars Bridge to Kennington Common; we did not venture onto the grass with the agitators, but, standing up on the cross rails outside the enclosure, we could see the gesticulations of the orators as they came forward on the van drawn up in the centre of the green. When the address was beginning to evoke tumultuous cheers, a solitary policeman, square and tall, appeared from the northern corner, walked through the dense artisan crowd to the foremost stand, and beckoned to Fergus O'Connor to return with him to the Superintendent of Police, under assurance of non-detention. I felt respect for both men and for the crowd as the speaker quietly descended, and a lane was made by the thousands present, while the two walked over the common as staidly as though they were alone on the ground. The Chartist champion was detained

only a few minutes. He came back by himself, knowing that the roofs of the neighbouring houses were manned with riflemen and that concealed measures had been taken to quell any outbreak of disturbance.

On re-ascending the van, he advised the law-abiding people to disperse, which they did without delay. We essayed to return by the road we had come, but at Blackfriars Bridge a cordon of police barred further passage. We turned towards Bankside. Here at the entrance a set of stalwart roughs armed with bludgeons were determined to have their fight, and we heard, as we were about to pass, the sound of bloody strife. Who that has heard such even in its mildest form can forget the hurtle? We felt the temptation to see the issue, and Millais could scarcely resist pressing forward, but I knew how in a moment all present might be involved in a fatal penalty. I had promised to keep him out of wanton danger, but it was not without urgent persuasion that I could get him away. We went along, accompanied by but few of the crowd, till we reached London Bridge; passing this we arrived at the Bank of England and the Mansion House, crested with sand-bags to mask the soldiery. We succeeded on our round in gaining a thorough knowledge of the state of affairs. Returning by way of Holborn, the sombre sky opened its silent artillery on us with spots of rain as large as grape shot, and cleared the streets of agitators, mischief-makers, and idlers alike. With the last we scampered home as swiftly as any of the crowd.[5]

This is an extraordinary glimpse of a political event in one of the primary sources for the history of Pre-Raphaelitism. Indeed, in the Brotherhood references to specific political or religious causes were prohibited, presumably in order to prevent disagreement or factionalism. This policy extended to their journal, *The Germ*, started in 1850. However, William Michael Rossetti's sonnet in praise of the Hungarian uprising was printed, although its title was changed by the group from 'For the General Oppression of the Better by the Worse Cause in July 1849' to simply 'Evil under the Sun', and therefore divorced it from its political specificity. Probably the most politically aware of the Brotherhood, William Michael Rossetti was later to concern himself with the abolition of slavery in America and the extension of the vote to women, both in their way causes which revealed a democratising, humanitarian idealism, although the confusion and contradictions of political difference meant that he had been sworn in as a special constable to protect his Inland Revenue office during the great Chartist demonstration of 1848. His brother wrote a mocking verse about the petitioners gathered in London, 'The English Revolution of 1848'. This ambiguous piece can be read either as a parody of the movement itself or an indictment instead of its lack of grit in not taking on the armed forces mustered in the capital: 'Shall not our sons tell to their sons what we could do and dare', he wrote, 'In this great year Forty-eight and in Trafalgar Square?'

In the period following 1848 London became a centre for political exiles from the failed revolts or reactionary retrenchment on the Continent. Unknown except to a very few in Britain at the time, the first edition of the Communist Manifesto was published in London in 1848, although it was not to be until 1850 that an English language version appeared. Karl Marx himself settled in the Metropolis in January 1849 and remained there until the end of his life; devouring economic texts under the great, encompassing dome of the British Museum Library, one of his fellow readers was Ford Madox Brown, diligently researching his subjects from Chaucer and the Bible, their ignorance of each other and totally alien trajectories of thought a paradigm of the rich anonymity of modern city life. But in their different ways, as John Ruskin, Thomas Carlyle, William Morris and John Stuart Mill were themselves to argue, both saw the need for change, an alternative to the industrialised, unregulated, profit-driven banal horror of mid-Victorian society. Britain could fill the vast halls of the Crystal Palace Great Exhibition with every ingenious invention and item of manufacture in 1851 but, each of these vastly different theorists asked, what was the point, where was this society going, what was it all for? Each in his own way articulated a common yearning for meaning and alternative ways of living.

The Pre-Raphaelite Brotherhood did not concern themselves with matters of political economy, other than a vaguely expressed admiration for Renaissance studio workshops; instead their agenda was the transformative power of a spiritually whole art, to bring about revival through top-down cultural change rather than a more fundamental shift in economic relations. The first picture to be exhibited with the deliberately unexplained initials PRB after the signature was Rossetti's *The Girlhood of Mary Virgin*. It was shown at the juryless Free Exhibition in 1849, but went without criticism, and instead attracted modest praise despite its archaic style and Mariolatry subject matter. Millais's *Isabella* and Hunt's *Rienzi* also attracted good comment when they were accepted for the 1849 Royal Academy spring exhibition. These were subjects taken respectively from the poem by Keats and the 1835 novel by Edward Bulwer Lytton, itself interestingly a thinly-veiled patrician parable of the unwiseness of Chartist democracy. This seemed an encouraging beginning for the Brotherhood, and in the autumn of 1849 Hunt and Rossetti travelled to the Louvre in Paris and to Belgium to further their researches into Early Italian and Northern Renaissance art. In January 1850 the first edition of *The Germ* appeared, followed by three more in February, March and May, a rich collection of writings by all the Brothers except Millais, and with contributions from their Pre-Raphaelite sympathisers and allies Ford Madox Brown, William Howell Deverell, William Bell Scott, Coventry Patmore and Christina Rossetti.

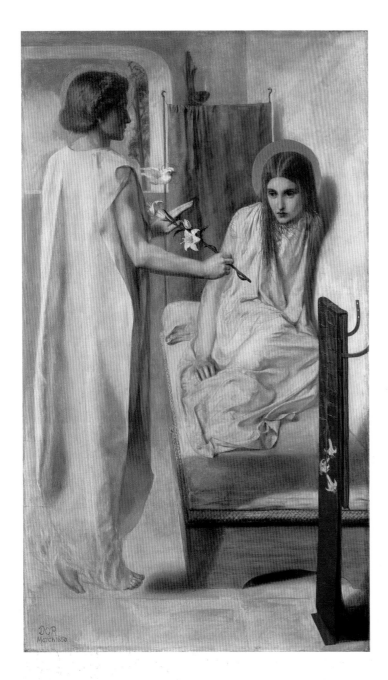

Fig.4
Dante Gabriel Rossetti
Ecce Ancilla Domini! (The Annunciation) 1849–50
Oil on canvas
72.4 x 41.9 (28½ x 16½)
Tate. Purchased 1886

But this was the calm before the storm. To the 1850 Royal Academy exhibition Millais sent *Christ in the House of his Parents* (fig.5) and *Ferdinand lured by Ariel*, while Hunt submitted *A Converted British Family sheltering a Christian Missionary from the Druids*; Rossetti showed at the National Institution exhibition *Ecce Ancilla Domini!* (fig.4) and Deverell sent *Twelfth Night* (no.2). There was an immediate explosion of controversy and criticism. In May the *Illustrated London News* had revealed the meaning of 'PRB' and, although none of their pictures was initialled this year, the critics were waiting. The press took the very name Pre-Raphaelite as a rebellious provocation, compounded by the knowledge they were a closed society and, more than anything, their pictures showed they were working effectively to a common agenda and shared set of ideals. Rossetti's *Ecce Ancilla Domini!* was enormously inventive in its emphatic spareness and archaism of design, the figures filling the picture space and its prevalent colour of white symbolising both the Virgin's purity and the high spiritual status of the picture itself. Modelled by Christina Rossetti, the Madonna draws her legs up protectively in a mixture of horror and resignation at the message the Angel Gabriel has brought her, Mary's words forming the Latin title of the picture – 'Behold the handmaid of the Lord!' 'A perversion of talent' was the judgement of the *Athenaeum*; 'Ignoring all that has made the art great in the works of the greatest masters,' it continued, 'the school to which Mr Rossetti belongs would begin the work anew ... setting at nought all the advanced principles of light and shade, colour and composition'.[6] This was a theme taken up by the *Illustrated London News* which lampooned the group of 'ingenious gentlemen who profess themselves practitioners of "Early Christian Art" and who – setting aside the Mediaeval schools of Italy, the Raffaelles, the Guidos and Titians and all such small beer daubers – devote their energies to the reproduction of saints squeezed out perfectly flat'.[7] The tendency towards 'flatness' by painters imitating the Gothic or German Nazarene style had been singled out for parody as early as 1848 in *Punch* where the 'Mediaeval-Angelico-Pugin-Gothic, or Flat Style' is shown side by side with the 'Fuseli-Michael-Angelesque School'; both works by the same artist had been rejected by the Royal Academy, and depict the same incident of 'Prince Henry Striking Judge Gascoigne in Court' (fig.6).

But it was Millais's *Christ in the House of his Parents* (fig.5) which suffered the greatest tirade of abuse in 1850, with violent, visceral language almost unique in the history of British art criticism. Millais had gone to enormous pains to ensure the accuracy of his painting. The carpenter's shop was said to be one he found near Oxford Street, while the sheep in the background were drawn from a pair of heads he bought from the local butcher. For the Holy Family he used his friends and relations and, although the head of Joseph was drawn from his own father, his body was modeled

by a real carpenter so that the musculature would be absolutely accurate. Such fidelity bordered on a kind of obsessive social realism but, in true Pre-Raphaelite spirit, it was combined with an interlocking, fully integrated symbolism – the sheep represent Christ's flock, the wound on his hand his future crucifixion, and the set-square hanging on the wall the Trinity. Mary kneels in a pose traditionally used when she is shown at the base of the Cross, and the ladder too relates to the Crucifixion, and the dove to the Holy Spirit. Christ's tender kiss is both a benediction and a reference to his own betrayal in the Garden of Gethsemane. Such was the critical outcry over the painting that Queen Victoria had it temporarily removed from the Royal Academy and brought to her for a special viewing; 'I hope it will not have any bad effect on her mind', Millais wrote disdainfully to Holman Hunt. 'Mr. Millais's principle picture,' wrote *The Times*, 'is, to speak plainly, revolting. The attempt to associate the holy family with the meanest details of a carpenter's

shop, with no conceivable omission of misery, dirt, or even disease, all finished with the same loathsome minuteness, is disgusting'. Charles Dickens in his journal *Household Words* went even further, railing famously:

> in the foreground … is a hideous, wry necked, blubbering, red-headed boy, in a bed-gown, who appears to have received a poke in the hand, from the stick of another boy with whom he has been playing in an adjacent gutter, and to be holding it up for the contemplation of a kneeling woman, so horrible in her ugliness, that … she would stand out from the rest of the company as a Monster, in the vilest cabaret in France, or the lowest gin shop in England … Wherever it is possible to express ugliness of feature, limb or attitude, you have it expressed. Such men as the carpenters might be undressed in any hospital where dirty drunkards, in a high state of varicose veins, are received.[8]

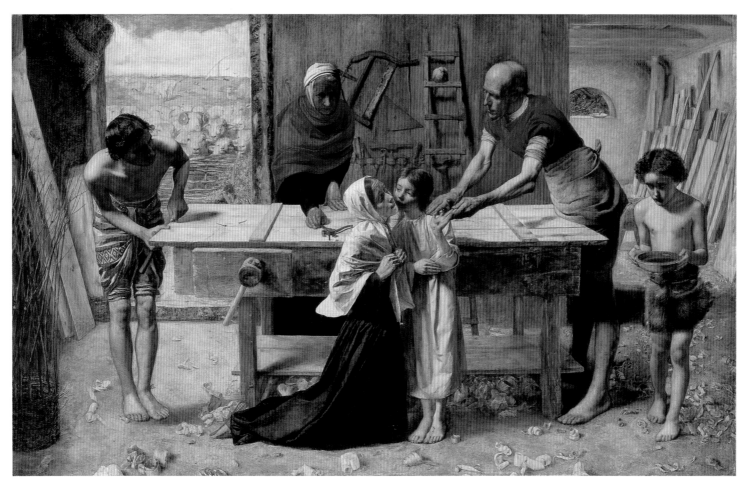

Fig.5

John Everett Millais

Christ in the House of his Parents 1850

Oil on canvas

86.4 x 139.7 (34 x 55)

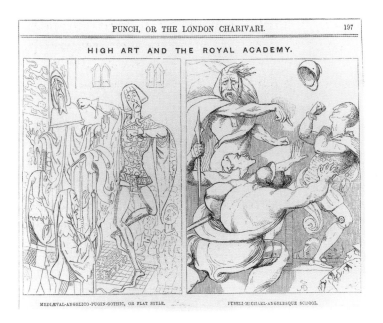

HIGH ART AND THE ROYAL ACADEMY.

MEDIÆVAL-ANGELICO-PUGIN-GOTHIC, OR FLAT STYLE. FUSELI-MICHAEL-ANGELESQUE SCHOOL.

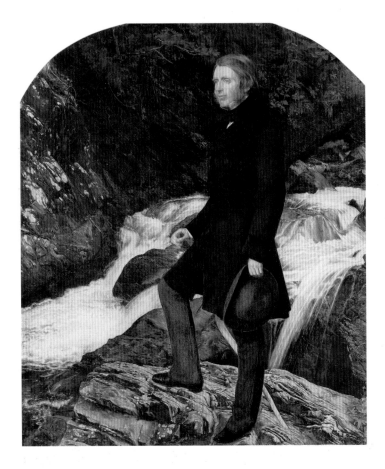

Fig.6
Punch 'High Art at the Royal Academy' 1848

Fig.7
JOHN EVERETT MILLAIS
John Ruskin 1853–4
Oil on canvas
78.7 x 68 (31 x 26 ¾)
Private Collection

The *Athenaeum* meanwhile criticised the picture on the basis of the group's admiration of the Early Italians, whose 'absence of structural knowledge never resulted in positive deformity. The disgusting incidents of unwashed bodies were not presented in loathsome reality; and flesh with its accidents of putridity was not made the affected medium of religious sentiment in tasteless revelation';[9] this oddly equated primitivism in art with a lack of personal hygiene. But all this seems not to have deterred Millais, or his quest for a kind of super realism. In 1851 he painted what was to be his masterpiece, *Ophelia* (fig.15). Enduring considerable discomforts, he painted the picture's background in the open air on the River Hogsmill at Ewell, and took over four months to complete it. For the figure of Ophelia herself Millais used Elizabeth Siddall and had her pose floating in a bath of tepid water, warmed only by lamps lit beneath. At some stage these went out; Lizzie caught a chill and her angry father threatened to sue Millais for the cost of her doctor's bill. Nevertheless, the resulting canvas was a triumph of observation and realism combined with a moving symbolism and pathos quite unlike anything that had gone before.

Criticism of the Pre-Raphaelites continued in a similar vein to the year before in 1851, but in a defining moment John Ruskin intervened. Ruskin's two volumes *Modern Painters* (1843, 1846) had analysed systematically the nature of beauty and quality in art, and had described in depth the innate 'truthfulness', accuracy and ideals of James Mallord William Turner's pictures to an audience more used to hearing them dismissed as the products of madness or whimsy. The books were greatly admired, not least for their unwavering sense of confidence and certainty, and Ruskin now brought his powers to the defence of the Pre-Raphaelites. In a pair of letters to The *Times*, whose critic had so abused them, he explained the Pre-Raphaelites' belief in 'truth to nature' and defended its honesty, ambition and potential. 'They will draw either what they see,' Ruskin explained, 'or what they suppose might have been the actual facts of the scene they desire to represent, irrespective of any conventional rules of picture-making; and they have chosen their unfortunate though not inaccurate name because all artists did this before Raphael's time, and after Raphael's time did *not* this, but sought to paint fair pictures rather than represent stern facts'. It was a master-stroke of public relations, and while derision continued for a time, it was effectively punctured. With his measurement of 'fair pictures' against 'stern facts' Ruskin alluded cunningly to just how suited the Pre-Raphaelites were to the Victorian spirit. For in their zeal to categorise, enumerate, observe and quantify, and in their admiration for craftsmanship, time-consuming, painstaking labour, diligence and earnestness, the Victorian mind, the very ethos of their spirit, was perfectly suited to Pre-Raphaelitism – and it was of course

exactly from this wider shared outlook that the group originally sprang. Underneath this impulse to catalogue and investigate lay a deep-set questioning uncertainty, and again the ambition of Pre-Raphaelitism uniquely placed it in a position to ruminate on serious subjects about love, death and religion.

The moral benefits of labour formed the subject of one of the most complex Pre-Raphaelite parables, *Work* 1852–65 (fig.8). Suitably taking him over a decade to finish, Ford Madox Brown gave a carefully choreographed sociological survey of every section of society and their different attitudes and relationships to work. At the heart are the group of heroic navvies, their healthy bodies bronzed and muscled through their labours, Brown stressed; they are laying water pipes, one of the great socially improving projects of the day. On the left, contrasted to them is a 'ragged wretch who has never been *taught* to *work*', Brown wrote; behind him pondering the impossibility of negotiating the obstruction on horseback are 'the *rich*, who have no need to work'.[10] The group of children in the foreground, one of whom is part of the work gang, are parentless, Brown explained, and being brought up by their ten-year-old sister holding the baby; they struggle in adversity, and their vigorous mongrel dog contrasts markedly with the tentatively cowering, overbred greyhound of the gentlefolk. Elsewhere are temperance tractarians, vagrants and a corrupt prospective parliamentary candidate; essentially it is a Hogarthian satire, but one with a sober message. On the right, surveying the scene, stands a grimacing Thomas Carlyle, apostle of the judgement put forward in his *Past and*

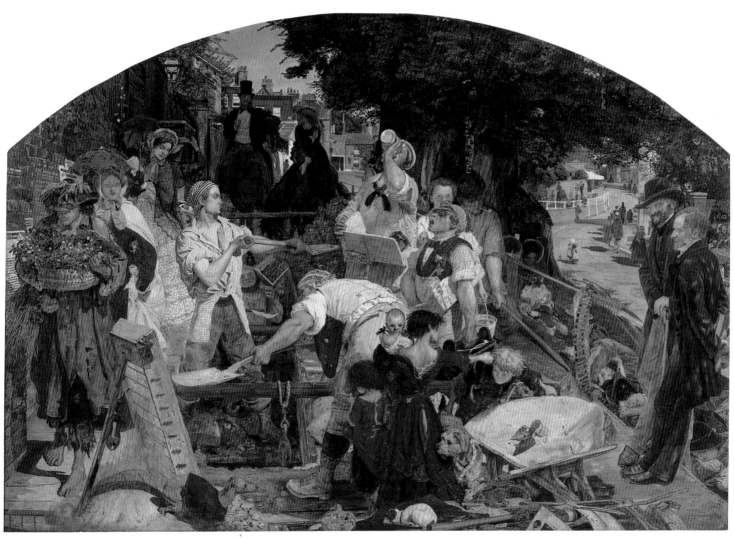

Fig.8
FORD MADOX BROWN
Work 1852–65
Oil on canvas
137 x 197.3 (54 x 77 ⅝)
Manchester City Art Galleries

Present (1843) that 'All true Work is Religion ... there is a perennial nobleness, and even sacredness, in Work ... In Idleness alone is there perpetual despair'.[11] It placed labour in the orbit of moral worth and integrity rather than simple necessity, and Carlyle offered not a philosophical or political programme but simple, easily adopted virtues to follow: work, duty and self-denial. Brown pursued the idea himself in the poem he composed to accompany the picture:

> Work! Which beads the brow and tans the flesh
> Of lusty manhood, casting out its devils!
> By whose weird art, transmuting poor men's evils,
> Their bed seems down, their one dish ever fresh ...[12]

The first two volumes of *Past and Present* contrast medieval and Victorian England. Carlyle examines the recently rediscovered and published manuscript *Chronicle of Jocelin of Brakelond* which gives an authentic account of life in the Abbey of St Edmund in the twelfth century. Secure in his purpose and position in a carefully structured and balanced society, Carlyle rhetorically asks if the medieval worker is not happier and better off than his modern counterpart. This was a question being addressed elsewhere in response to the industrialised, urbanised country that Britain had rapidly become. In 1841 the census had revealed that for the first time more people lived in the city than on the land, often in conditions of considerable squalor, pollution and alienation. The Catholic architect Augustus Welby Pugin considered the social benefits of a return to a medieval way of life in his book *Contrasts, or a Parallel between the Noble Edifices of the Middle Ages and Corresponding Buildings showing the present Decay of Taste* (fig.9). Pugin believed that a revival of Catholicism and a Gothic style of architecture and design would bring a corresponding rejuvenation of society. This might today seem somewhat naïve, but at its heart lay a wholly modern and instinctive understanding of the links between environment and behaviour. The concept of medieval-style skilled work under humane conditions was taken up by William Morris and the Arts and Craft Movement, and was even applied in his unprofitable wallpaper and weaving factory at Merton Abbey, while Ruskin argued that a return to the guild system and high standards of craftsmanship was the only way to transform the quality of workers' lives. This too might easily be dismissed as immature fantasy, but again it contains the nugget of insight that human nature takes satisfaction in having made something well, and that exposure to beauty can elevate and inspire. But these ideas could only ever remain fantasies, however potent; the factory system and mass market were far too profitable to abandon, and consolidation of the progression from one mode of production to another more efficient one was irreversible.

There was a similar uncertainty at the heart of the nation's religious life. In 1850 the harsh criticism of Millais's picture of Christ's childhood was partly because it was perceived to have touched on the explosive debate about the return of ritual to the Church of England. The Oxford Movement led by Edward Bouverie Pusey argued that through the resuscitation of ceremony in Anglican services would come a revival of meaning and belief. But since the disestablishment of the Church of England in the sixteenth century such practices had been derided as Catholic and the debate reopened old wounds about the limits and allegiances that sprang from papal power. Pope Pius IX's re-establishment of the Roman Catholic hierarchy in England caused widespread rioting in 1850 under the banner 'No Popery', and the following year Parliament passed the pernicious Ecclesiastical Titles Act which banned Catholic dioceses from taking the same names as their Anglican counterparts. But the Oxford Movement's concentration on the miraculous nature of sacramental ceremony ran counter to other factions both inside and outside the Church of England who believed in the evangelical relevance only of Christ's word, and the modernisation of Christian religion. By using real people in naturalistic circumstances Millais had appeared to be advancing the concept of Jesus as an ordinary man and, by implication in this deeply hierarchic society, of equality before the eyes of God. In fact this was not Millais's outlook or intention at all. He himself worshipped at St Andrew's in Wells Street, which was a church well known for its ritualistic services, and he had significant contacts with the Oxford Movement through his friendship with Thomas Combe, one of its theologians. The concept for the picture itself came to Millais during an extended stay in Oxford, and Holman Hunt claimed that the idea had struck him whilst listening to a sermon by Pusey himself.

In his 1849 drawing *The Disentombment of Queen Matilda* (no.3), Millais set out a quite explicit view of the confrontation between extreme Protestantism and a community of nuns. Matilda was the wife of William the Conqueror, and together they were buried in Caen. In 1562, during the religious wars which swept France, the royal tombs were broken open by the Calvinists, and their bodies disinterred. Always susceptible to the more ghoulish moments from history, Millais took the subject from the account from the first chapter in Agnes Strickland's *Lives of the Queens of England* (1840):

> The entreaties and tears of the abbess and her nuns had no effect on the men, who considered the destruction of church ornaments and monumental sculpture a service to God quite sufficient to atone for the sacrilegious violence of defacing a temple consecrated to his worship and rifling the sepulchres of the dead. They threw down the

monument, and broke the effigies of the queen which lay thereon. On opening the grave in which the royal corpse was deposited, one of the party observing that there was a gold ring set with a fine sapphire on one of the queen's fingers, took it off, and with more gallantry than might be expected of such a person, presented it to the abbess Madam Anna de Montmorenci.[13]

This is the central dramatic incident which Millais chose to depict, as the abbess reaches forward with evident distaste to receive the queen's ring. It is a knowingly profane insult on the part of her tormentor, for nuns wear only the wedding ring which marries them to Christ, and one of the sisters plucks at the abbess's sleeve in an attempt to restrain her. It must be significant that Millais chose the moment of confrontation between Calvinists and Catholics; his portrayal of the nuns in orderly ranks, filling one half of the composition, and continuing to stand fast in their prayerful duty despite their horror, contrasts markedly with the writhing mass of the Protestant grave robbers, among whom disorder reigns. This was an important distinction, for ritual set boundaries of behaviour and observance, and what Millais perhaps suggests is that without this framework extreme non-conformism might lead to anarchy.

Within the Pre-Raphaelite Brotherhood itself there was a diversity of religious outlook. William Michael Rossetti was a professed atheist, while the ascetic, self-denying James Collinson was a convinced Puseyite. Eventually Collinson converted to Catholicism, left the group, and broke off his engagement to the Anglican Christina Rossetti. Dante Gabriel was nominally an Anglican, but did not bother to attend Church; for him a belief in the twin sacraments of love and poetry was a truer religion, although he also maintained a flirtation with Swedenborgian mysticism.[14] Holman Hunt was an atheist but in 1851 had a sudden and dramatic conversion, and became an ardent broad church protestant. His belief in a living Christ was embodied in *The Light of the World* (fig.10), a startlingly original image which, after initial incomprehension, became the best-known religious picture in nineteenth-century Britain and one of the biggest selling prints; a copy Hunt made of the original toured the Commonwealth, attracting huge crowds in Australia and New Zealand in 1906. Hunt took inspiration from a verse he came across in the Book of Revelation: 'Behold, I stand at the door, and knock; if any man hear my voice, and open the door, I will come in to him, and will sup with him and he with me' (3:20). The risen Christ knocks at the door of the soul itself, and although it is overgrown with brambles, threads of ivy have run up the timbers as evidence of years of inaction, but also symbolic of enduring life and hence the resurrection. This is a very humane-looking Saviour whose earnest enquiry after each mortal soul allows redemption however long he

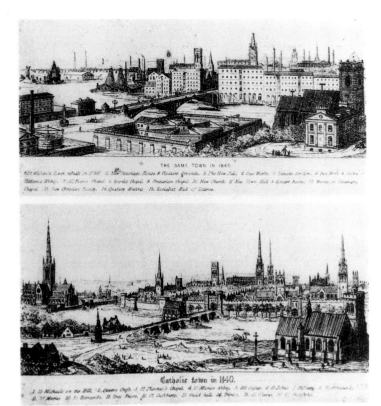

Fig.9
A.W.N PUGIN
'Contrasted Towns' in *Contrasts*, 1841

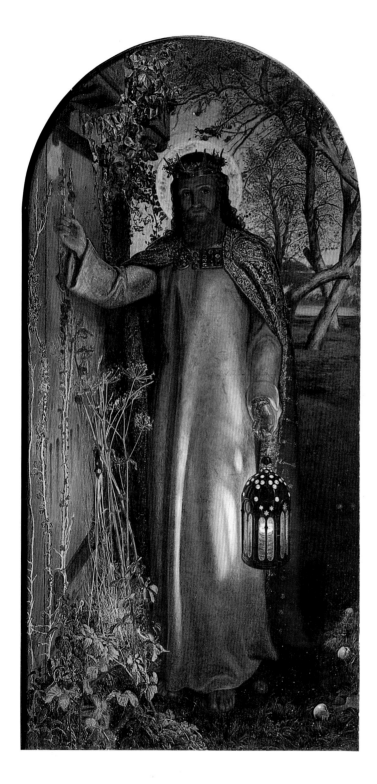

has been ignored; and it implies a direct, vigorous relationship with the Saviour himself, without the intrusion of Church, ceremony or priest. It was an evangelical clarion for the vitality of Christ's teachings independent of ritual. Hunt's picture was shown along with *The Awakening Conscience* (no.12) at the 1854 Royal Academy exhibition. Both ruminations on salvation, it was difficult for the critics to decide which they liked least. 'The face of this wild fantasy', wrote Frank Stone, the art critic of *The Athenaeum*, 'though earnest and religious, is not that of a Saviour … It expresses such a strange mingling of disgust, fear, and imbecility, that we turn from it to relieve the sight'.[15]

Ford Madox Brown took even further the idea of Christ the man in his *Jesus Washing Peter's Feet* (no.10), in which the ostensible subject was the Last Supper but treated in a wholly original way. When first exhibited it was accompanied by the description in John's Gospel: 'He riseth from supper and laid aside his garments; and took a towel and girded himself. After that he poureth water into a basin, and began to wash the disciples' feet, and to wipe them with the towel wherewith he was girded … For I have given you an example, that ye should do as I have done to you' (13:4–5,15). Brown interpreted from this text that Christ was naked before his disciples, and originally when the picture was sent to the Royal Academy annual exhibition in 1852 he appeared clothed only in the towel which girded him. There was an immediate outcry; nobody would buy the scandalous canvas, and it was not until 1857 that Brown secured a purchaser after he had reworked it and clothed Christ. Much later Brown wrote ruefully:

> of course with all the flesh the picture was fuller of artistic material: but for which I should never have chosen a subject without a woman in it – of course the intention is that Jesus took upon himself the appearance of a slave as a lesson of the deepest humility … People however could not see the poetry of my conception. & were shocked at it, & would not buy the work - & I getting sick of it painted clothes on the figure.[16]

But perhaps Brown was being a little disingenuous, for a more forceful explanation for the negative way in which the picture was received was his characterisation of Christ as an ordinary man, willing to throw himself into humble tasks. The washing of Peter's feet had never been a scene traditionally chosen by religious painters, who instead usually opted to portray more elevated or mystical moments. Although it is an incident which seems to embody the heart of the New Testament message, the idea that Christ, the King of Kings, was simply the equal or even the servant of the lowliest was still a deeply revolutionary one in mid-Victorian Britain. The concept of equality in the eyes of God much too easily led to a secular,

political view that the rich were only the same as the poor, and indeed should be, and that they should have the same rights.

The Christian Socialists were an evangelical group who sought to bring relief directly to the working class, through good works but principally through education. Many establishment figures found this a disturbing notion, for an educated, literate class was also one which could begin to make demands and have access to the texts which supported them with the weight of moral justification. Brown himself was an admirer and associate of the Christian Socialist leader Frederick Denison Maurice; he agreed to teach art at the Working Men's College which Maurice set up, and it is Maurice who stands beside Thomas Carlyle in Brown's *Work* (fig.8). Maurice was a deeply subversive figure; he was a Chartist, and his book *The Kingdom of Christ* (1838) argued that politics and religion were inseparable. It called upon the Church to devote itself to addressing social questions and, most revolutionary of all, held that only a redistribution of wealth would improve the circumstances of the working class and produce a just, Christian society. Maurice believed that Christ was the embodiment of a form of muscular simplicity, manliness and moral vigour which would serve as an ideal role model for the working class, and this characterisation seems to suffuse Brown's portrayal of the Saviour.

Holman Hunt's other 1854 Academy contribution took up another subject from modern life that was much debated, the scandal of the Fallen Woman; *The Awakening Conscience* (no.12) frankly depicted a kept mistress at the moment of revelation at her position. The moral pitfalls and social censure of sex outside marriage was obliquely addressed in contemporary novels such as *Basil: A Story of Modern Life* of 1852 by Wilkie Collins, brother of the Pre-Raphaelite painter Charles Collins, and Mrs Gaskell's *Ruth* of 1853. But Henry Mayhew's ethnographic sociological survey of the capital's working class population *London Labour and the London Poor*, which began appearing in 1849, devoted extensive space to the different gradations and classes of prostitutes; he published verbatim interviews with his subjects, in which they explained how they had come to turn to prostitution. Hunt himself said that his interest in treating the subject arose initially from reading Dickens's description of Peggotty's desperate search for little Emily in *David Copperfield* (1850). With characteristic thoroughness Hunt hired a villa which was claimed to be a real life *maison de convenance* in St John's Wood, an area notorious for its courtesans living under such circumstances. Hunt showed the moment when, as her lover sings to her, the woman is suddenly struck by the error of her ways. This is represented by a shaft of sunlight which penetrates the room, and by the lush, unspoilt naturalness of the garden shown reflected in the mirror. Every detail in the picture is a symbol reflecting on the subject itself. The song the man has been singing is 'Oft in the Stilly Night', a ballad which contrasts present sadness with past innocence and pleasure. The man's rumpled, discarded glove represents the woman's lost virtue and also hints at how he could similarly so easily cast her aside, while the tangle of tapestry wool symbolises the trap in which she is enmeshed. She wears rings on all her fingers except her wedding finger, making explicit the nature of their relationship. A Victorian audience would have immediately noted the vulgar flashiness of the room's decoration and furniture and this was intended by Hunt to contrast to the vision of the natural world beyond. The woman's apparel is also deliberately risqué: although it is nearly midday she still wears her nightgown. Such a depiction of undress would have been considered scandalous, and it was Hunt's sister who persuaded him to make the picture more modest by adding the shawl tied round her waist. The frame also bears symbols relating to the canvas. Marigolds are emblems of sorrow and the bells represent warning, while a star at the top symbolises spiritual salvation. Inscribed on it is the verse from Proverbs which had suggested the composition to Hunt: 'As he that taketh away a garment in cold weather, so is he that singeth songs to an heavy heart'. 'The unintended stirring up of the deeps of pure affection by the idle singing of an empty mind', Hunt explained, 'led me to see how the companion of the girl's fall might himself be the unconscious utterer of a divine message'.[17] As the woman starts up she distracts the cat under the table from the bird it has been playing with. A microcosm of the relationship between the man and the mistress, the incident's outcome remains ambiguous – will the bird escape and fly or be consumed? Ruskin praised the picture in the press, but sensed that the woman's spiritual revelation might result in her being put out on the streets where her only recourse would be the worse fate of the common prostitute. Ruskin's voice stood alone as a source of critical admiration. Almost every other critic reacted to Hunt's masterpiece with either incomprehension or stupefaction at the inappropriateness of the subject-matter and refused to address its symbolic and spiritual dimension. The *Morning Chronicle* derided it as 'an absolutely disgraceful picture', while Frank Stone in the *Athenaeum* said it was 'drawn from a very dark and repulsive side of modern domestic life'.[18] However, Stone was no doubt pricked by a quite personal irritation. Always an opponent of Pre-Raphaelitism, his own painting *Cross Purposes* was a very popular print, and Hunt included it above the piano in the tasteless room of *The Awakening Conscience*.

For the kept woman Hunt used as a model Annie Miller, a girl from the London slums of Cross Keys. Hunt wanted to have her as a wife, but first wished to impose his own image on her. Like Pygmalion, he wanted to fashion her as his ideal woman and so arranged for her

to be taught elocution, deportment and dancing while she was still modelling for the picture. During Hunt's planned absence in the Middle East, Annie's education was to be supervised by a Mrs Bramah, the aunt of a friend of Frederic Stephens. Significantly, she belonged to a society devoted to rescuing fallen women, which might give some indication of how Hunt viewed Annie. He left strict instructions during his absence, but she spent his money on having fun instead of turning herself into Hunt's ideal. To Hunt's fury, Rossetti took her to the theatre and other low entertainments and possibly also became her lover. This was the beginning of the chill in the two artists' relationship. Worse still for Hunt, and bitterly ironic in light of the subject of *The Awakening Conscience*, while he was away Annie became the kept mistress of Lord Ranelagh. Hunt found out only by accident after the affair was over when a tipsy William Allingham told him in 1859 that Annie must be in dire need after Ranelagh's break with her; Hunt now abandoned her too.

Rossetti addressed the subject of prostitution in his verse narrative 'Jenny' – 'Lazy laughing languid Jenny, Fond of a kiss and fond of a guinea' – and it was also material for his unfinished picture *Found* (see fig.1), virtually his only modern life subject. A country swain coming into the capital with a caged lamb discovers his lost sweetheart working as a common prostitute. The model was Fanny Cornforth, a voluptuously figured woman viewed as vulgar and untrustworthy by many of Rossetti's friends but whose irreverent humour and lack of respect for social conventions delighted the artist himself. Fanny, whose real name was Sarah Cox, was rumoured to have worked as a prostitute herself at some stage; it was claimed she met Rossetti in the Strand where, cracking nuts between her teeth, she threw the shells at him in a mixture of flirtation and a provocation of propriety. Rossetti's long-standing relationship with Elizabeth Siddall had brought him happiness and a period of intense creativity for much of the 1850s; but by the time he met Fanny his ardour was beginning to cool. Although he married Lizzie in 1860, it seems by this time he was already seeking pleasure with other women, most notably Fanny herself; and by 1862 Lizzie was dead of a laudanum overdose, broken by his inconstancy and the birth of a stillborn child.

In 1859 Rossetti took up oil painting again, and started work on *Bocca Baciata* (fig.11), using Fanny as the model. It marked a steep change in his art and signified a new direction for British art as a whole. It was as if freeing himself from painting solely the medievalist watercolours that had occupied him for most of the 1850s paralleled his cutting free of his emotional commitment to Lizzie and these pictures' romantic, mythic idealism. In *Bocca Baciata* the figure is thrust firmly into the foreground and there is no ostensible subject other than the beauty of the sitter herself.

Sumptuously decorative and richly painted, the picture contains elements which are suggestive rather than narrative – the marigolds are symbols of sadness and regret, although whether of the model or the painter is ambiguous, and the apple alludes to temptation and the Garden of Eden. The title itself derives from a couplet in Boccaccio's *Decameron* – 'the mouth that has been kissed does not lose its freshness, indeed it renews itself as the moon does'. Such pictures were explicit testimony of the power of sexual allure and an embodiment of Rossetti's feelings of erotic yearning for the opposite sex. In a total break with Pre-Raphaelite principles, Rossetti developed the tendency first seen in his medievalist watercolours such as *The Wedding of St George and Princess Sabra* (no.28) to suppress subject in favour of an image that promoted instead an indefinable mood and atmosphere, and sought to produce a direct emotional response in the viewer through its pattern and design. This was a virile form of aestheticism, and it was to be explored further in the 1860s by James McNeil Whistler and Albert Moore, whose own decorative, hierarchic figure paintings similarly suppressed subject; although painted very differently, Whistler's *Three Figures* (fig.12), for instance, follows the same principals of Rossetti's aestheticism. Holman Hunt was appalled by this development in Rossetti's art, and grasped immediately the moral line which *Bocca Baciata* had crossed. In a private letter to his patron Thomas Combe he wrote:

> I will not scruple to say that it impresses me as very remarkable in power of execution – but still more remarkable for gross sensuality of a revolting kind peculiar to foreign prints ... I would not speak so unreservedly of it were it not that I see Rossetti is advocating as a principle the mere gratification of the eye and if any passion at all – the animal passion to be the aim of art ... I disfavour any sort of sympathy with such notion[19]

It was a vivid reminder that the original members of the Brotherhood now followed very different trajectories. The PRB had begun to pull apart as early as 1853 with Millais's appointment as an Associate of the Royal Academy and rapid embracement of a new found conservatism; Collinson resigned, Hunt absented himself in the Middle East, Woolner disappeared to Australia and Rossetti buried himself in Elizabeth Siddall and abandoned any pretext of working from nature. Christine Rossetti produced a humorous but incisive sonnet which summed it all up:

> The PRB is in its decadence:
> For Woolner in Australia cooks his chops,
> And Hunt is yearning for the land of Cheops;
> DG Rossetti shuns the vulgar optic ...
> And he at last the champion great Millais,

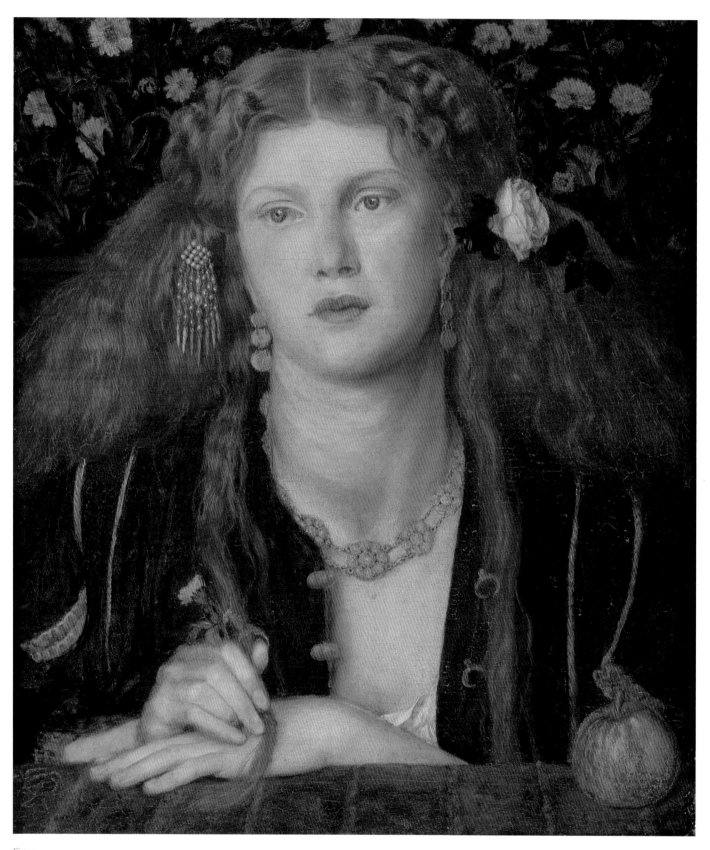

Fig.11

DANTE GABRIEL ROSSETTI

Bocca Baciata 1859

Oil on panel

32.1 x 27 (12 ⁵⁄₈ x 10 ⁵⁄₈)

Museum of Fine Arts, Boston. Gift of James Lawrence

Attaining academic opulence,
Winds up his signature with ARA
So rivers merge in the perpetual sea;
So luscious fruit must fall when over-ripe;
And so the consummated PRB.

This was, however, far from the end, but simply a new beginning. Pre-Raphaelitism in its ideals and scope had in many ways become decidedly more mainstream, and with it came a new generation of imitators and advocates. One of the earliest centres of Pre-Raphaelite influence was Liverpool. The local history painter William Henry Windus was converted to Pre-Raphaelitism after seeing Millais's *Christ in the House of his Parents* (fig.5) at the Royal Academy, and he returned to persuade members of the Liverpool Academy to both show the Brotherhood's pictures and award them the annual prizes. This in turn influenced a group of other local painters, including Thomas Wade (see no.61). But ultimately it led to the destruction of the Liverpool Academy, which became rent by disagreements over the new style and its merits, and not a little by Windus's heavy-handed campaigning.

The most important figure in the second wave of 'High' Pre-Raphaelitism was Edward Burne-Jones. A student friend of William Morris, he was introduced to the possibilities of Pre-Raphaelite painting while at university in Oxford, and he participated in Rossetti's decorative mural scheme for the Union debating chamber.

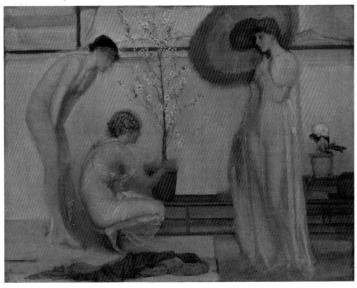

Fig.12
<small>James Abbott McNeill Whistler</small>
Three Figures in Pink and Grey 1868–78
Oil on canvas
139.1 x 185.4 (54¾ x 73)
<small>Tate. Purchased with the aid of contributions from the International Society of Sculptors, Painters and Gravers as a Memorial to Whistler, and from Francis Howard 1950</small>

Burne-Jones initially worked very much in the vein of Rossetti's Arthurian watercolours, but these medievalist fantasies gradually gave way to a distinct and personal mature style. It was characterised by a more ambiguous form of aestheticism, such as that found in his subjectless reverie *The Golden Stairs* (fig.14), and his use of archetypal myths to negotiate existential worries. The publication of Darwin's *On the Origin of the Species* in 1859 caused significant anxiety with its implication of a godless society, but this in turn generated a fresh potency for ancient mythology as the vehicle of modern concerns, and the use of symbolism to explore new uncertainties. Central to much of this material was a developing fear of women, who were becoming vocal in their need for the justice of equal legal, political and educational rights. Burne-Jones's *Phyllis and Demophoön* (fig.13) illustrates the story from Ovid in which the heartbroken Phyllis, believing herself abandoned, kills herself, but at the moment of death is turned into an almond tree. It caused an uproar when it was exhibited at the Old Watercolour Society in 1870, and to Burne-Jones's anger was eventually removed. Its poor reception was caused partly by the intentionally androgynous lack of distinction between male and female types, and the unheroic pose of Demophoön; but it was also because of the predatory characterisation of Phyllis, who erupts from the tree and encircles and entraps the returned Demophoön. The picture was also disquieting because of its personal dimensions. In 1862 the married Burne-Jones had met and fallen passionately in love with Maria Zambaco, a beautiful Greek sculptress living in London. Rent with guilt and unable to decide where his future happiness lay Burne-Jones tried to end the affair in 1869, but Maria attempted suicide. They eventually parted the following year but Maria, whom he had once consciously introduced into his work as a figure of love and fascination, now constantly re-emerged unbidden in his paintings and drawings, indicating that Burne-Jones was unable to free himself from his feelings for her (see nos.62, 64, 65).

Burne-Jones's style matured into a strong sense of design and adoption of Michelangelesque forms and this was subsequently imitated by a generation of artists that included John Melluish Strudwick (see no.69), Marie Stillman and Evelyn de Morgan. True Pre-Raphaelitism, in its stressing of 'truth to nature' and subject-matter, was abandoned by many of the original Brothers at various stages in the 1850s, although Hunt continued to hold to his original doctrines and beliefs. What we now term Raphaelitism developed and mutated rapidly, and quickly came to encompass a much wider group of artists than the seven members of the Brotherhood. To illustrate the evolution of the wider movement and its variations and continuities of subjects and styles, the plates in this book have been arranged chronologically.

By 1897 when the new National Gallery of British Art opened at Millbank – almost immediately known simply as the Tate Gallery – Burne-Jones, Hunt and Millais were considered the apogees of ambition for the revival of the national school of painting. Rossetti was still viewed by some with slight suspicion because of his reliance on sensuality and scarcely concealed erotic intent, but he too was widely represented in the two groundbreaking exhibition surveys of Pre-Raphaelite art held at the Tate in 1911–12 and 1913. Ironically, the first of these opened in the same month that the second of Roger Fry's Post-Impressionist exhibitions closed at the Grafton Galleries. For the first time Fry introduced to a British audience recent developments in Continental art, including works by Cézanne, Matisse, Picasso and Braque. The Cubist and 'primitivist' works caused enormous shock and were widely ridiculed in the press in an interesting reprise of the scorn heaped on Pre-Raphaelite art when it was exhibited almost exactly sixty years before. Although the objects were as different as they could possibly be, the nature of the criticism and much of the language was similarly visceral: primitivism was decried as retrograde, and the subjectless, direct appeal to the senses insulting and immoral. But modernism came increasingly to set the critical agenda and the Pre-Raphaelites slipped from popular admiration in the new century, representative of so much of the past that now seemed fatuous, coy or overblown. When the centenary exhibition of their art was held at the Whitechapel Art Gallery in 1948, Wyndham Lewis, whose Vorticist work had been included in the Second Post-Impressionist show, felt compelled to write of his 'disappointment … due to an impression, in which more seriousness was attributed to this school than they in fact reveal … It was all so pretty … the Pre-Raphaelite Movement proved, in the end, a rebellious, picturesque, but shallow interlude in Victorian philistinism.'[20]

Today a post-modern audience can happily feel able to fast-forward or rewind through historic and 'modern' art. One of the great advantages of Tate Britain is its ability to show the long view of British art history. The continuum of its displays stretches from the sixteenth century to the present day, and it is possible to demonstrate continuities and contrasts across the centuries. The core collection of Pre-Raphaelite works was built up at the Tate relatively quickly, largely thanks to the generosity of the ageing generation of original collectors or their offspring. A good example of this is the bequest made in 1940 by Beresford Rimington Heaton. His aunt Mary Ellen Heaton was one of Rossetti's greatest patrons and with Ruskin's guidance she also collected other artists of the circle. In total there are eight works by Rossetti in the collection which came from this single source, several included in the present selection, and with them came an important group

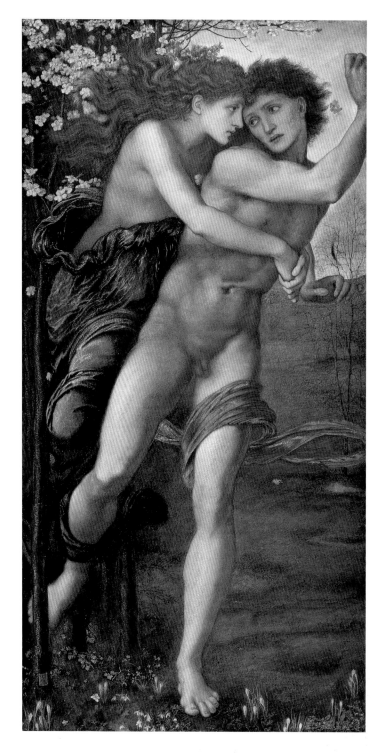

Fig.13
EDWARD COLEY BURNE-JONES
Phyllis and Demophoön 1870
Pastel
91.5 45.8 (36 x 18)
Birmingham Museums & Art Gallery

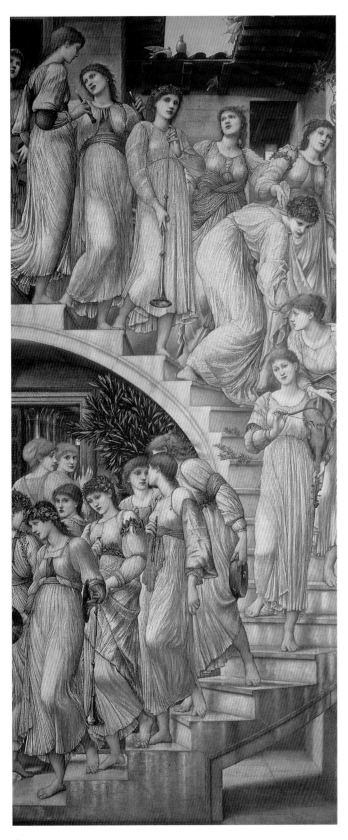

Fig.14
EDWARD COLEY BURNE-JONES
The Golden Stairs 1872–80
Oil on canvas
269.2 x 116.8 (106 x 46)
Tate. Bequeathed by Lord Battersea 1924

of watercolours by Turner. However, Pre-Raphaelite works were acquired for the national collection in the nineteenth century itself. In 1891 a subscription fund was raised to give Ford Madox Brown a commission for the future Tate Gallery, plans for which were just beginning to be discussed. Brown died before completing it and so in 1893 the Subscription Committee, which included his old friend Frederic Stephens, instead used part of the money to purchase *Jesus washing Peter's Feet* (no.11) for the future National Gallery of British Art. Other works have been acquired in more recent years. Foremost among these is Millais's early masterpiece *Mariana*. This had been in the Makins family for a considerable period, but in 1999 it was acquired for the nation by being accepted in lieu of inheritance taxes. One of his relatively few 'true' Pre-Raphaelite pictures it is one of Millais's most important works, and now one of the great treasures of the Tate's collection.

NOTES

1 William Holman Hunt, *Pre-Raphaelitism and the Pre-Raphaelite Brotherhood*, London 1905, I, pp.130–1.

2 William Michael Rossetti, *Dante Gabriel Rossetti: His Family-Letters with a Memoir*, I, London 1895, p.126.

3 Op. cit., p.133.

4 *The Times*, 4 October 1848.

5 William Holman Hunt, *Pre-Raphaelitism and the Pre-Raphaelite Brotherhood*, London 1905, I, pp.101–2.

6 *The Athenaeum*, 20 April 1850, p.524.

7 *Illustrated London News*, 4 May 1850.

8 Charles Dickens, 'Old Lamps for New Ones', *Household Words*, 15 June 1850, p.266.

9 *The Athenaeum*, 1 June 1850, p.590.

10 Ford Madox Brown, *Work, and other Paintings by Ford Madox Brown, at the Gallery, 191 Piccadilly*, exh. cat., London 1865, n.p.

11 Thomas Carlyle, *Past and Present*, London 1885 ed., pp.165, 169.

12 Ford Madox Brown, *Work, and other Paintings by Ford Madox Brown, at the Gallery, 191 Piccadilly*, exh. cat., London 1865, n.p.

13 Agnes Strickland, *Lives of the Queens of England*, London 1840, I, pp.118–20.

14 See *The Age of Rossetti, Burne-Jones and Watts: Symbolism in Britain*, exh. cat., Tate Gallery, 1997–9, pp.191–4.

15 *The Athenaeum*, April 1854.

16 Letter dated 3 May 1876 to Charles Rowley, quoted *The Pre-Raphaelites*, exh. cat., Tate Gallery 1984, no.42.

17 William Holman Hunt, *Pre-Raphaelitism and the Pre-Raphaelite Brotherhood*, London 1905, I, p.347.

18 *The Athenaeum*, April 1854.

19 Quoted Elizabeth Prettejohn, *The Art of the Pre-Raphaelites*, London 2000, p.108.

20 Wyndham Lewis, 'The Brotherhood', *The Listener*, 22 April 1948, p.672.

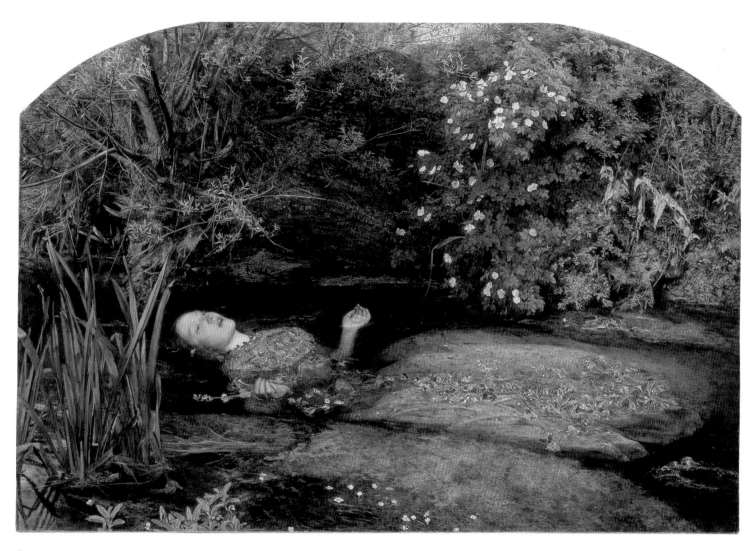

Fig.15
JOHN EVERETT MILLAIS
Ophelia 1852
Oil on canvas
76.2 x 111.8 (30 x 44)
Tate. Presented by Sir Henry Tate 1894

Overleaf
DANTE GABRIEL ROSSETTI
Dante's Dream at the Time
of the Death of Beatrice 1856
(no.21, detail)

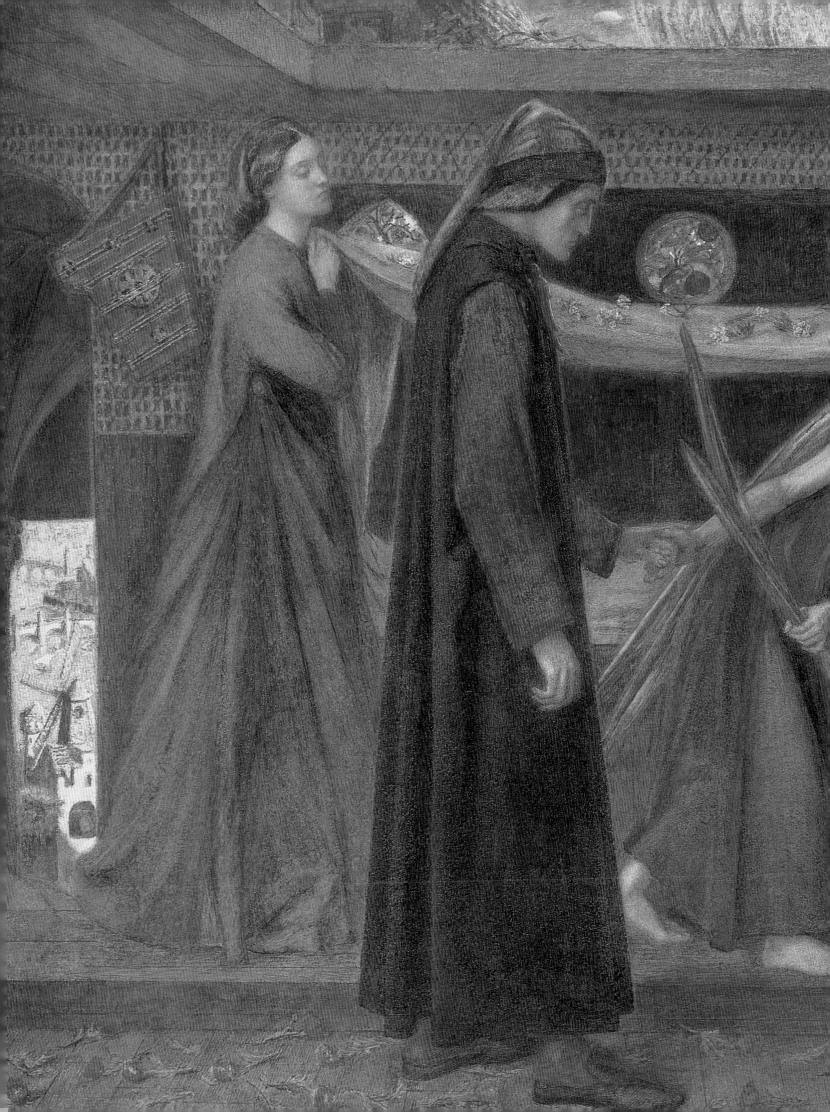

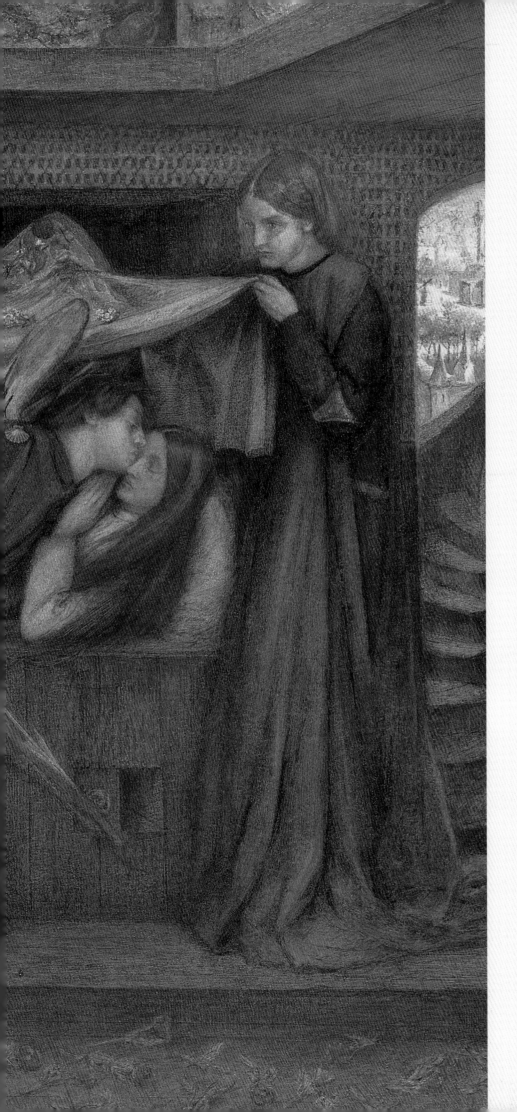

CATALOGUE

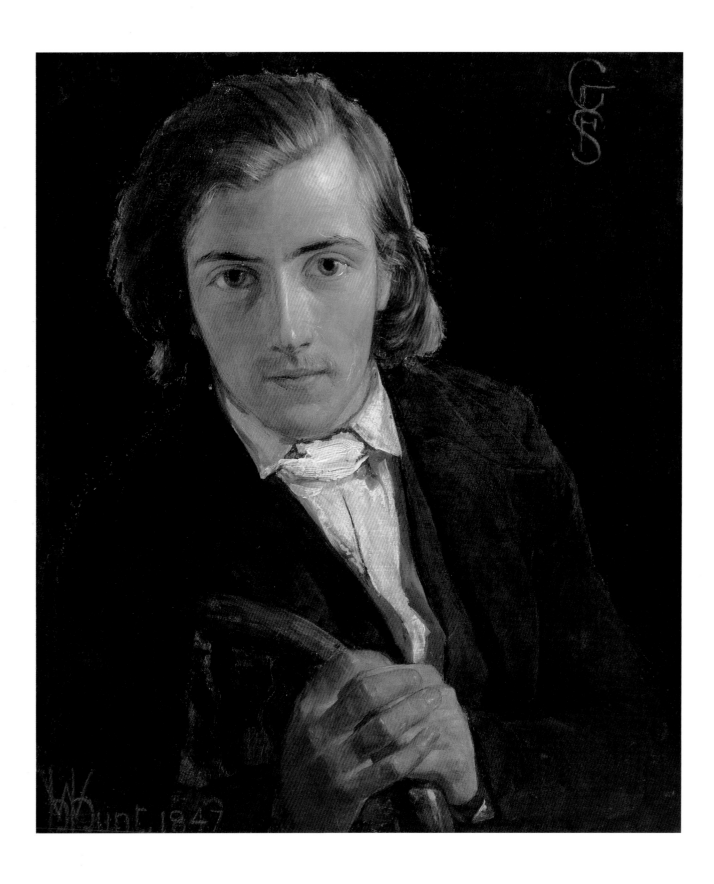

1

WILLIAM HOLMAN HUNT 1827–1910
F.G. Stephens 1847

Oil on mahogany panel 20.3 x 17.5 (8 x 6⅞)

Bequeathed by H.F. Stephens 1932

Hunt met Stephens when he enrolled in the
Royal Academy Schools in December 1844.
Stephens was the son of a London vicar and had
been at the art school since January. The two quickly
became close friends and, although Stephens was
slightly older and artistically more experienced,
Hunt characteristically took the role of mentor. This
suited both Hunt's innately dominant character and
Stephens's belief, which was incorrect, that he was
not a good painter. At Hunt's proposal he became
one of the members of the Brotherhood, and
followed strict Pre-Raphaelite principles in his work
(see no.5).

This is one of Hunt's most sensitive portraits, and
it was given as a present to Stephens's mother.
Crippled by an accident as a child, Stephens was an
enormously gifted man who eventually gave up
painting altogether and forged a career as a
successful critic and writer, becoming the principal
apologist and interpreter for the Pre-Raphaelites
work. He and Hunt remained close friends, with
Stephens working as studio assistant and researcher
for him, and even painting much of the replica of *The
Light of the World*. But in 1880 the two quarrelled; by
now Hunt had become a respectable, pious
establishment institution and his second wife Edith
urged her husband to distance himself from
Stephens, who knew too much about their early
tribulations and their marriage, unrecognised by
British law. Yet it had been Stephens and his wife
Clare who had taken Edith in when her parents had
thrown her out because of her relationship with
Hunt. Painted in happier times, Hunt's portrait was
bequeathed to the Tate by Frederic Stephens's son.

WALTER HOWELL DEVERELL 1827–54
Study for 'Twelfth Night' *c*.1848

Pen and ink and pencil 21.6 x 29.2 (8½ x 11½)

Purchased 1919

Deverell shows the moment in Act IV of Shakespeare's comedy *Twelfth Night* when the love-sick Duke of Orsino asks his clown Feste to sing 'Come away, come away, Death'. Orsino's love for Olivia is ultimately unrequited, but he is secretly loved in return by Viola, who is at his court disguised as a page boy. For this convoluted tale of cross-dressing and mistaken identity Deverell cast himself and his friends. He is the central figure of Orsino, making great play of his widely admired handsome looks. Rossetti posed for Feste the fool while for Viola, dressed as a man, Deverell cast Elizabeth Siddall. Squared for transfer to the canvas, this drawing is the earliest known image of the young girl whom Deverell had encountered working in a milliner's shop near Leicester Square in 1849. He asked her to model for him but was initially rebuffed until, he reported to Holman Hunt, 'I got my mother to persuade the miraculous creature to sit for my Viola in "Twelfth Night", and today I have been trying to paint her; but I have made a mess of my beginning' (William Holman Hunt, *Pre-Raphaelitism and the Pre-Raphaelite Brotherhood*, London 1905, pp.198–9). Rossetti met her when he came to sit for Feste, and it was the beginning of the relationship that would bring first happiness and then tragedy.

The final oil was the first major work Deverell painted in the meticulous Pre-Raphaelite style. When Collinson resigned from the Brotherhood in 1850 he was nominated as a replacement, but ultimately he did not become a member. In 1854 he died, aged just twenty-six.

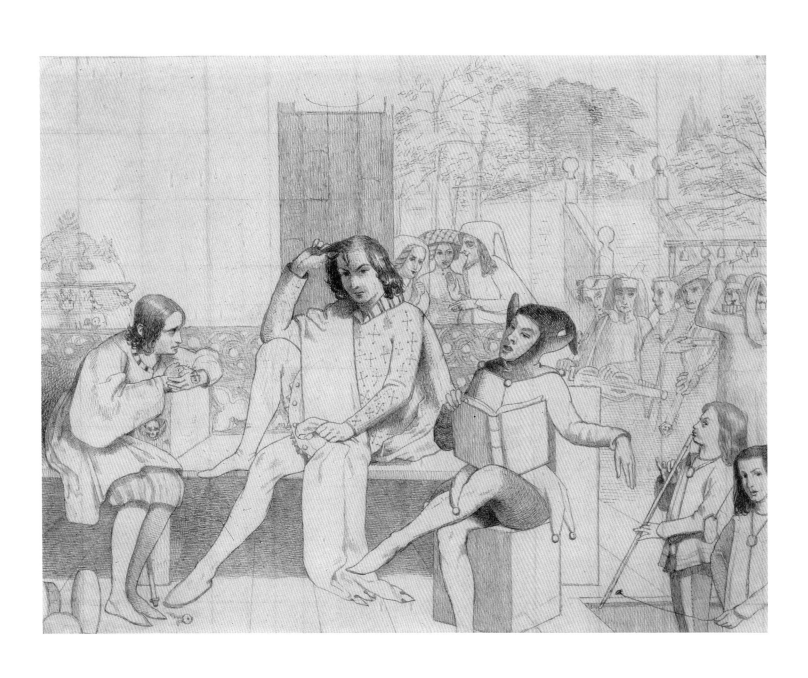

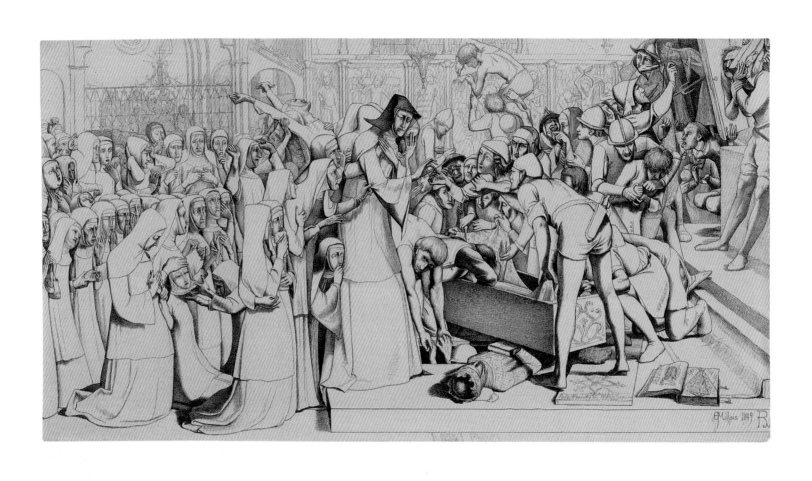

3

JOHN EVERETT MILLAIS 1829–96
The Disentombment of Queen Matilda 1849

Pen and ink 22.9 x 42.9 (9 x 16⅞)

Purchased 1945

Matilda was the wife of William the Conqueror, and together they were buried in Caen. In 1562, during the religious wars which swept France, the royal tombs were broken open by the Calvinists, and their bodies disinterred. Always susceptible to the more ghoulish moments from history, Millais took the subject from the account in Agnes Strickland's *Lives of the Queens of England* (1840):

> The entreaties and tears of the abbess and her nuns had no effect on the men, who considered the destruction of church ornaments and monumental sculpture a service to God quite sufficient to atone for the sacrilegious violence of defacing a temple consecrated to his worship and rifling the sepulchres of the dead. They threw down the monument, and broke the effigies of the queen which lay thereon. On opening the grave in which the royal corpse was deposited, one of the party observing that there was a gold ring set with a fine sapphire on one of the queen's fingers, took it off, and with more gallantry than might be expected of such a person, presented it to the abbess Madam Anna de Montmorenci.
> (I, pp.118–20)

This is the central dramatic incident that Millais shows, as the abbess reaches forward with evident distaste to receive the queen's ring. It is a knowingly profane insult on the part of her tormentor, for nuns wear only the wedding ring which marries them to Christ, and one of the sisters plucks at the abbess's sleeve in an attempt to restrain her.

As with Millais's *Christ in the House of his Parents* (see no.4) and other pictures by the Pre-Raphaelites from around the middle of the century, this extraordinary drawing touches on contemporary concerns about religious observance and the rifts in the Anglican Church between those opposed to and those in favour of a return to ancient Catholic ritual. Catholicism continued to be seen as powerfully pagan in its ceremonies, and the Pre-Raphaelite painters were at first viewed as suspiciously sympathetic to Rome because of their religious subject-matter, admiration for pre-Reformation art and devotion to symbolism. Through his friendship with Thomas Combe, one of their leading theologians, Millais himself was quite close to the Oxford Movement, who sought a return to High Church patterns of worship; he himself attended St Andrew's Church in Wells Street, near Oxford Circus, which was well known for its ritualistic Anglican services.

Against this background, then, it is significant that Millais chose to show a moment of confrontation between Calvinists and Catholics. His portrayal of the nuns in orderly ranks, continuing to stand fast in their prayerful duty despite their horror, contrasts markedly with the writhing mass of the Protestant grave-robbers, among whom disorder reigns. This was an important distinction, for ritual set boundaries of behaviour and observance; what Millais perhaps suggests is that without this framework extreme Nonconformism can lead to anarchy. Derision for the sanctity of royalty is also important, for Catholicism was the doctrine of Absolutist monarchy, and not many months before the drawing was made several of Europe's rulers had lost their thrones in the revolutions of 1848.

4

JOHN EVERETT MILLAIS 1829–96
Study for 'Christ in the House of His Parents' c.1849

Pencil 9 x 33.7 (3½ x 13¼)

Bequeathed by H.F. Stephens 1932

Mr Millais's principle picture,' wrote *The Times* when it was exhibited at the Royal Academy in 1850, 'is, to speak plainly, revolting. The attempt to associate the holy family with the meanest details of a carpenter's shop, with no conceivable omission of misery, dirt, or even disease, all finished with the same loathsome minuteness, is disgusting'. Charles Dickens in his journal *Household Words* went even further, railing famously:

> in the foreground ... is a hideous, wry necked, blubbering, red-headed boy, in a bed-gown, who appears to have received a poke in the hand, from the stick of another boy with whom he has been playing in an adjacent gutter, and to be holding it up for the contemplation of a kneeling woman, so horrible in her ugliness, that ... she would stand out from the rest of the company as a Monster, in the vilest cabaret in France, or the lowest gin shop in England ... Wherever it is possible to express ugliness of feature, limb or attitude, you have it expressed. Such men as the carpenters might be undressed in any hospital where dirty drunkards, in a high state of varicose veins, are received. (15 June 1850,p.266)

Such extreme, visceral reactions seem odd today, with perhaps the Victorian obsession

with cleanliness being the most evident. But Millais's masterpiece was deeply radical in design and intent. What both Dickens and the establishment *Times* found so shocking was that the Holy Family were depicted as very ordinary people in an everyday environment; it was a concept that was both democratising and revolutionary, and one which smacked of Christian Socialism (see no.11). The year in which the picture was exhibited saw the debate between High and Low Anglicanism at its height and, although Millais himself belonged to a High Church tradition, it must have appeared as a manifesto for egalitarianism and the intervention of the spiritual into the everyday.

The picture is, in true Pre-Raphaelite spirit, a combination of realistic detail and underlying Christian symbolism. Millais certainly went to great lengths in his quest for realism, even to the extent of buying sheeps' heads from the butcher from which to draw the sheep in the background, and using a real carpenter to model for Joseph's body so that the musculature was absolutely accurate. Theworkshop itself is supposed to have been one he discovered off Oxford Street. Yet the painting is full of symbolism: the wounded hand, the ladder and Mary's

pose foreshadow the Crucifixion, the sheep represent Christ's flock and the set-square hanging on the wall stands for the Holy Trinity; Christ's kiss is both a benediction and a reference to Judas's kiss of betrayal in the Garden of Gethsemane.

The painting caused such an outcry that Queen Victoria had it brought to her for a special viewing. 'I hope it will not have any bad effect on her mind', Millais wrote sardonically to Holman Hunt. Notoriety did not, however, hinder its sale. The finished oil was bought by Thomas Plint, a Nonconformist stockbroker committed to evangelical community projects, a fact which to its critics must have confirmed the picture's Low Church agenda.

The drawing shown here is one of Millais's earlier compositions for the subject, and differs from the oil (fig.5) by substituting for St John a female figure on the right, who may be intended to be St Anne. It is a magnificent example of Millais's drawing style in this period, where precise, sharply-drawn lines are contrasted with areas without shading and sections that are more densely drawn and washed in. Bequeathed to the Tate by his son, the drawing was given to Frederic Stephens by Millais just after the oil was completed.

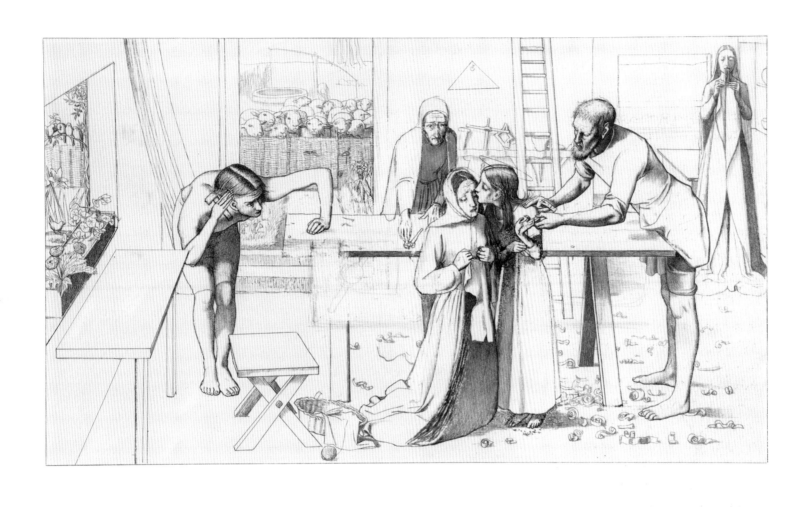

5

FREDERIC GEORGE STEPHENS 1828–1907
The Proposal (The Marquis and Griselda) c.1850

Oil on canvas 80.6 x 64.8 (31 3/4 x 25 1/2)

Bequeathed by H.F. Stephens 1932

Perhaps inspired by Ford Madox Brown's depictions of the author, Stephens was the first member of the Pre-Raphaelite Brotherhood to treat a subject from Chaucer, the medieval poet who was listed by them among the 'Immortals'. For his picture Stephens took an episode from 'The Clerk's Tale' in *The Canterbury Tales*. This gives a version of the folk tale of Patient Griselda in a reworking of the last story told in Boccaccio's *Decameron*. The Marquis of Saluzzo falls in love with a peasant girl who is poor but extremely beautiful. In a truly misogynistic parable of male insecurity the Marquis marries her, but then subjects her to a series of almost unendurable trials to test her love for him. These include pretending he is already married and that her children have been killed; throughout all these provocations Griselda meekly asserts her continuing affections and devotion to her husband. The Marquis finally accepts what he had previously been unable to and, Chaucer tells us:

> Ful many a yeer in heigh prosperitee
> Lyven thise two in concord and in reste.

Stephens chose the moment that begins this sorry tale when the Marquis offers his ring to Griselda. The downturned eyes and red hair suggest that Stephens may have used Elizabeth Siddall as the model, who by 1850 was sitting to both Deverell and Rossetti (see no.2). The theme of a woman of lesser social standing being the object of passion of a higher-born man was one which fascinated several of the Pre-Raphaelite circle. On one level this appealed to their belief that love knew no boundaries, but it was also linked with the subversion of middle-class propriety by acting as an agency of social elevation. The background was painted directly from the kitchen of the lodgings the artist shared with Hunt and Rossetti at Knole in Kent.

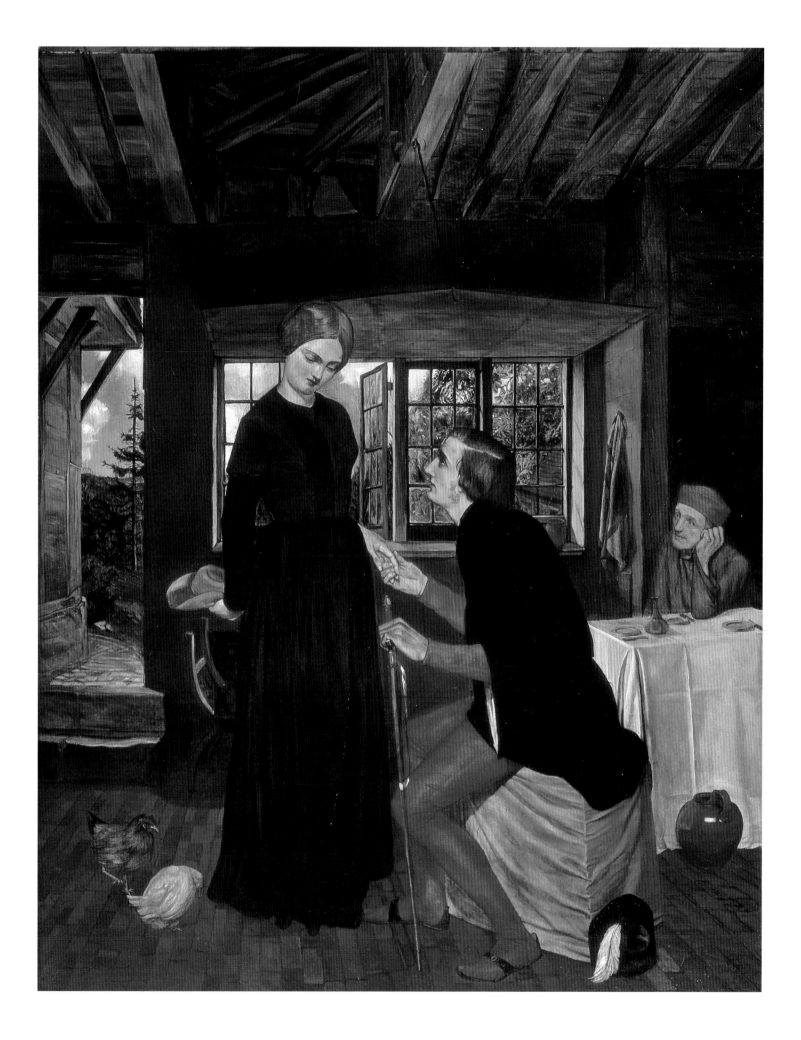

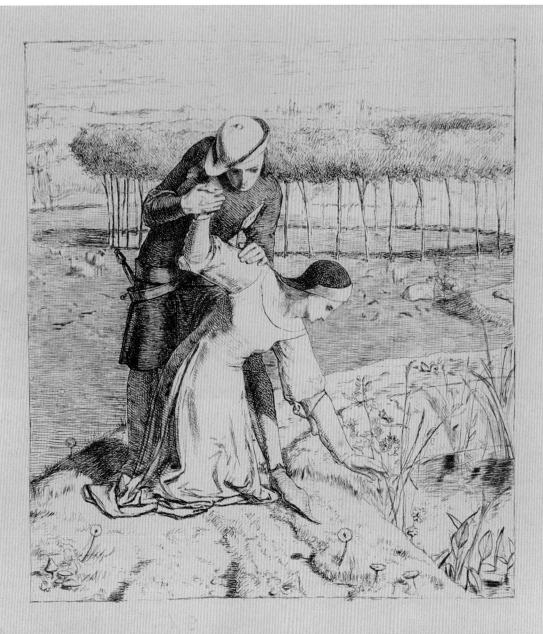

6

William Holman Hunt 1827–1910
Frontispiece to 'The Germ' 1850

Etching 20.3 x 12.1 (8 x 4¾)

Bequeathed by H.F. Stephens 1932

The Pre-Raphaelite Brotherhood was a consciously literary art movement, and so Rossetti's suggestion that they publish writings in a journal seemed a natural progression. The first edition of *The Germ* appeared in January 1850, priced one shilling and containing poems and texts by Ford Madox Brown, Coventry Patmore, William Michael Rossetti, Dante Gabriel and Christina Rossetti and others. Holman Hunt provided the only visual material, the frontispiece which illustrated Woolner's two poems, 'My Beautiful Lady' and 'Of my Lady in Death'. 'These compositions were', William Michael Rossetti recalled, 'I think, nearly the first attempts which Mr Woolner made in verse … Coventry Patmore, on hearing the poems in September 1849, was considerably impressed by them: "the only defect … being that they were a trifle too much in earnest in the passionate parts, and too sculpturesque generally"' (Preface to *The Germ*, stock ed., 1901). Woolner's verses were in truth rather weak, and Hunt appears to have of precaution not followed the texts closely for his illustrations. In the main picture a young man balances his sweetheart as she plucks a bloom, 'truly a song without words', as Burne-Jones described it, 'for out of its golden silence came voices for all who hearken, telling a tale of love' (*Oxford & Cambridge Magazine*, 1856). Below this idyll is the future, the ultimate separation of lovers by death, as the man sobs on his lover's grave. For the processionary nuns in the background Hunt may have been inspired by *The Body of Christ borne to the Tomb* (c.1799–1800) by Blake, an artist greatly admired by the Pre-Raphaelites, particularly Rossetti. The theme of death's parting may partly have been suggested by Rossetti's own poem *The Blessed Damozel* (see no.67) started in 1848. Seven hundred copies of the first edition of *The Germ* were printed, but the Brotherhood found it hard to sell them. Attracting mixed reviews, it ran to four editions before its demise, having never made a profit.

JOHN EVERETT MILLAIS 1829–96
Mariana 1851

Oil on mahogany panel 59.7 x 49.5 (23 ½ x 19 ½)

Accepted by H.M. Government in lieu of tax and allocated to the Tate Gallery 1999

When it was first exhibited at the Royal Academy in 1851 this picture was accompanied by the following lines from Tennyson's 'Mariana' (1830):

> She only said, 'My life is dreary,
> He cometh not,' she said;
> She said, 'I am aweary, aweary,
> I would that I were dead!'

Tennyson's poem was inspired by the character of Mariana in Shakespeare's play *Measure for Measure*. Rejected by her fiancé Angelo, after her dowry is lost in a shipwreck, she leads a lonely existence in a moated grange. She is still in love with Angelo – now Deputy to the Duke of Vienna – and longs to be reunited with him.

In the picture the autumn leaves scattered on the ground mark the passage of time. Mariana has been working at some embroidery and pauses to stretch her back. Her longing for Angelo is suggested by her pose and the needle thrust fiercely into her embroidery. The stained-glass windows in front of her show the Annunciation, contrasting the Virgin's fulfilment with Mariana's frustration and longing. Millais copied the scene from the window of the Chapel of Merton College, Oxford. However, the heraldic design appears to have been his own invention. The motto '*In coelo quies*' means 'In Heaven there is rest' and clearly refers to Mariana's desire to be dead. The snowdrop symbolises 'consolation' in the language of flowers but it is also the birthday flower for 20 January, St Agnes' Eve, when young girls put herbs in their shoes and pray to St Agnes to send them a vision of their future husband. It may also refer indirectly to John Keats's narrative poem 'The Eve of St Agnes', which, like Tennyson's 'Mariana', is partly also concerned with the theme of sexual yearning. The mouse in the right foreground is Tennyson's mouse that 'Behind the mouldering wainscot shriek'd, Or from the crevice peer'd about'. The miniature altar in the background, decorated with a small triptych and a silver casket, refers to Tennyson's other poem on the same theme, 'Mariana in the South', in which Mariana prays desperately to the Virgin Mary.

Millais may have intended the picture to complement Holman Hunt's *Claudio and Isabella* (1850), a scene also taken from *Measure for Measure*. But as a subject from Tennyson the picture acquired a certain topicality, since Tennyson was made Poet Laureate in November 1850.

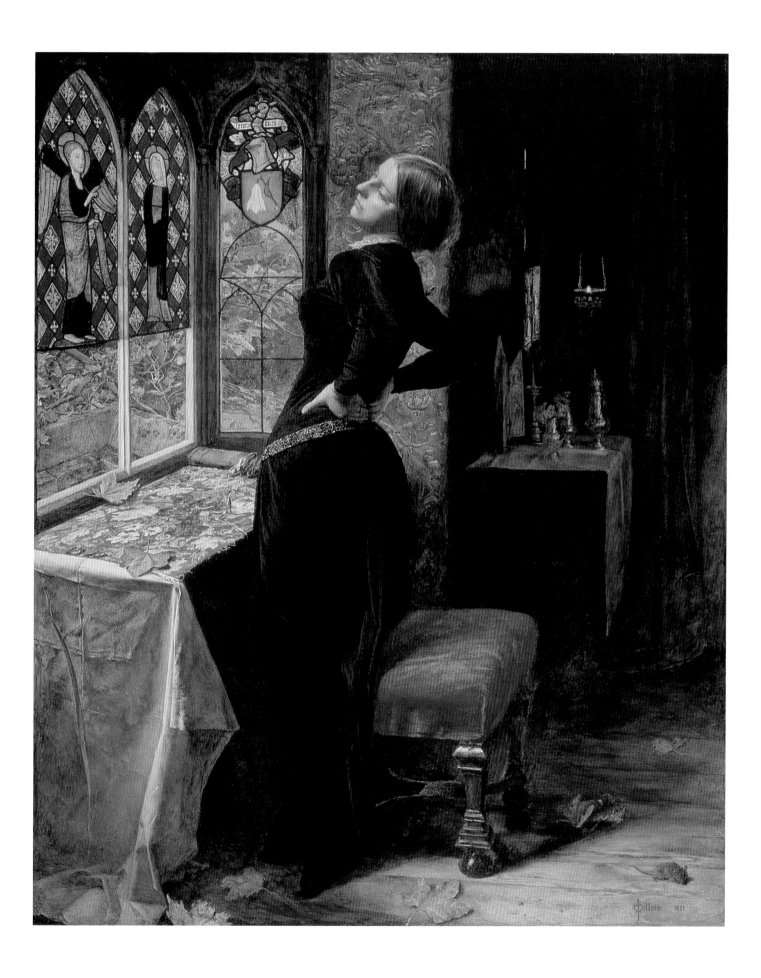

FORD MADOX BROWN 1821–93
'Take your Son, Sir' ?1851–92

Oil on canvas 70.5 x 38.1 (27 ¾ x 15)

Presented by Miss Emily Sargent and Mrs Ormond in memory of their brother,

John S. Sargent 1929

The subject for this enigmatic picture may have been inspired by a visit Brown made to the National Gallery in order to view some recently acquired Old Master pictures of the Virgin and infant Christ. Here he has innovatively relocated a religious subject to the modern day and an increasingly secular age: the nimbus around the Madonna's head has become a convex bull's-eye mirror, in which the father of the child is reflected, and the stars in the background are simply those on the room's wallpaper. But this does not seem to be a straightforward transposition of a traditional subject, or simply to represent the innocence and hope of new life or the warmth of motherhood. Instead, the mother's features seem tense and bitter and the flush of her cheeks suggests anger. The father is shown wearing his hat, as if he has just come in, and Brown's title, which is inscribed below the child, indicates that this may be the first time he has seen his baby. Taken together, these pointers might indicate that the woman is a mistress, or that she had been left pregnant by her lover and that this is a scene of confrontation between them. This would be a modern-life subject in the vein of

Holman Hunt's *Awakening Conscience* (1853, no.12) or to a lesser extent Rossetti's *Found* (fig.1), where a farmer rediscovers his sweetheart as a fallen woman in the metropolis.

Brown used his wife Emma as the model for the mother, and their newborn son Arthur Gabriel for the baby, while the man in the mirror appears to be the artist. His depiction of himself and his family seems surprising in view of the apparent subject, but Brown reused designs he had already made independently in a practical approach to composition. Brown and Emma had themselves lived together for some years before he married her in 1853, and their first child was born out of wedlock. The picture, started perhaps in 1851, then enlarged and worked on again in 1856–7 and 1860, remained unfinished at Brown's death. The reworking proved continually troublesome, but he must also have been deterred by the death of Arthur in infancy, aged only four months, in 1857. Sold from Brown's estate sometime between 1909 and 1911, the picture was acquired by John Singer Sargent and presented by his sisters to the Tate in his memory in 1929.

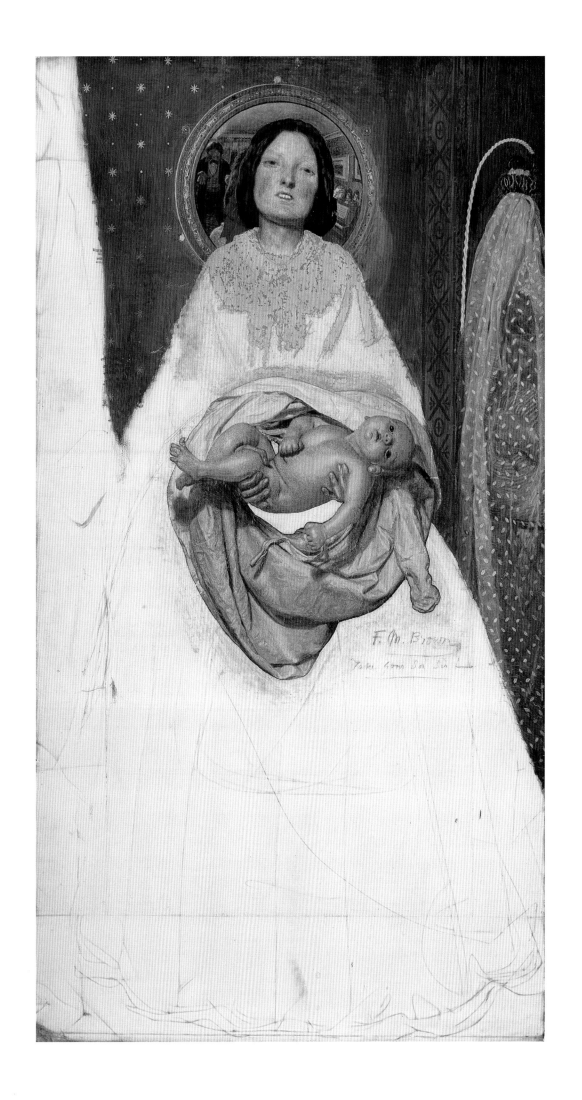

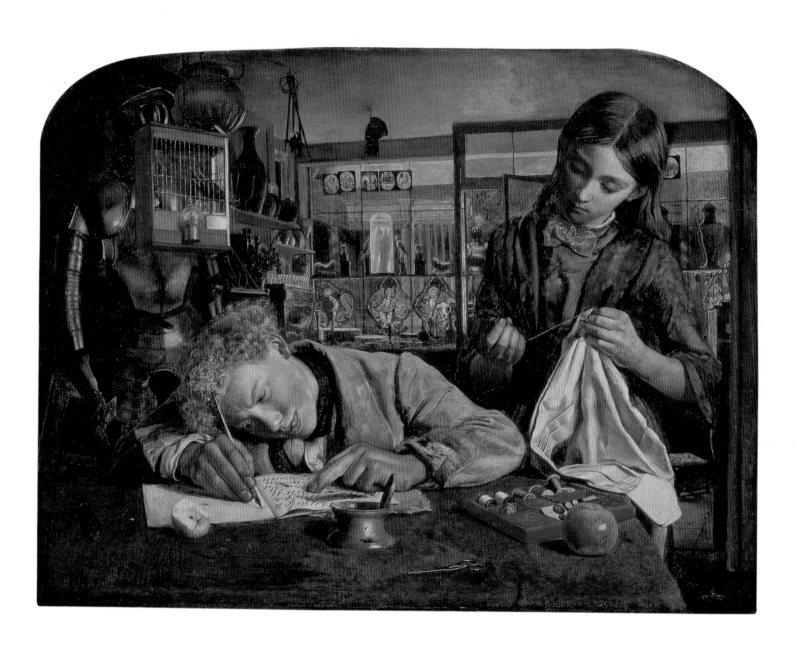

9

ROBERT BRAITHWAITE MARTINEAU 1826–69
Kit's Writing Lesson 1852

Oil on canvas 52.1 x 70.5 (20 ½ x 27 ¾)

Presented by Mrs Phyllis Tillyard 1955

Published in 1841, Charles Dickens's novel *The Old Curiosity Shop* was an immediate and lasting success. Little Nell's manipulatively protracted deathbed scene appealed strongly to the Victorian love of pathos, although it caused widespread shock, and her selfless goodness was a source of admiration. The story concerns Nell and her grandfather, who runs the eponymous shop of the title. While an endearing character he is also a compulsive gambler, and due to this weakness borrows money from the evil Daniel Quilp. Unable to repay the money, he flees the shop with Nell and goes on the run from Quilp.

Dickens was surprisingly little used as a source for contemporary painters, not least the Pre-Raphaelites. He had of course done little to endear himself to them with his ferocious criticism of Millais's *Christ in the House of his Parents* in 1850 (see no.4) in which he objected to the characterisation of the Holy Family as ordinary people. Martineau was a friend first of Millais's, who introduced him to others among the Pre-Raphaelite circle. In 1851 he painted his first subject taken from *The Old Curiosity Shop* and

the following year submitted this new picture to the Royal Academy. It shows one of the happier and more comic moments in Dickens's tale, when Nell gives the errand boy Kit a lesson to try to improve his writing. Kit is devoted to Nell and her grandfather and tries to help them. The passage illustrated describes how in the writing lessons Kit

tucked up his sleeves and squared his elbows and put his face close to the copy-book and squinted horribly at the lines – how, from the very first moment of having the pen in his hand, he began to wallow in blots, and to daub himself with ink up to the very roots of his hair – how, if he did by accident form a letter properly, he immediately smeared it out again with his arm in his preparations to make another – how, at every fresh mistake, there was a fresh burst of merriment from the child and louder and not less hearty laugh from poor Kit himself – and how there was all the way through, notwithstanding, a gentle wish on her part to teach, and an anxious desire on his to learn ...

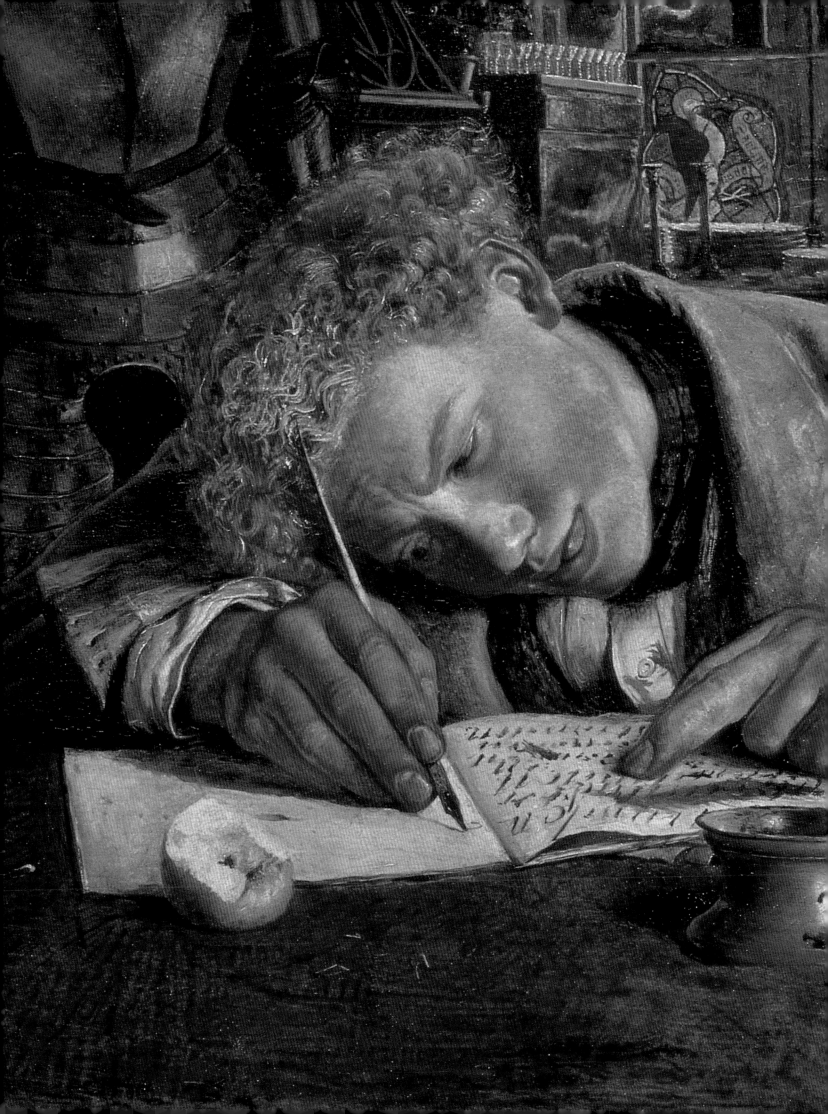

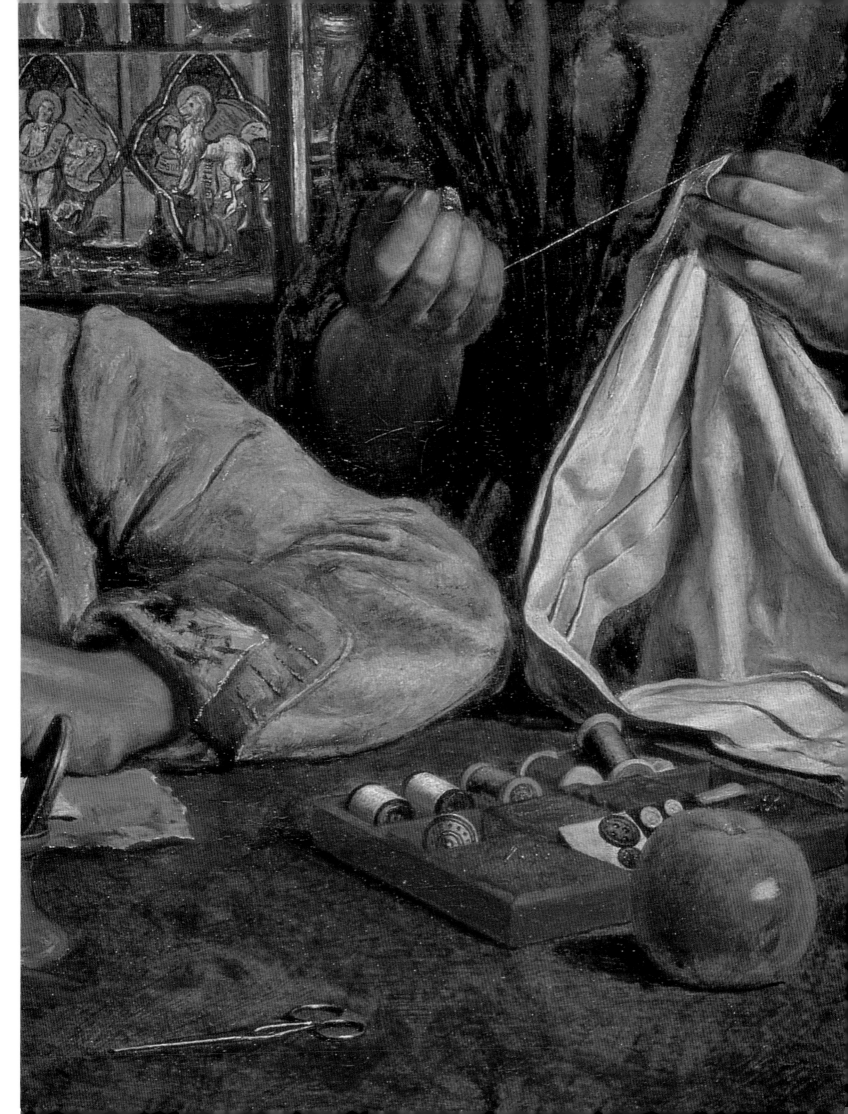

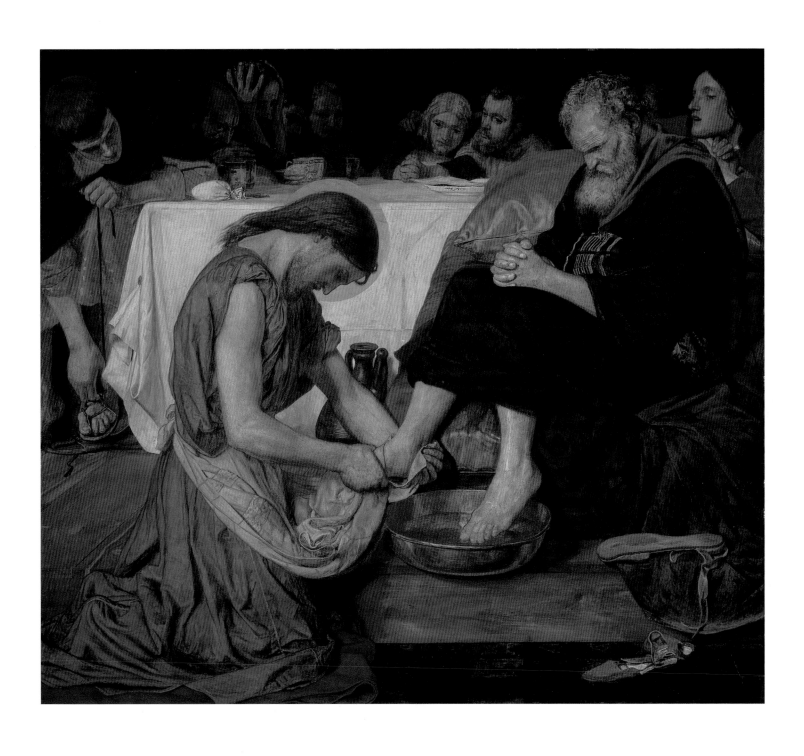

FORD MADOX BROWN 1821–93
Jesus Washing Peter's Feet 1852–6

Oil on canvas 116.8 x 133.3 (46 x 52 ½)

Presented by Subscribers 1893

Perhaps inspired by the unconventional religious intensity of Millais's *Christ in the House of his Parents* (see no.4), Brown took as his subject the Last Supper, but treated it in a wholly original way. The figures fill the close-up, compressed space of the composition and the low standpoint makes it appear as if the viewer, too, is kneeling alongside Christ. When it was first exhibited it was accompanied by the description in John's Gospel: 'He riseth from supper and laid aside his garments; and took a towel and girded himself. After that he poureth water into a basin, and began to wash the disciples' feet, and to wipe them with the towel wherewith he was girded ... For I have given you an example, that ye should do as I have done to you' (13:4–5,15).

Brown originally painted Christ clothed only in the towel that girded him, but when the picture appeared in the Royal Academy annual exhibition in 1852 there was an outcry. The *Art Journal* commented, 'we care not whether the exhibitor affect pre- or post-Raffaelism, but we contend that coarseness and indignity in painting are always objectionable' (1852; quoted *The Pre-Raphaelites*, exh. cat., Tate Gallery 1984, no.42). Brown, too, was indignant, for not only was his picture hung so high that its top touched the ceiling, it was at an angle that reflected light off it. It was only after Brown had reworked the scandalous painting, clothing the figure of Christ, that a purchaser was found in 1857. Some twenty years later he wrote of the episode:

> of course with all the flesh the picture was fuller of artistic material: but for which I should never have chosen a subject without a woman in it – of course the intention is that Jesus took upon himself the appearance of a slave as a lesson of the deepest humility ... People however could not see the poetry of my conception. & were shocked at it, & would not buy the work – & I getting sick of it painted clothes on the figure' (Letter dated 3 May 1876 to Charles Rowley, quoted *The Pre-Raphaelites*, exh. cat., Tate Gallery 1984, no.42)

Another dimension to the negative way in which Brown's picture was received was perhaps also his characterisation of Christ as an ordinary man carrying out humble tasks. Although central to the message of the New Testament, the idea of Christ the servant was viewed with great suspicion in middle-class Victorian Britain, where the notion of equality in the eyes of God had uncomfortable social implications. Universal suffrage was much discussed by some, but still a long way off, and the work of the Christian Socialists bringing relief to the working classes primarily through education caused considerable unease in more conservative circles. Brown was himself an admirer of the Christian Socialist leader Frederick Denison Maurice – indeed, he depicted him alongside Thomas Carlyle in his famous rumination on Victorian society, *Work* 1852–65 (fig.8). Maurice argued that politics and religion were inseparable and that the Church should devote itself to addressing social questions, particularly the redistribution of wealth to improve the lot of the working class and bring about a just, Christian society. He saw Christ as the embodiment of muscular, moral vigour, and an ideal role model for the working class. Brown's Christ, as he diligently cleans his disciples' feet, seems to have this same character.

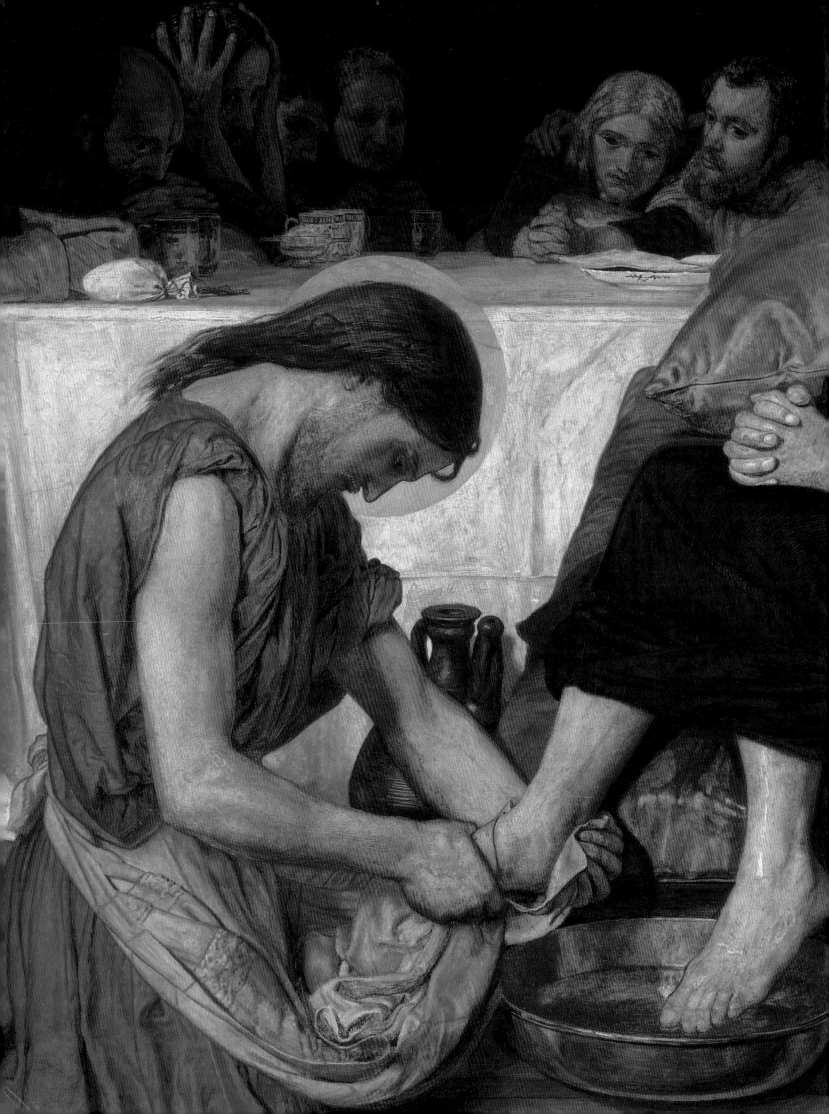

The picture's poor reception must have enraged Brown, for it had caused him problems from the start. Visiting Millais and Holman Hunt painting in the open air at Worcester Farm Park in 1851, he was initiated into their secret technique of painting onto a wet white ground. This provided great luminosity, and Brown consequently employed it for the first time for the figures' flesh in *Jesus Washing Peter's Feet*. However, it evidently gave him great trouble and, always a somewhat quick-tempered man, he wrote crossly of having attempted it only 'at Millais' lying instigation', and bitterly judged it a technique that was 'dangerous like Millais' advice' (*The Diary of Ford Madox Brown*, ed. Virginia Surtees, New Haven & London 1981, p.76). These difficulties led to his getting behind and having to rush the painting of the disciples, for whom Brown he used a mixture of friends and professional models. Frederic Stephens sat for Christ (see no.10), a bricklayer for Judas, seen tying his sandals on the far left, and among the disciples feature Holman Hunt and his father, Dante Gabriel Rossetti and his brother William Michael, and perhaps also their sister Christina; Millais, however, was not invited to model.

In 1891 a subscription fund was raised to give Brown a commission for the future Tate Gallery, which was just beginning to be discussed. But Brown died before completing it and in 1893 the Subscription Committee, which included his old friend Frederic Stephens, instead used part of the money to purchase *Jesus Washing Peter's Feet* for the future National Gallery of British Art. It was the first picture by Brown to enter the national collection.

WILLIAM HOLMAN HUNT 1827–1910
The Awakening Conscience 1853

Oil on canvas 76.2 x 55.9 (30 x 22)

Presented by Sir Colin and Lady Anderson through the Friends of the Tate Gallery 1976

One of the Pre-Raphaelites' central ambitions was to paint subjects which were relevant to modern life. The metropolitan prevalence of prostitution and the 'fallen' woman was widely discussed in the 1850s. The moral pitfalls and social censure of sex outside marriage formed the subject of novels such as *Basil: A Story of Modern Life* of 1852 by Wilkie Collins, brother of the Pre-Raphaelite painter Charles Collins, and Mrs Gaskell's *Ruth* of 1853. Henry Mayhew's ethnographic survey of the capital's working-class population, *London Labour and the London Poor*, devoted extensive space to the different gradations and classes of prostitutes, and recorded his interviews with them. A prostitute was the eponymous subject of Rossetti's ballad 'Jenny', begun in 1847 and worked on over many years, and his painting *Found* (see fig.1), conceived in 1853, showed a country swain's rediscovery of his lost sweetheart working as a London streetwalker.

All of these undoubtedly served as the background to Holman Hunt's decision to paint *The Awakening Conscience*, a picture which quickly became an icon of Pre-Raphaelitism. Hunt himself said that his interest in treating the subject arose from reading Dickens's description of Peggotty's search for little Emily in *David Copperfield* (1850). His subject is a kept woman and, with characteristic thoroughness, he hired a villa which was a real life *maison de convenance* in St John's Wood, an area then famous for its courtesans living under such circumstances. Hunt shows the moment when, as her lover sings to her, the woman sees the error of her ways, represented by the shaft of sunlight penetrating the room and the unspoilt natural beauty of the garden reflected in the mirror.

The picture is full of symbolic detail: the man has been singing is 'Oft in the Stilly Night', a ballad contrasting the innocent pleasure of the past with present sadness. His discarded glove represents the woman's lost virtue – and hints at the ease with which he might also cast her aside; the tangled tapestry wool represents the trap in which she is enmeshed; her bare wedding-ring finger emphasises the nature of their relationship. The woman is dressed in a nightdress, although it is nearly midday: it was Hunt's sister who persuaded him to add the shawl around her waist to make her state of undress less shocking. The vulgarity of the room's décor contrasts with the natural beauty of the garden outside. As the woman rises she distracts the cat under the table from its game with a bird – like her, the bird may escape and fly away, but its fate is uncertain.

The frame is also decorated with related symbols: marigolds for sorrow, bells for warning, and a star at the top for spiritual salvation. Hunt also includes the verse from Proverbs which inspired the composition: 'As he that taketh away a garment in cold weather, so is he that singeth songs to an heavy heart'. As Hunt later wrote, 'The unintended stirring up of the deeps of pure affection by the idle singing of an empty mind led me to see how the companion of the girl's fall might himself be the unconscious utterer of a divine message' (William Holman Hunt, *Pre-Raphaelitism and the Pre-Raphaelite Brotherhood*, London 1905, I, p.347).

The picture was widely criticised for its inappropriate subject-matter; its symbolic dimension was largely ignored. Frank Stone, no doubt enraged that his own painting, *Cross Purposes*, appears above the piano,

wrote in the *Athenaeum* that Hunt's painting was 'drawn from a very dark and repulsive side of modern domestic life' (April 1854). Ruskin alone praised the picture in the press, wondering at the same time whether the woman's spiritual revelation might result in her being put out on the streets to suffer the worse fate of the common prostitute.

Hunt's model for the kept woman was Annie Miller, a girl from the slums of Cross Keys. Hunt wanted to have her as a wife once he had fashioned her as his ideal woman. He arranged for her to be given lessons in elocution, deportment and dancing while she was still modelling for the picture. Unfortunately when Hunt went away to the Middle East, leaving her under the supervision of a Mrs Bramah who belonged to a society devoted to rescuing fallen women, Annie spent his money having fun instead of 'improving' herself as he had planned. Furthermore, to Hunt's fury, in his absence Rossetti took her to the theatre and other popular entertainments and possibly also became her lover; this was the beginning of the chill in the two artist's friendship. Worse still for Hunt, and bitterly ironic in light of *The Awakening Conscience*, while he was away Annie became the kept mistress of Lord Ranelagh. Having discovered by accident of this affair after Ranelagh had abandoned her, Hunt finally abandoned her too.

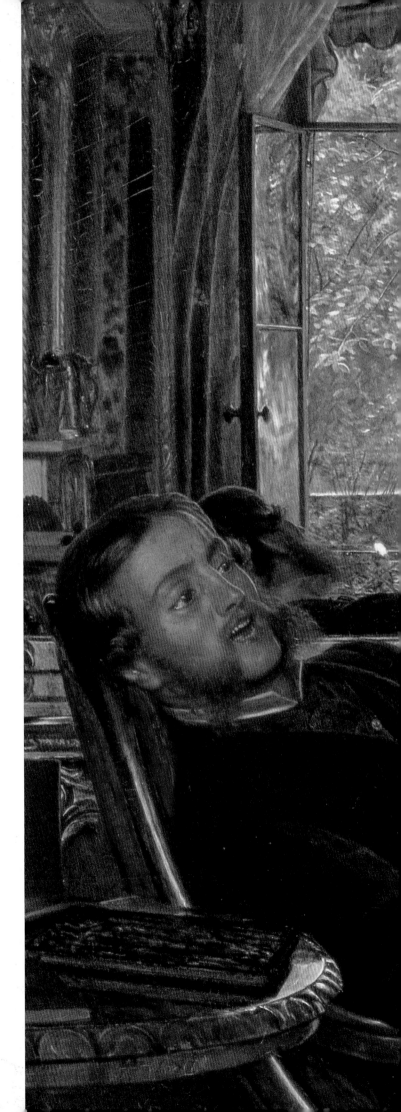

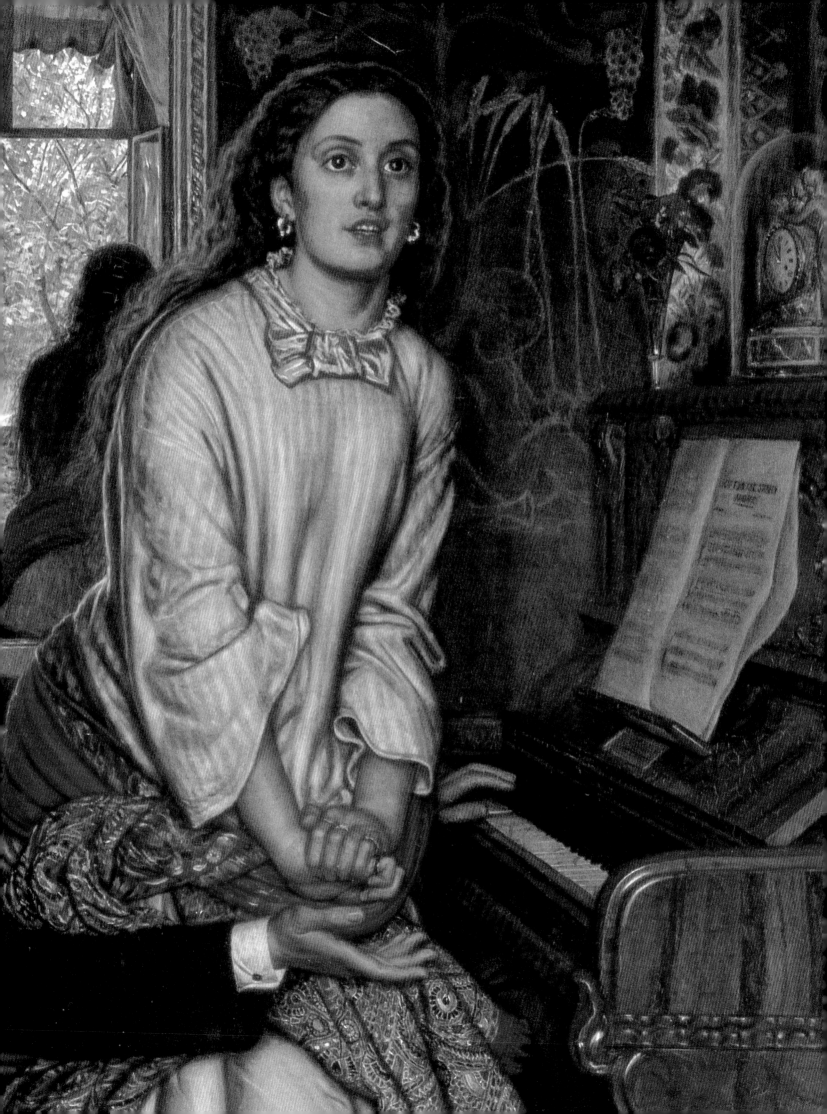

13

HENRY WALLIS 1830–1916

The Room in Which Shakespeare Was Born 1853

Oil on board 29.2 x 41.9 (11½ x 16½)

Purchased 1955

Wallis appears to have been on the periphery of the Pre-Raphaelite circle, and to have been closest to Arthur Hughes. In 1848, the year of the Brotherhood's formation, he entered the Royal Academy Schools, and must have observed over the following two years the effect of the young painters on the Academy exhibitions. Shakespeare was high on the list of 'Immortals' compiled by the Pre-Raphaelites, although admiration of him was fairly universal. Wallis may have had in mind the commercial potential of such widespread enthusiasm for Shakespeare when he started this picture of the room in which he was born. Indeed, it was one of three such pictures he made at the same time, and for the 1854 Academy exhibition he showed it with *In Shakespeare's House: Stratford on Avon* and *The Font in which Shakespeare was Christened.* Accompanying *The Room in which*

Shakespeare was Born was a long descriptive quote from Charles Knight's 1842 biography of Shakespeare which described 'that mean room, with its massive joists and plastered walls, firm with ribs of oak, where we are told the poet of the human race was born' (p.30). On the same page is a woodcut illustration which takes the same viewpoint as Wallis's canvas, and it is possible that together with the text these two sources formed the basis for his composition. Nevertheless, in its simplicity and emptiness, and his concentration on rendering the textures of wood and plaster, Wallis produced a highly effective and atmospheric picture. He was to make a series of paintings with literary connections including subjects around Dr Johnson (1854), Andrew Marvell (1856), Montaigne (1857), Sir Walter Raleigh (1858 and 1862), and famously, Chatterton (c.1856, see no.25).

CHARLES ALLSTON COLLINS 1828–73
Convent Thoughts 1853

Pen and ink 33 x 19.7 (13 x 7 ¾)

Bequeathed by Mrs Louise d'Este Oliver 1920

Collins made this refined pen and ink version of the composition two years after the original oil was exhibited at the Royal Academy in 1851.

The nun contemplates a passion flower, so called because it symbolises the story of Jesus's suffering – at the centre is a cross, while the five petals and five sepals represent the ten Apostles; the filaments within the flower the crown of thorns; and the five anthers, Christ's five wounds. But it is also a reference here to the life away from physical passion that is the nun's vocation. Collins was a deeply religious man who was ascetic by nature and attracted to the ceremonial and mystical elements of High Anglicanism. He was a close friend of Millais, who rather lampooned this side of his character, although it was undoubtedly partly this seriousness which brought him close to Holman Hunt.

Millais proposed Collins as the replacement in the Brotherhood for Collinson, after he had resigned. But Woolner opposed the proposal 'savagely', a view supported by William Michael Rossetti because, he wrote, 'the connexion would not be likely to promote the intimate friendly relations necessary between all Pre-Raphaelite Brothers'. Bitter argument in the Church of England between those who wanted a return to ritual and those who did not was a powerful contemporary issue, and Collins's sympathies for the former group may have been a factor in the Pre-Raphaelite Brotherhood's rejection of his membership. As a group championing 'Early Christian' art and the use of arcane symbols, and as a slightly mysterious Brotherhood, they stood open to claims that they were of ritualistic, Catholic persuasion. This was far from the case, but Collins's oil version was strongly criticised in the press on this basis. Ruskin leapt to its defence, claiming its principal importance was as a supreme example of truth to nature and botanical observance. But the picture is deeply symbolic: the white lilies are emblems of purity and the Virgin Mary, the fish symbolise Christ, while the concept of the enclosed garden is traditionally associated both with the Madonna and more generally with virginity.

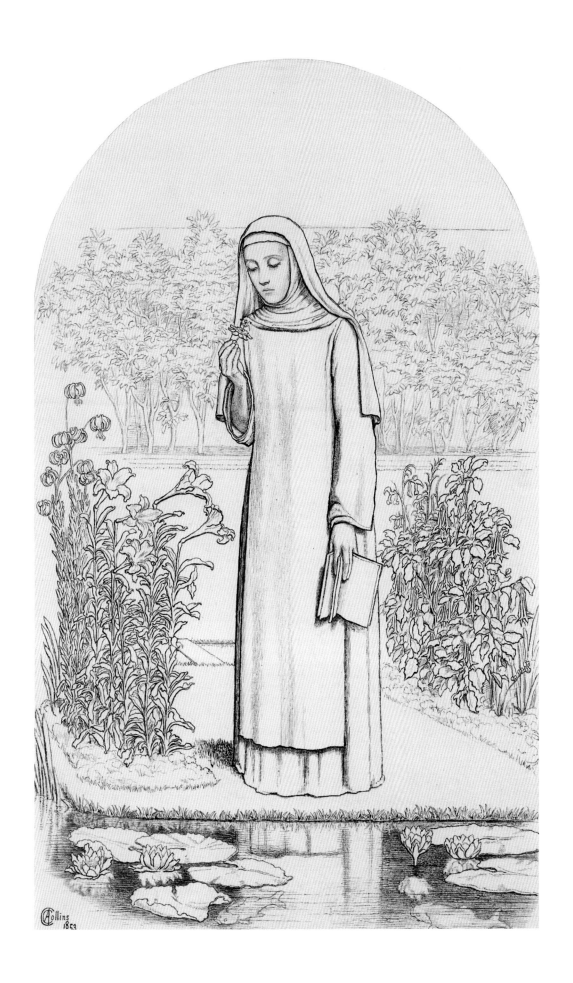

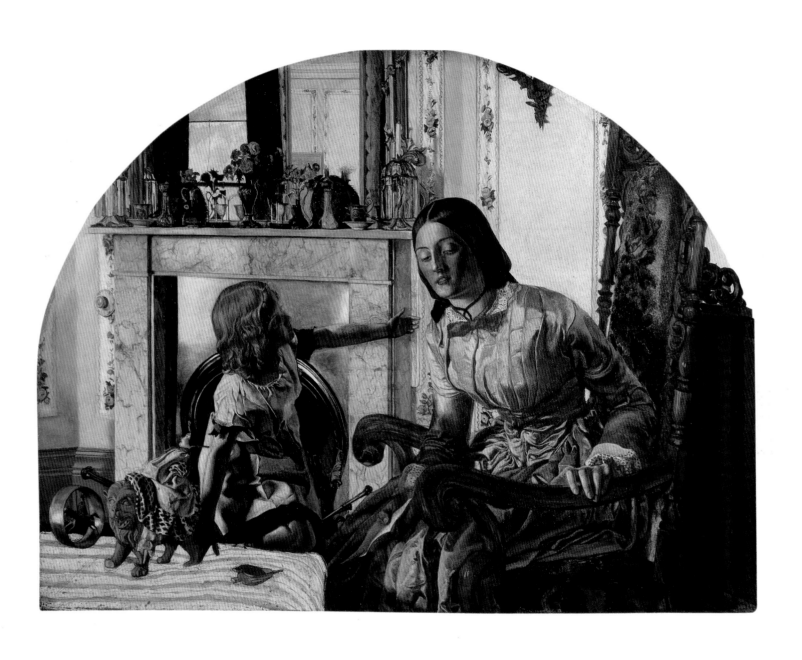

FREDERIC GEORGE STEPHENS 1828–1907
Mother and Child c.1854

Oil on canvas 47 x 64.1 (18 ½ x 25 ¼)

Bequeathed by H.F. Stephens 1932

Stephens presents a dramatic and common contemporary occurrence which has destroyed the domestic harmony and innocence of the scene. The woman starts forward and grips the arm of the chair as disbelief and grief sweep across her face. A letter which she holds loosely in her hand informs her that her husband has been killed at war. In March 1854 Britain had begun hostilities in the Crimea; clues that the sad results of this conflict are the real subject are among the child's toys. The lion symbolises Britain itself and its martial endeavour, while seated somewhat precariously, the doll riding it is intended to represent Queen Victoria. Contained forever within the rolling toy, the soldier on horseback alludes to the father's profession. The tiny pair of doll's house bellows must allude to the fanning of the flames of war, but perhaps also to the puffed pride of nationalism. Stephens's use of toys for the picture's symbolism suggests the view that war itself is childish. There are emblems of love in the language of flowers – roses are everywhere, on the mantelpiece, on the wallpaper, and embroidered on the chair back – symbols of the couple's devotion to each other. A partly illegible inscription by Stephens on the left spandrel draws parallel between dead rose leaves and perished love. With agonising poignancy, the child reaches forward to comfort its mother and ask what is wrong. Stephens cleverly depicts a frozen moment which at the same time constructs a narrative drama of what has just happened and, in the telling of the child that its father is dead, what is about to happen.

Initial public enthusiasm for the war against Russia quickly subsided when William Howard Russell's reports in *The Times* revealed the troops' sufferings and the general mismanagement of the war, especially during the winter of 1854. These accounts upset Queen Victoria who described them as 'infamous attacks against the army which have disgraced our newspapers' while Prince Albert, who took a keen interest in military matters, judged 'the pen and ink of one miserable scribbler is despoiling the country'. Russell's reports led to a government inquiry.

For Stephens the practice of painting was enormously time-consuming and he went to great lengths to construct the correct perspective of *Mother and Child* and test out its colour scheme. Many of his works remained at a point where he felt unable to finish them; as a result he eventually abandoned painting for writing. He claimed to have destroyed all his paintings, but thankfully some survive.

Dante Gabriel Rossetti 1828–82
Elizabeth Siddall Plaiting her Hair *c*.1854

Pencil 17.1 x 12.1 (6¾ x 4¾)

Bequeathed by H.F. Stephens 1932

The daughter of a Southwark ironmonger and cutler, Elizabeth Eleanor Siddall (1829–62) was working as a milliner's assistant in a shop off Leicester Square when she was 'discovered' in 1849 by Rossetti's friend, the painter Walter Howell Deverell. Deverell used her as a model in his *Twelfth Night* (see no.2), and she quickly became a favourite for the Pre-Raphaelites with Millais famously casting her as Ophelia (fig.15). Rossetti seems to have fallen in love with her almost immediately, and by 1852 they were engaged. He would not permit her to sit to anyone else, and drew her obsessively. Here she plaits the long auburn hair which so fascinated Rossetti, her face set in an expression of introspection, radiating stillness and absorption. Rossetti was fascinated by Lizzie's hair, and seeing it let down was an act of intimacy.

One of Rossetti's affectionate nicknames for Lizzie was 'Guggum'; Ford Madox Brown recalled visiting Rossetti:

Gabriel as usual diffuse and in consequent in his work. Drawing wonderful and lovely 'Guggums' one after another, each one a fresh charm, each one stamped with immortality.

...

He showed me a drawer full of 'Guggums', God knows how many. It is like a monomania with him. Many of them are matchless in beauty however and one day will be worth large sums (Brown, *Diary*, Oct. 1854, Aug. 1855).

After initial bliss, the relationship between the lovers began to founder. Although the couple married in 1860, Rossetti had already proved an inconstant lover and evidently began to stray. Lizzie was dogged by ill health from 1852; after being delivered of a stillborn child in 1861 she sank into decline. The following year, with Rossetti continuing to neglect her, she took a laudanum overdose and died.

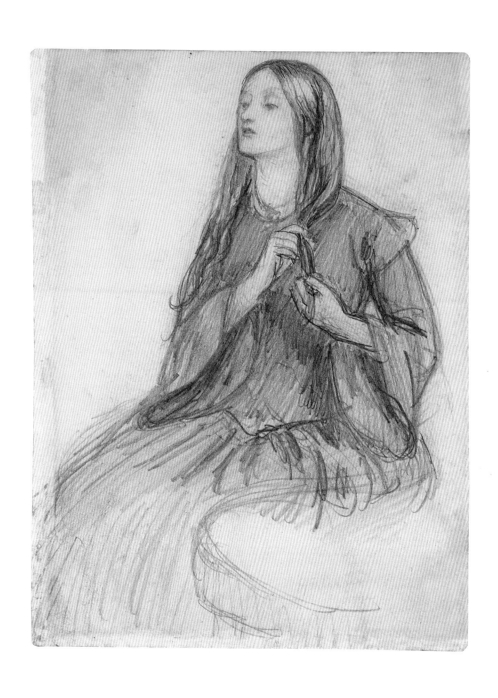

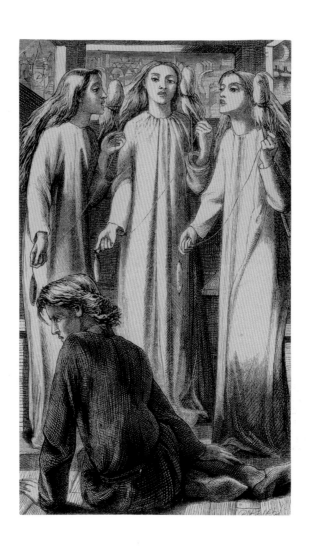

17

Dante Gabriel Rossetti 1828–82
The Maids of Elfen-Mere, 1855

Wood engraving 12.7 x 7.6 (5 x 3)

Purchased 1924

Rossetti designed this illustration for William Allingham's volume of poetry, *The Music Maker, A Love Story and Two Series of Day and Night Songs*, which was published in 1855, and also had plates by Arthur Hughes and Millais. It retells an ancient German legend about a young man visited by three fairy damsels each night. They enchant him by singing their magic song and as they do so spin out their threads. But they always leave before the stroke of midnight, despite his wish for them to stay longer. The youth tries to trick them into staying longer by turning back the clock, but this has dire consequences: the maids come no more and in the morning three red stains appear on the surface of the Mere. Rossetti was himself fascinated by tales of the supernatural, and this story, with its themes of entrancement, the passage of time and the unwitting causing of tragedy, would have appealed to him strongly.

Rossetti, however, was displeased with the print based on his drawing. He first drew it on a woodblock the same way round as the drawing, so it printed back to front. A second block corrected this, although Rossetti still forgot to reverse the time on the town clock. The block cutters had made the maidens' mouths look like goldfish, Rossetti complained, and he tore the plate from his copy of the poems. But in truth it is one of Rossetti's most affecting illustrations, brilliantly designed and full of evocative mysticism. The Dalziel brothers greatly admired it, and it was responsible for inspiring them to produce their famous edition of Tennyson poems illustrated by Rossetti and his circle (see no.30). It was one of the first works by Rossetti that Burne-Jones saw. Writing in the *Oxford and Cambridge Magazine* in January 1856, he considered it: 'The most beautiful drawing for an illustration I have ever seen; the weirdness of the Maids of Elfen-Mere, the musical timed movement of their arms together as they sing, the face of the man above all, are such as only a great artist could conceive.'

Dante Gabriel Rossetti 1828–82
Paolo and Francesca da Rimini 1855

Watercolour 25.4 x 44.9 (10 x 17 5/8)

Purchased with assistance from Sir Arthur Du Cros Bt and Sir Otto Beit KCMG
through the National Art-Collections Fund 1916

Rossetti's father was a noted Dante scholar and, perhaps inevitably in view of being named after the Italian poet, his son inherited and felt an even keener interest in him. Even while still a teenager Rossetti started translating Dante's poems, and eventually published them in 1861. The tragic story of the adulterous lovers, Paolo and Francesca, is recounted in the fifth canto of Dante's *Inferno*, and was a popular subject with artists and sculptors from the late eighteenth century onwards.

Rossetti's composition is divided into three parts, reading from left to right. The left-hand panel illustrates the following lines from Dante's text:

One day
For our delight we read of Lancelot,
How him love thrall'd. Alone we were, and no
Suspicion near us ... then he, who ne'er
From me shall separate, at once my lips
All trembling kiss'd.

Rossetti depicts Paolo and Francesca secretly embracing, with a large illuminated book open on their knees and a plucked red rose at their feet. The figure in the book dressed, like Paolo, in red and blue, is Lancelot, who also suffered for his forbidden love.

The central section depicts Dante and his guide through Hell, Virgil, crowned with laurel; together they regard with concern the two lovers on the right, who appear to float like wraiths in each others arms, amid the flames of Hell. Their adulterous relationship uncovered, they were murdered by Francesca's husband and Paolo's brother, Sigismondo Malatesta, and banished to the second circle of Hell. Rossetti brings the story to life by inscribing quotations from Dante's text around the edge of the composition.

The picture is rendered in the archaic, medievalising style of this period of Rossetti's art. The drawing is simple and the colours generally muted. Only Francesca's long golden hair looks forward to the more sensuous creatures of Rossetti's later works. According to the artist Ford Madox Brown, Rossetti began the picture on an impulse, and, working day and night, completed the composition within a week. The picture was originally planned as a triptych in oils, with the same scenes as in the watercolour, but with the lovers kissing as the central motif. Having completed the picture, Rossetti quickly sold it to Ruskin for thirty-five guineas because Elizabeth Siddall had run out of money on her way to the south of France. She appears to be the model for Francesca, the act of reading about Lancelot surely a memory of Rossetti and Lizzie's avid consumption of the texts together.

Ruskin bought the drawing after having rather talked Ellen Heaton out of it, she having given Rossetti a commission for any subject of his choosing. 'A most gloomy drawing', Ruskin wrote to her, 'very grand – but dreadful of Dante seeing the soul of Francesca and her lover ... thoroughly grand and noble ... Prudish people might not think it a young lady's drawing. I don't know. All the figures are draped – but I don't know quite how people would feel about the subject ... The common-pretty-timid-mistletoe bough kind of kiss was not what Dante meant. Rossetti has thoroughly understood the passage throughout' (quoted Virginia Surtees, *Dante Gabriel Rossetti 1828–1882: The Paintings and Drawings: A Catalogue Raisonné*, Oxford 1971, no.75).

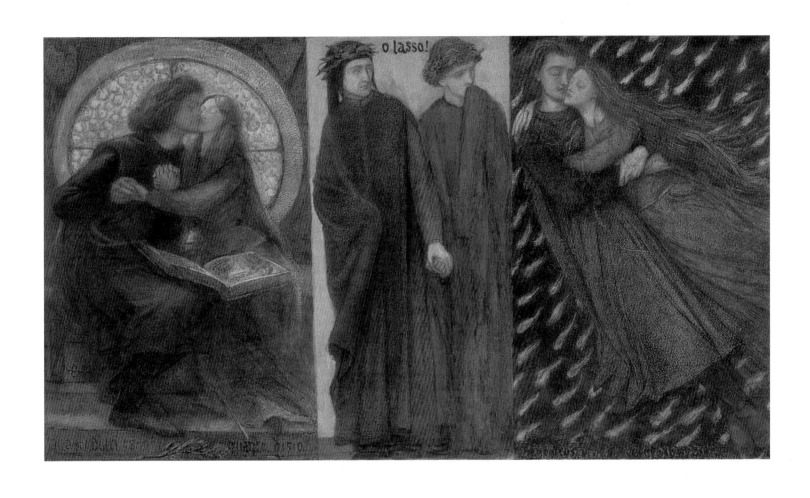

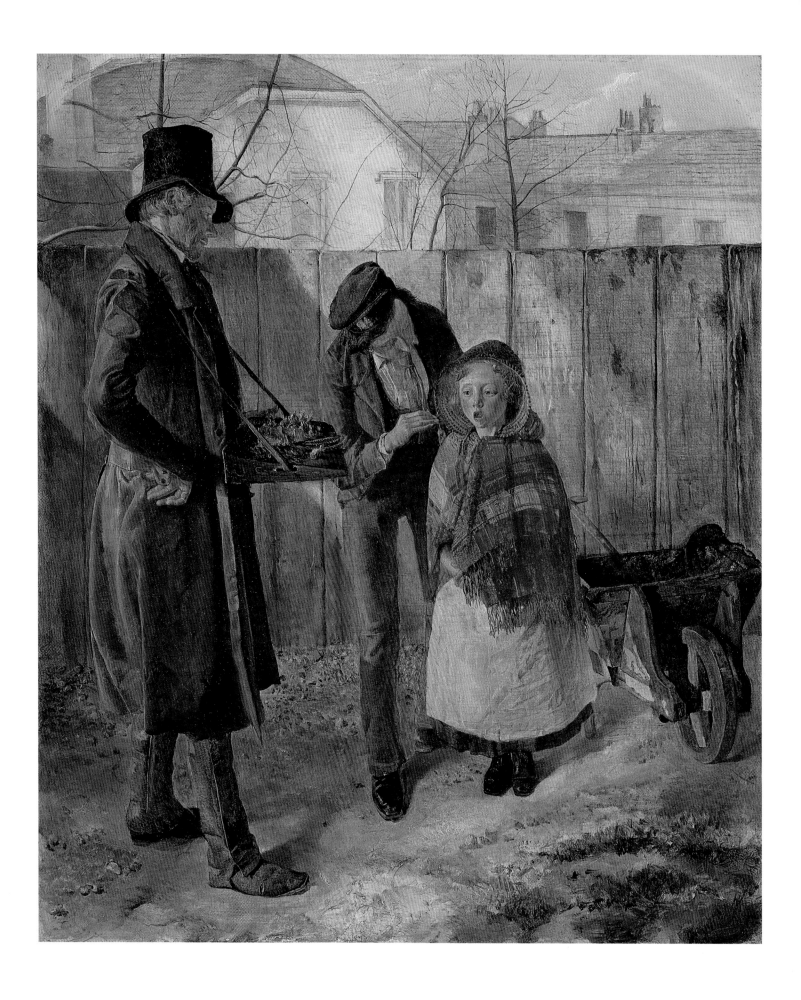

19

JAMES CAMPBELL c.1825/8–1893
The Lollipop 1855

Oil on canvas 35 x 30 (13 ³/₄ x 11 ³/₄)

Presented by David Posnett and the Leger Galleries 1996 to celebrate the
Tate Gallery Centenary 1997

This was the first picture that the Liverpudlian painter Campbell exhibited in London, where it was shown at the Society of British Artists in 1855 and sold for four guineas. It is an example of the small-scale, intricately painted genre subjects for which he is best known and which often portray incidents from respectable lower middle-class and artisan life in Liverpool. Campbell was a member of the group of painters within the Liverpool Academy who were particularly receptive to Pre-Raphaelite ambitions and techniques and who supported and imitated the London school. William Windus was the most important member and leader of this group, and it was through his efforts that the London Pre-Raphaelites regularly exhibited at the Liverpool Academy in the earlier part of the 1850s. He was also instrumental in regularly gaining for one of their number the annual prize for the best contribution by a non-Liverpool artist. But such campaigning eventually led to bitter factional disagreements within the Academy, and eventually it collapsed.

Showing a scene taken from contemporary life, *The Lollipop* is painted with the detailed execution and bright, clear colour that characterise Campbell's work and which embody his commitment to Pre-Raphaelitism. The use of lighter and less intense colours generally distinguishes works by the Liverpool Pre-Raphaelites from those of their London fellows. Campbell treats the blank surfaces of the fence and rough ground with equal detail to the rest of the picture, and lends them an abstract, emotive quality in themselves. Sometimes described as an almost Dickensian painter, Campbell's image of a poor blind child being given a treat in the form of a lollipop is a study in minutely observed character and sentiment. But in showing someone afflicted by a disability it touched on one of the pressing social debates of the day about how and how far such people should be cared for by society, and whether they should be the formal responsibility of local or even national government. The limits and duties of charity were greatly discussed, and it is telling that in Campbell's picture, the act of bringing simple pleasure to the child has been paid for by a humble workman, his wheelbarrow illustrating his social position. A common sight in every neighbourhood, the street seller himself would also have been near the very bottom of any tradesman hierarchy. He was the kind of figure described in detail in Henry Mayhew's sociological survey *London Labour and the London Poor*, which began appearing in instalments from 1849; this also included a vivid interview with a beggar afflicted by blindness. Despite her blank expression and large eyes that apparently register nothing, the girl's obediently folded arms, tidy feet, slightly inclined head and open mouth suggest that the lollipop is to be received almost like a sacrament.

In the year before Campbell exhibited his picture in London, Millais started work on *The Blind Girl*, which similarly addresses some of these issues, although its principal subject is sensory experience. It is tempting to speculate whether there may have been any contact between the two painters.

ARTHUR HUGHES 1832–1915
The Eve of St Agnes 1856

Oil on canvas 71 x 124.5 (28 x 49)

Bequeathed by Mrs Emily Toms in memory of her father, Joseph Kershaw 1931

Keats's poem 'The Eve of St Agnes' tells the story of Madeline. On St Agnes's Eve, a night of feasting, she is told that she might see a vision of her true love. She awakes to the gentle serenading of her lover Porphyro who, at risk of being put to death, has crept into her chamber. The poem ends with their elopement. Hughes's painting depicts three scenes: Porphyro's approach to the castle; the awakening of Madeline; and the lovers' stealthy escape over the drunken porter.

By the time Hughes painted the picture Keats was neither particularly well remembered nor highly regarded. But his high romanticism and lush, sensuous language made him a natural source for Pre-Raphaelite inspiration. Rossetti particularly admired him, and it was seeing Holman Hunt's own treatment of the story of Madeline and Porphyro which brought the two men together. Hughes too would have been familiar with Hunt's picture, and the panel showing the elopement owes a great deal to his composition. Keats's stature revived in subsequent decades, a process both represented and helped by William Michael Rossetti's publication of a collected edition and biography.

Hughes translates the sensuousness of the imagery in 'The Eve of St Agnes' into the deep colours and glossy brushwork of his paintings, and clever use is made of the contrast between the darkness which cloaks Porphyro's approach and the rich, warm light shining out from the castle. In Madeline's chamber the pearly play of virginal moonlight on her pure-white bed and nightgown is set against the rich colours of the stained glass in the background, an allusion to Porphyro's passion and her own innocent state. The tautly composed final scene includes a dog who, in the language of allegory, represents loyalty, and the scene introduces a moment both of hesitation in Madeline, who disloyally breaks with the wishes of her father, and of tender farewell. When the picture was shown at the Royal Academy Ruskin lavished praise upon it, describing it as 'A noble picture …The half-entranced, half-startled face of the awakening Madeline is exquisite' (Ruskin, *Works*, XIV, p.70). Rossetti too admired the picture and predicted it would make Hughes's fortune.

The lavishly designed frame perfectly fits the Gothic subject-matter of the story but also introduces an interesting allegorical commentary on the tale. Ivy trails round the panels, a traditional symbol of everlasting life and hence the Resurrection. The patron saint of young virgins, St Agnes vowed that her body was consecrated to Christ and rejected all suitors. By his inclusion of the ivy Hughes seems to be suggesting a choice Madeline must make between physical and spiritual love, and the contrasts between temporal love and the eternal love of God.

Under the central panel Hughes has included lines from the poem:

> They told her how, upon St Agnes' Eve,
> Young virgins might have visions of delight,
> And soft adorings from their loves receive
> Upon the honey'd middle of the night,
> If ceremonies due they did aright;
> And supperless to bed they must retire,
> And couch supine their beauties, lily white;
> Nor look behind, nor sideways, but require
> Of Heaven with upward eyes for all that they desire.

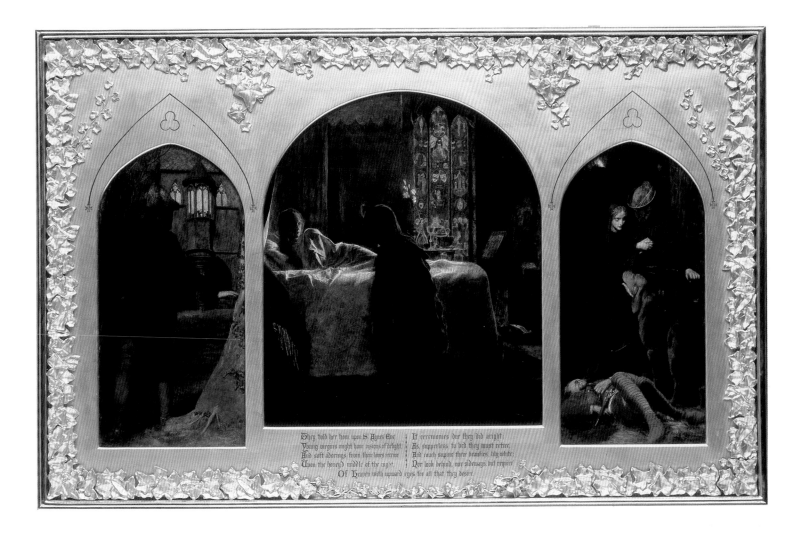

They told her how upon St. Agnes' Eve
Young virgins might have visions of delight,
And soft adorings from their loves receive
Upon the honey'd middle of the night,
If ceremonies due they did aright;
As, supperless to bed they must retire,
And couch supine their beauties, lily white;
Nor look behind, nor sideways, but require
Of Heaven with upward eyes for all that they desire.

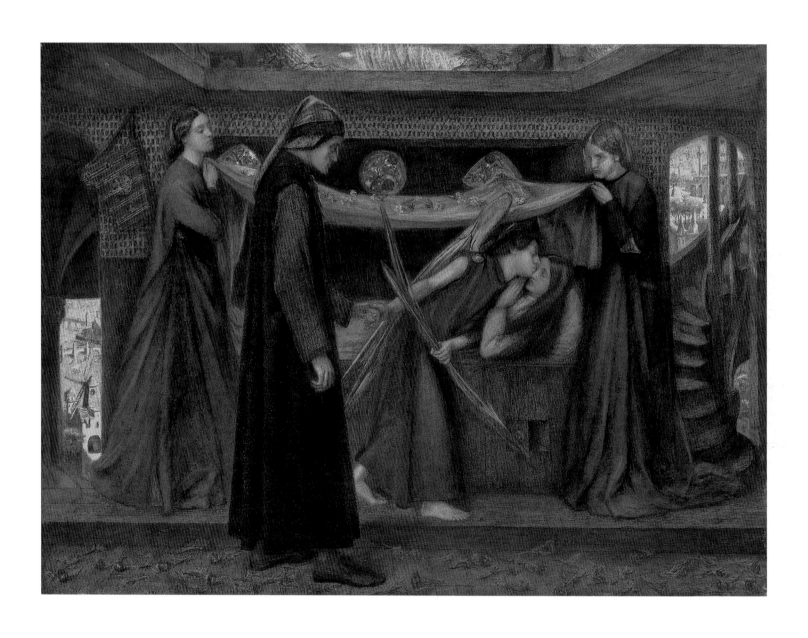

Dante Gabriel Rossetti 1828–82
Dante's Dream at the Time of the Death of
Beatrice 1856

Watercolour 48.7 x 66.2 (19 ⅛ x 26)

Bequeathed by Beresford Rimington Heaton 1940

Both in his work and in his life, Rossetti identified closely with the thirteenth-century Italian poet Dante Alighieri. In this watercolour he illustrates a passage from Dante's *Vita Nuova*, in which the poet receives a vision of the death of his beloved Beatrice:

> Then lifting up mine eyes, as the tears came,
> I saw the Angels, like a rain of manna,
> In a long flight flying back Heavenward;
> Having a little cloud in front of them,
> After the which they went and said 'Hosanna'
> And if they had said move, you should have heard.
> Then Love said, 'Now shall all things be made clear
> Come and behold our lady where she lies.'
> These 'wildering phantasies
> Then carried me to see my lady dead.
> Even as I there was led,
> Her ladies with a veil were covering her;
> And with her was such very humbleness
> That she appeared to say, 'I am at peace'.

The subject of lovers parted by death was one which fascinated Rossetti from an early age, and formed the subject of his poem 'The Blessed Damozel' (see no.67). In 'Dantis Tenebrae' Rossetti asks his father rhetorically in one of the verses:

> And dids't thou know indeed, when at the font
> Together with thy name thou gav'st me his,
> That also on thou son must Beatrice
> Decline her eyes according to her wont ...

ELIZABETH ELEANOR SIDDALL 1829–62
Sir Patrick Spens 1856

Watercolour 24.1 x 22.9 (9 ½ x 9)

Purchased 1919

Encouraged and advised by Rossetti, Elizabeth Siddall began painting in 1852 and made over a hundred works in the following ten years. Her style and subject-matter were close to Rossetti's, but their relationship was mutual and their medieval, romantic dreams supported and fed from each other's. They sometimes collaborated, and Lizzie's compositions were adapted and adopted by Rossetti for his pictures *Before the Battle* 1858 and *St George and the Princess Sabra* (no.46). Ruskin greatly admired her work, and paid her a retainer to support her career and provide her with a measure of financial independence, while also buying his ability to dictate subject and style.

This picture is based on an ancient Scottish ballad taken from Sir Walter Scott's *Minstrelsy of the Scottish Border* (1802–3) which was one of the Pre-Raphaelite circle's favourites (see no.41). The King of Scotland asks Sir Patrick Spens, the best sailor in the land, to sail him to Norway to fetch back his daughter. But on the return the ship is lost in a great storm, and the king, his court, and all aboard perish. In Scotland their wives and families look in vain for the ship's sail on the horizon, realising what has happened; this is the moment Siddall depicts.

> O long, long may their ladies sit
> With their fans into their hands
> Or ever they see Sir Patrick Spens
> Come sailing to the land.

> O long long may the ladies stand
> With their gold combs in their hair
> All waiting for their ain dear lorde
> That they shall not see mair.

The figure on the right appears to be a self-portrait and the half-closed eyes and tilted-back head are reminiscent of some of Rossetti's drawings of her. Lizzie was greatly interested in poetry, having a keen admiration for Tennyson and the Border ballads, and she wrote poems herself, encouraged by Rossetti.

This watercolour was one of a number of compositions for a projected volume of Scottish ballads which was to be put together by William Allingham and illustrated by Rossetti and Siddall. Produced at the height of her short artistic career, this is one of Siddall's most complete compositions: the figures are expressed so that different stages of searching, realisation and grief are shown simultaneously. It is also one of her earliest watercolours – she began using watercolour for the first time in 1856. Here she paints in a careful and restrained manner, in the brilliant blues and greens of the Pre-Raphaelite palette. This is the only known work by Siddall in which the landscape plays so dominant a role, and it is likely that the composition was influenced by the artist's visits to Hastings in 1854, where she went to recover from illness, and Nice in 1855–6.

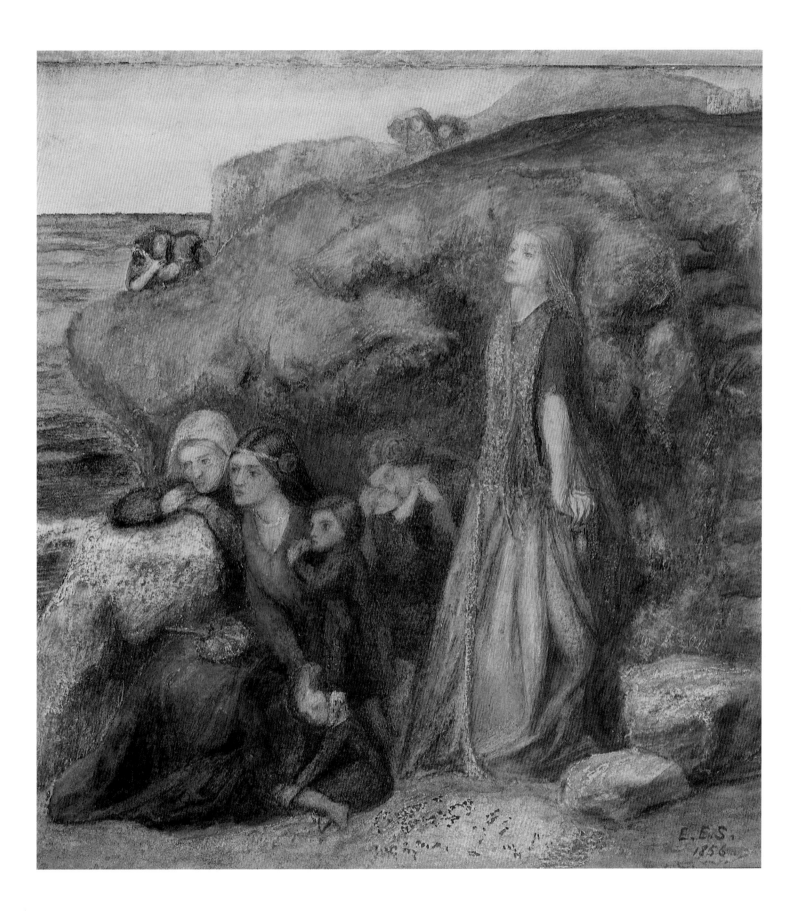

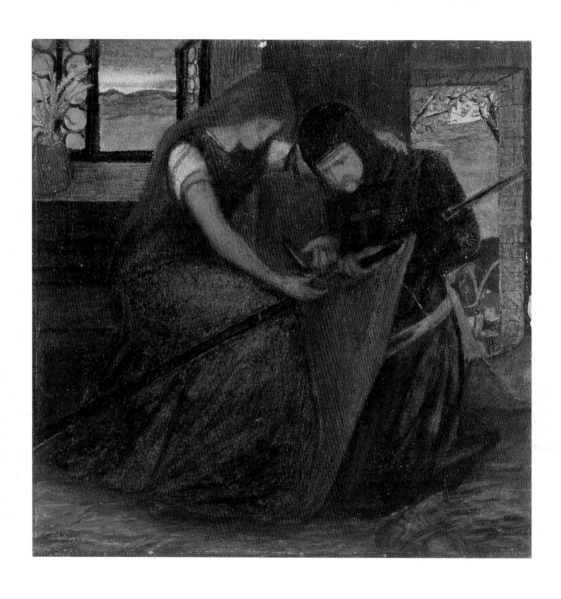

23

ELIZABETH ELEANOR SIDDALL 1829–62
Lady Affixing Pennant to a Knight's Spear *c.*1856

Watercolour 13.7 x 13.7 (5 ³/₈ x 5 ³/₈)

Bequeathed by W.C. Alexander 1917

The subject of this painting is chivalric, albeit laden with sexual symbolism. The figures appear to be Siddall herself and a knight who has features similar to Rossetti's. It is a scene of preparation and leave-taking, but not one which is overburdened with melodrama. Instead, the moment of romantic gesture is treated as a matter of simple practicality. The masculine world of battle and blood is seen through the open window and door, where a groom holds ready the knight's charger. The spheres of male and female experience are given explicit contrast: the woman's association with the domestic warmth and containment of the interior seems to offer a paradigm of Victorian relations between the sexes. The untied flowing hair of the lady shows the intimacy of the couple, as does the gentle touch of her hand on the knight's shoulder, a gesture both practical and consoling. This is a design of considerable sophistication in its content and shows how medievalising subjects might be the vehicle for more contemporary concerns. The sanctity of the home was a theme widely explored, for instance in Coventry Patmore's set of poems *An Angel in the House*, as were the different roles into which men and women were expected to fit.

Some have claimed that Siddall's pictures simply copy Rossetti's, while others have viewed his painting lessons for her as a form of control and dominance. Both of these views are reductive, for while there may be some stylistic similarities between their pictures, Siddall's are wholly distinct and individual, and embody her own particular insight. It is interesting that both *Lady Affixing a Pennant* and *Sir Patrick Spens* (no.22) depict the act of parting or being parted. After Rossetti's initial ardour had cooled he frequently neglected Lizzie, and his extended absences with other lovers after their marriage led eventually to her laudanum overdose.

It is likely that this drawing was given to Burne-Jones, for in 1912 the Tate's Director bought it from his son Philip, using funds given by W.C. Alexander.

THOMAS WOOLNER 1825–92
Alfred Tennyson 1856

Plaster 26 x 26 (10¼ x 10¼)

Purchased 1988

Woolner was the only sculptor member of the Pre-Raphaelite Brotherhood. In Australia he had discovered great demand for casts of his 1849 medallion of Tennyson, and on his return he decided to make another version. The first time Tennyson had sat to him marked a considerable coup for a young and relatively unknown sculptor, and it had been Coventry Patmore who persuaded the poet laureate to sit. The sittings for the new version began in February 1855, with Woolner assuring the Tennysons that he would not take up too much of their time. A final version was not ready until April 1856, but Mrs Tennyson thought the nose too prominent and asked him to shorten it 'a wee bit' to add a character of greater distinction to the portrait. Not usually comfortable with criticism, however constructive, Woolner was nevertheless quite happy to oblige. He recognised a good thing when he saw it, and knew that Tennyson was good for business and that the way to securing commissions to portray the effacing Laureate was through his wife. Indeed, Woolner and Mrs Tennyson carried on an extensive and intimate correspondence.

When all was finished in July 1856 Woolner was delighted with the final effect, writing, 'now I consider it the *very best* med: I have done' (Amy Woolner, *Thomas Woolner, R.A., Sculptor and Poet: His life in Letters*, 1917, p.115). Woolner went on to make further portrait sculptures of Tennyson, providing him with both status and income. The portrait roundel was engraved and served as the frontispiece for Moxon's illustrated edition of Tennyson's works (see no.30).

On his voyage home from Australia Woolner had read the story of a fisherman whose wife remarried, believing wrongly that he had been lost at sea, and turned it into a narrative. He gave this to Tennyson, who subsequently revised the story as 'Enoch Arden', one of his most popular poems with the Victorian public. Woolner himself wrote verses, including those published in *The Germ* (see no.6) and an extraordinary twelve-volume epic about the sculptor Pygmalion and his ideal creation, Galatea.

In later life Woolner became estranged from many of the Pre-Raphaelite circle, including Rossetti, having quarrelled with him, and Hunt, with whom he spuriously claimed to have enjoyed a homosexual relationship.

25
Henry Wallis 1830–1916
Study for 'Chatterton' c.1856

Pen and ink and ink wash 19.4 x 25.4 (7 ⅝ x 10)

Purchased 1973

This is a study for Wallis's most famous work, *Chatterton*, which created a sensation when it was first exhibited at the Royal Academy in 1856, accompanied by the following quotation from Marlowe:

Cut is the branch that might have grown full straight
And burned is Apollo's laurel bough.

Ruskin described the finished painting in his *Academy Notes* as 'faultless and wonderful'.

Thomas Chatterton (1752–70) was an eighteenth-century poet, a romantic figure whose melancholy temperament and early suicide captured the imagination of numerous artists and writers. He is best known for a collection of poems, written in the name of Thomas Rowley, a fifteenth-century monk, which he copied onto parchment and passed off as medieval manuscripts. Having abandoned his first job working in a scrivener's office, Chatterton struggled to earn a living as a poet. In June 1770 he moved to an attic room where he lived on the verge of starvation until, in August of that year, at the age of only seventeen, he poisoned himself with arsenic.

Condemned in his lifetime as a forger by influential figures such as the writer Horace Walpole (1717–97), he was later elevated to the status of tragic hero by the French poet Alfred de Vigny (1797–1863).

Wallis may have intended the picture as a criticism of society's treatment of artists, since the painting alludes to the idea of the artist as a martyr of society through his Christ-like pose and the torn sheets of poetry on the floor. In the finished painting the pale light of dawn shines through the casement window, illuminating the poet's serene features and livid flesh. The harsh lighting, vibrant colours and lifeless hand and arm increase the emotional impact of the scene. A phial of poison on the floor indicates the method of suicide.

Following the Pre-Raphaelite credo of truth to nature, Wallis produced this work in the same attic room in Gray's Inn where it was believed that Chatterton had killed himself, and took pains to re-create it here. The model for the figure was the novelist George Meredith (1828–1909), then aged about twenty-eight; two years later Wallis eloped with Meredith's wife.

FORD MADOX BROWN 1821–93
Chaucer at the Court of Edward III 1856–68

Oil on canvas 123.2 x 99.1 (48 ½ x 39)

Purchased 1906

This is a later replica of the much larger version of 1851 which was bought by the Art Gallery of New South Wales in 1876, and which was the first of Brown's works to be acquired for a public collection. Brown developed the composition from the central panel of a triptych design, *The Seeds and Fruits of English Poetry*, which he had made for the competition to select murals for the Palace of Westminster. The subject suggested itself while he was browsing in the British Museum Library for inspiration and came across a description of Chaucer's 'ennobling' of the English language in Mackintosh's *History of England*. Brown recalled later in his diary how he 'immediately saw visions of Chaucer reading his poems to knights and Ladyes fair, to the king and court amid air and sun shine' (*The Diary of Ford Madox Brown*, ed. Virginia Surtees, New Haven & London 1981, p.1). The high-tiered format of *Chaucer at the Court of Edward III* owes a great deal to the popular early Victorian painter Daniel Maclise, but the crisp delineation of forms and strong colouring show the influence of the German Nazarene painters Peter Cornelius and Johann Friedrich Overbeck, whose work Brown had seen on a visit to Rome in 1845–6; on the same Continental trip he had also admired pictures by Holbein which he saw at Basle.

Brown was particularly keen to render the effects of sunlight accurately, and placed his models in the sun to do so. 'This picture', he wrote in the catalogue to his 1865 solo exhibition, 'is the first in which I endeavoured to carry out the notion, long before conceived, of treating the light and shade absolutely, as it exists at any one moment, instead of approximately, or in generalised style. Sunlight not too bright, such as is pleasant to sit in out of doors, is here depicted.' This pursuit of exactness of lighting was part of the precision of 'truth to nature', and the subject also fitted well with emerging Pre-Raphaelite admiration for an idealised medievalist past. But Brown's choice of Chaucer for his monumentalising canvas should also be seen within a wider context in the 1840s and 1850s. Painters had begun to turn to their own native sources for inspiration, an expression of nationalistic reassertion of the validity of British culture rather than simply employing the Classical myths of ancient Greece and Rome or stories from the Bible. This was the background against which Tennyson would rework the story of the Morte d'Arthur, and it was central, too, for Pre-Raphaelite belief in the emotive potential of English literature.

Brown used a wide mixture of sitters as models for the picture, including Walter Deverell as Thomas of Woodstock and, suitably enough as he was a poet, Rossetti for Chaucer himself, reading aloud 'The Legend of Custance' to Edward III and his court at the Palace of Sheen on the Black Prince's forty-fifth birthday.

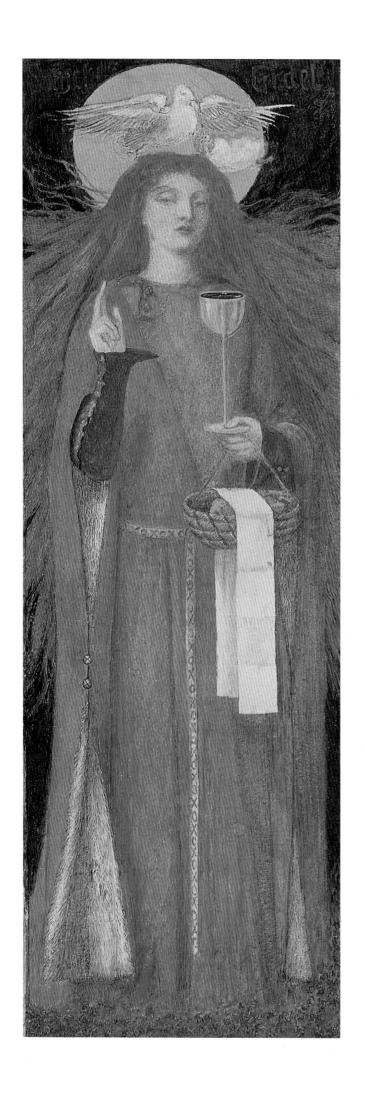

Dante Gabriel Rossetti 1828–82
The Damsel of Sanct Grael 1857

Watercolour 34.9 x 12.7 (13 ¾ x 5)

Purchased with assistance from Sir Arthur Du Cros Bt and Sir Otto Beit KCMG
through the National Art-Collections Fund 1916

Here Rossetti casts Lizzie Siddall in the role of the guardian of the Holy Grail, the mystical cup with which Christ celebrated the first Eucharist at the Last Supper. Rossetti and the other Pre-Raphaelites delighted in Malory's Arthurian tales and Tennyson's reworkings of them, and they formed the subject for many of their pictures. The drawing illustrates the passage:

> And there came a dove, and in her bill a little
> censer of gold,
> And where withal there was such a savour as if all
> the spicery of
> The world had been there. So there came
> a damozel, passing fair and
> Young, and she bare a vessel of gold between her
> hands.

Rossetti makes great play of Lizzie's hair, which fans out wide around her head, and her fair complexion. She holds the Grail in one hand and makes the sign of the benediction with the other. The dove above her symbolises the Holy Spirit, although Rossetti also called Lizzie 'the dove' and it is tempting to speculate that he is representing the joys of his relationship with her as sacramental and religious.

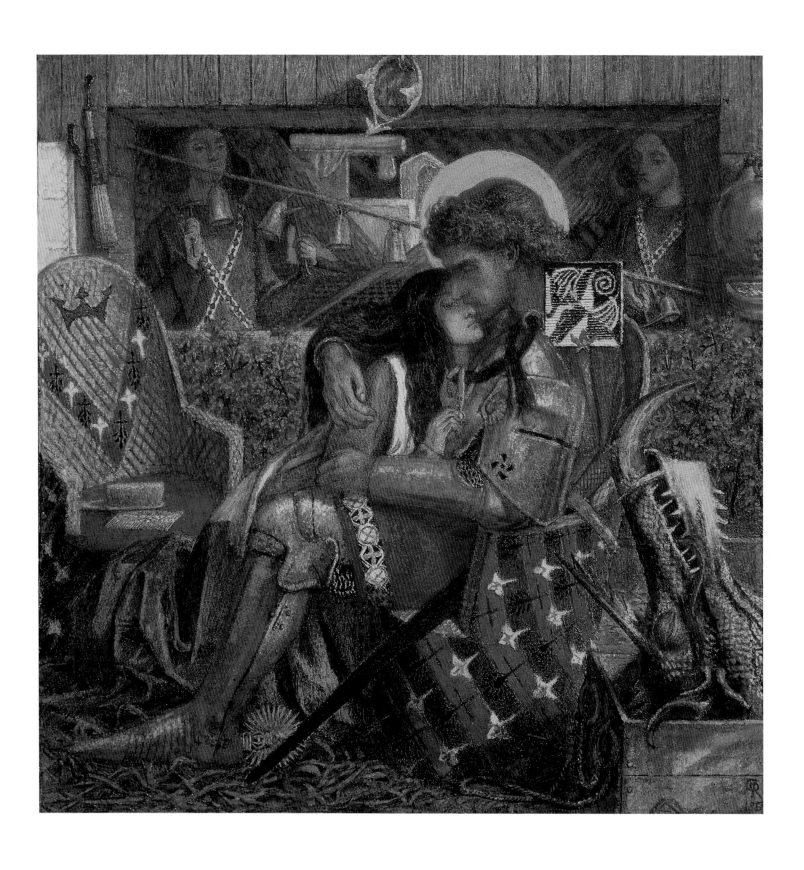

DANTE GABRIEL ROSSETTI 1828–82
The Wedding of St George and Princess Sabra 1857

Watercolour 36.5 x 36.5 (14 ³/₈ x 14 ³/₈)

Purchased with assistance from Sir Arthur Du Cros Bt and Sir Otto Beit KCMG
through the National Art-Collections Fund 1916

Rossetti made this watercolour at a time when his relationship with Elizabeth Siddall was in the balance. Although they had got engaged in 1852, Rossetti was still hedging on naming the day and it was in fact not to be until 1860 that they were finally married. Siddall had grown weary at Rossetti's repeated enthusiasm to wed and then characteristic retreat from commitment. In his own mind he was evidently unsure whether he should go ahead or not, and the theme of marriage sometimes bled into his work from this time. In the autumn of 1857 he was in Oxford, working on the mural decorations of the Union, and spent a great deal of time with Burne-Jones and William Morris. He and Morris had met Jane Burden and, although he was deeply attracted to her, Rossetti stood by as Morris wooed her and eventually proposed marriage. The long, dark tresses of Princess Sabra in this watercolour are very different from Lizzie's, and it appears that Jane Burden must have been the model. Rossetti might appear, then, to be actively wavering in considering his choice of wife. Princess Sabra, rescued from the dragon by St George, has threaded a lock of her hair through his armour, and cuts it free. However, both look not at each other, but into the distance or into themselves, in a pose which is physically close but emotionally distant. In the background two angels ring the marriage bell and the wedding bed has been prepared. In the foreground is the dead dragon's head.

It was in this year that Rossetti developed a new rigour to his medieval watercolours and evolved a way of working where there was little perspectival recession and every section of the composition, laden with decoration and embellishment, is treated absolutely equally. In this way the abandonment of any great narrative can instead be replaced by a sense of evocative mood and sensory atmosphere which is not necessarily related to the ostensible subject. In a letter to William Bell Scott, Rossetti's patron Lady Trevelyan remarked on his new-found enthusiasm for 'subjects which really have no meaning except a vague medievalism, which is very chivalrous and fine once in a way, but not what one wants him spending years of life upon. However he'll come out of that phase' (Nov.1858, quoted Virginia Surtees, *Dante Gabriel Rossetti 1828–1882: The Paintings and Drawings: A Catalogue Raisonné*, Oxford 1971, no.110).

WILLIAM HOLMAN HUNT 1827–1910
The Lady of Shalott 1857

Wood engraving 9.5 x 7.9 (3 ¾ x 3 ⅛)

Presented by Harold Hartley 1925

With his heady mix of medievalism and myth, Tennyson was the Pre-Raphaelite's favourite poet and their treatment of his subjects became part of their collective identity as a self-consciously literary artistic movement. In 1857 the publisher Edward Moxon conceived the idea of an illustrated edition of Tennyson's poems and, among others, commissioned Millais, Rossetti and Holman Hunt to provide designs to be reproduced as wood engravings. Hunt completed six, for which he was paid £25 each. In 'The Lady of Shalott' Tennyson writes of a maiden condemned to live in a tower, weaving a magic tapestry and experiencing life only in the reflections of a mirror. She is forbidden to either view or experience the world at first hand on pain of a fatal curse. Gradually the Lady becomes 'half sick of shadows' and, unable to resist, she turns to look full upon the magnificent knight Lancelot. It is this dramatic movement that Hunt chose to illustrate:

> Out flew the web and floated wide;
> The mirror crack'd from side to side;
> 'The curse is come upon me', cried
> The Lady of Shalott.

Hunt depicts the maiden ensnared in the web-like threads of her tapestry, almost as if these themselves will throttle her, but also symbolising the unknown bonds which have imprisoned her in a stultifying half-existence. But Hunt's lady, whose hair flies wildly about her, seems far from being a passive victim. Tall and powerful, she pulls at the thread, and Hunt seems to suggest that her rejection of the rules of her imprisonment is not simple weakness, but rather an act of rage and defiance. Ambiguously, Hunt also introduces a religious element not mentioned in the text. In a panel next to the mirror Christ on the Cross gazes at the lady, perhaps suggesting that her sufferings offer redemption or perhaps contradictorily symbolising the opportunities for atonement offered by duty and self-denial in the tower.

Hunt's illustration was one of the most dramatic and intriguing designs in the Moxon edition, yet Tennyson was far from pleased with it. Hunt recalled a difficult meeting in which the Poet Laureate demanded:

> 'why did you make the Lady of Shalott, in the illustration, with her hair wildly tossed about as if by a tornado?' Rather perplexed, I replied that I had wished to convey the idea

of the threatened fatality by reversing the ordinary peace of the room and of the lady herself; that while she recognised that the moment of catastrophe had come, the spectator might also understand it. 'But I didn't say that her hair was blown about like that ... Why did you make the web wind round and round her like the threads of a cocoon?' 'Now,' I exclaimed, 'surely that may be justified, for you say – Out flew the web and floated wide; The mirror crack'd from side to side: a mark of the dire calamity that had come upon her.' But Tennyson broke in, 'But I did not say it floated round and round her.' My defence was, 'May I not urge that I had only half a page on which to convey the impression of weird fate, whereas you use about fifteen pages to give expression to the complete idea?' But Tennyson laid it down that 'an illustrator ought never to add anything to what he finds in the text ...' (William Holman Hunt, *Pre-Raphaelitism and the Pre-Raphaelite Brotherhood*, London 1905, II, p.124).

Evidently intrigued by the subject, and perhaps somewhat defiantly, Hunt later made a large painting of the composition now in Wadsworth Athenaeum, Connecticut.

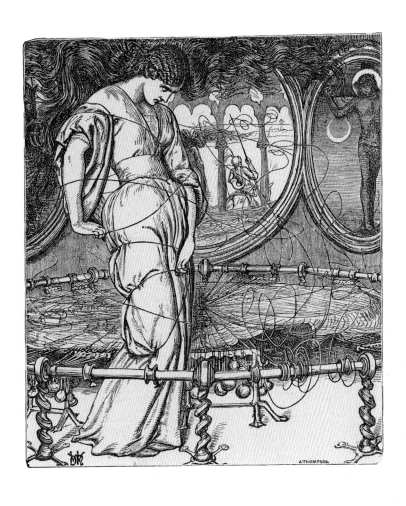

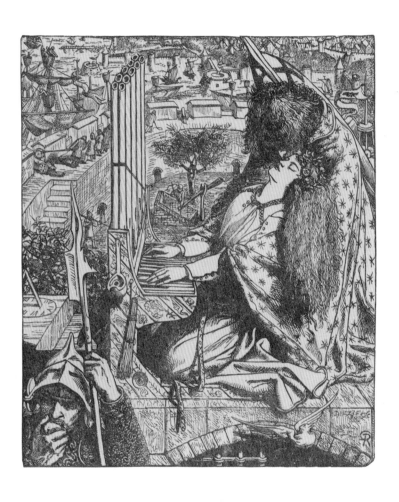

Dante Gabriel Rossetti 1828–82
The Palace of Art, engraved by the Dalziel
Brothers, published 1857

Wood engraving 8.6 x 7.9 (3 ³/₈ x 3 ¹/₈)

Presented by Harold Hartley 1925

Rossetti contributed five plates to Moxon's deluxe illustrated edition of Tennyson. Engraved by the Dalziel brothers, this one was used to accompany 'The Palace of Art' and illustrates the lines:

> Or in a clear-wall'd city on the sea
> Near gilded organ pipes, her hair
> Wound with white roses, slept St Cecily;
> An angel looked at her.

Elizabeth Siddall modelled for the figure of St Cecilia who, as the patron saint of music, plays an organ but falls back into an ecstatic amorous embrace, suggesting parallels between music and sexual rapture. The city in which this takes place is under siege, an allegory of the challenges to the sanctity of the Palace of Art. In the foreground a rough soldier bites into a crisp apple, perhaps a reference to temptation and the Fall of Man. Tennyson is said to have been deeply puzzled by the illustration, which takes an elaborated rather than literal vision of his verses, something with which he took issue elsewhere in the Moxon edition (see no.29).

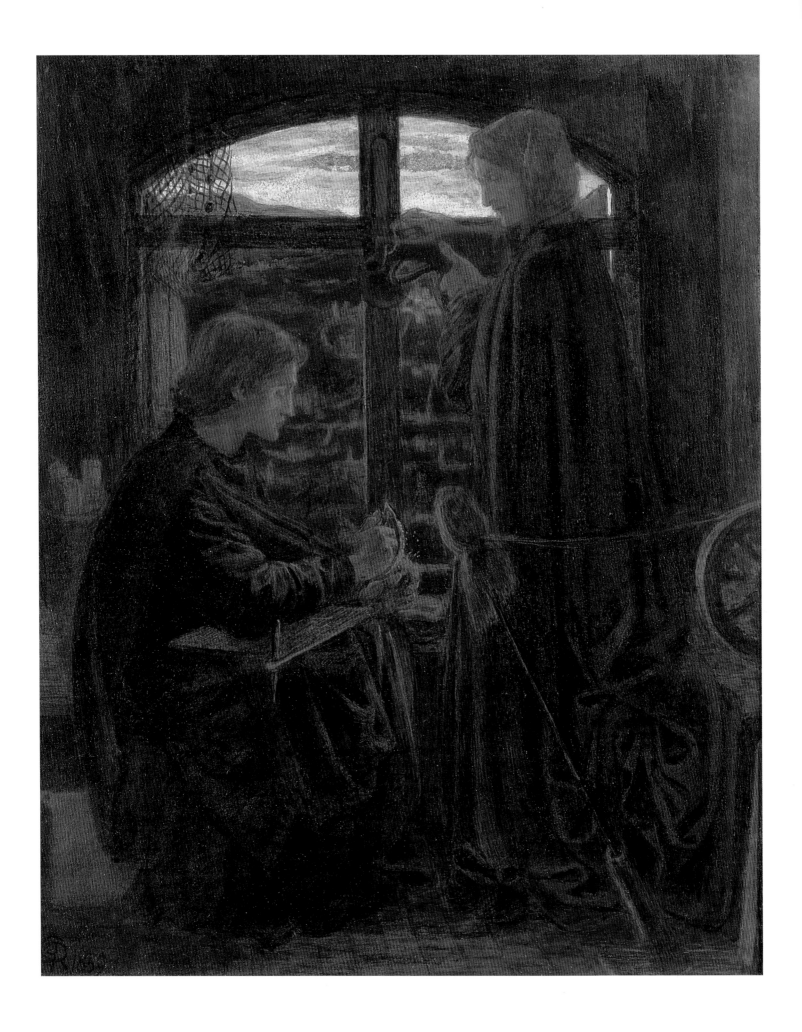

31

DANTE GABRIEL ROSSETTI 1828–82
Mary in the House of St John 1859

Watercolour 38.1 x 31.8 (15 x 12 ½)

Bequeathed by Beresford Rimington Heaton 1940

As originally conceived, this design was to form part of a triptych, with a reworking of *The Girlhood of Mary Virgin* as the centre panel and the other wing showing the Madonna planting a lily and a rose. It was, however, never realised. Rossetti explained that the present subject was

> The Virgin's abode in the house of St John after the crucifixion …The Virgin would be standing in the embrasure of a deep window, at the coming on of twilight, and rising from her work to trim the lamp suspended in the centre … St John seated near her, with his tablets and writing implements on his knees …The motto on the frame might be 'a little while and ye shall not see me, and again a little while and ye shall see me' (quoted Virginia Surtees, *Dante Gabriel Rossetti 1828-1882: The Paintings and Drawings: A Catalogue Raisonné*, Oxford 1971, no.110)

The window mullions form a cross and, in a deeply symbolic act, it is at the centre of this that Mary holds the lamp. Outside, the houses of Jerusalem spread out; the Gospels on which St John toils will spread the light of God through the world. On a more fundamental level this is also an elaboration of God's word being symbolised by light itself, and John holds the tinder to light the lamp.

Rossetti had already addressed this subject in his poem 'Ave' of 1849, and it may be this that suggested his treatment of the watercolour:

> Mind'st thou not (when the twilight gone
> Left darkness in the house of John,)
> Between the naked window-bars
> That spacious vigil of the stars? –
> For thou, a watcher even as they,
> Wouldst rise from where throughout the day
> Thou wroughtest raiment for His poor;
> And, finding the fixed terms endure
> Of day and night which never brought
> Sounds of His coming chariot …

The model for Mary was the actress Louisa Ruth Herbert. Rossetti was enchanted by her and made many drawings of her, writing excitedly in 1858:

> I am in the stunning position this morning of expecting the actual visit … of a model whom I have been longing to paint for years – Miss Herbert of the Olympic Theatre – who has the most varied and highest expression I ever saw in a woman's face, besides abundant beauty, golden hair etc. (Virginia Surtees, *Dante Gabriel Rossetti 1828–1882: The Paintings and Drawings: A Catalogue Raisonné*, Oxford 1971, p.64)

Ellen Terry judged acidly: 'She was not a good actress but appearance was made up to many for her want of skill … very tall, with pale gold hair and the spiritual, ethereal look which the aesthetic movement loved' (quoted Andrea Rose, *Pre-Raphaelite Portraits*, Sparkford 1981, p.102).

DANTE GABRIEL ROSSETTI 1828–82
Fanny Cornforth 1859

Pencil 14 x 14.6 (5½ x 5¾)

Bequeathed by J.R. Holliday 1927

Rossetti reputedly met Fanny Cornforth (1824–1906) in the Strand when, cracking nuts with her teeth, she flirtatiously started throwing the shells at him. Her own account was that Rossetti accosted her in Surrey Gardens and pestered her until she agreed to sit to him. She became Rossetti's confidante, model and mistress, even while his wife Elizabeth Siddall was still alive, and his continuing liaison with her was viewed as one of the principal reasons for their troubled marriage. Fanny was considered vulgar and crooked by Rossetti's friends, but he continued to value her friendship and she was one of the few people to visit him in his final illness.

Rossetti's drawing of Fanny is one of a number he made in 1859 of women other than Lizzie, and it is almost as if in the act of capturing their likeness he was marking the cooling of his affections for her, and his attraction to other women. All of these are similarly composed pictures of heads, where the only subject is the beauty of the sitter. The same year Rossetti went on to paint in oils the first of his aesthetic allegories of feminine allure, *Bocca Baciata* (fig.11), a title taken from lines in Boccaccio's *Decameron* where he states that 'lips that have been kissed lose not their freshness'. This marked a watershed in Rossetti's art; here too the sitter was Fanny Cornforth, set face-on. The drawing was bought by Rossetti's friend George Price Boyce for £2.

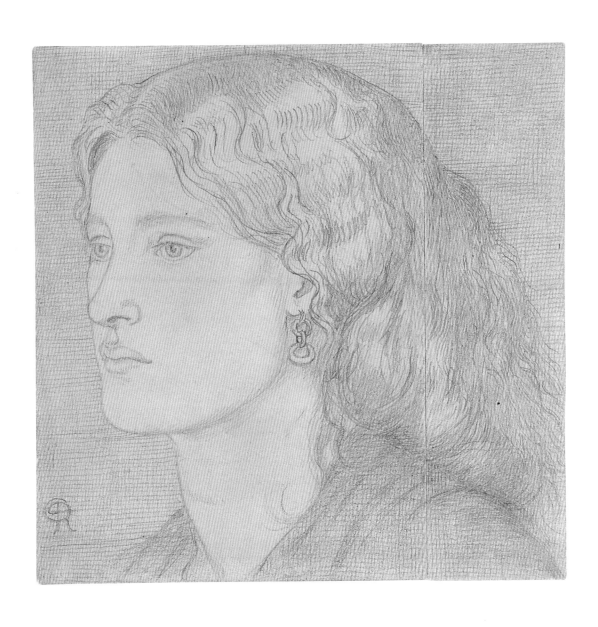

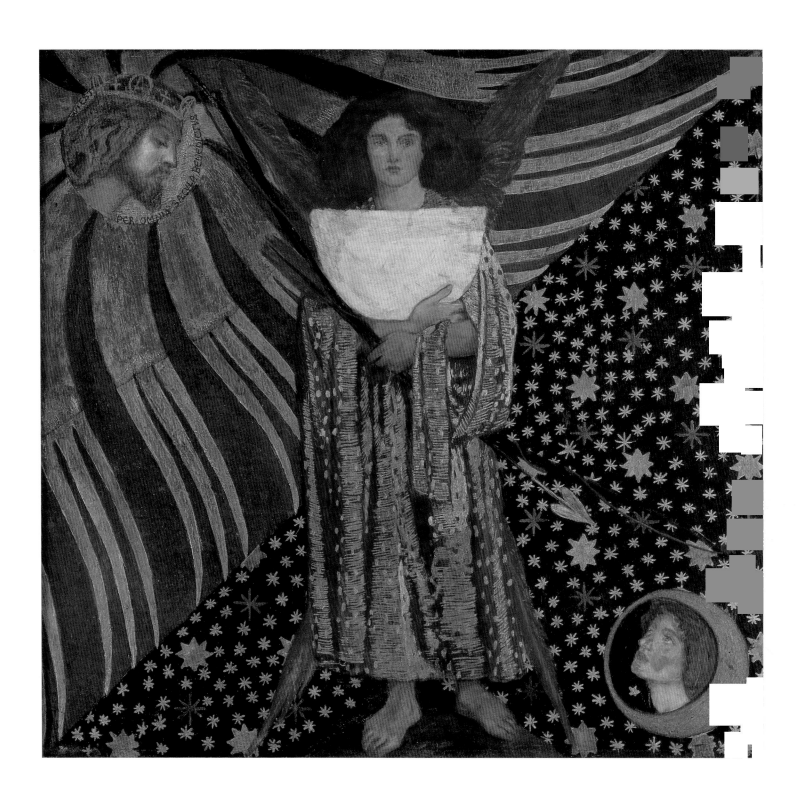

33

DANTE GABRIEL ROSSETTI 1828–82
Dantis Amor 1859–60

Oil on mahogany panel 74.9 x 81.3 (29½ x 32)
Presented by F. Treharne James 1920

This originally formed the centre panel decorating a large settle belonging to William Morris. It is unfinished, and possibly only the heads are by Rossetti. Symbolising the death of Beatrice and her transition from Earth to Heaven, the design creates a sort of heraldic diagram of her union with Christ, but is also a testament of Rossetti's belief that love is the eternal life-force of the universe. The subject of all three panels was Beatrice Portinari, for whom Dante nurtured an enduring but unrequited love, as recounted in the *Vita Nuova*. Rossetti was fascinated by Dante's story – which he translated for his own publication, *The Early Italian Poets* (1864) – and saw in it a parallel with his own love for Lizzie Siddall.

The settle was apparently painted dark red, which would have provided a rich setting for Rossetti's boldly schematic designs. The central panel, *Dantis Amor* (Dante's Love), symbolises Beatrice's death, which occurred between the events depicted in the other two panels, *The Salutation of Beatrice in Florence* and *The Salutation in the Garden of Eden*. Rossetti presented the two Salutation panels to Morris as a wedding present. The earthly Beatrice in the first panel was modelled on Morris's new wife, Jane Burden, with whom Rossetti was also smitten. The heavenly Beatrice in *Dantis Amor*, however,

was modelled on his own wife, Lizzie Siddall.

The picture depicts Beatrice's death and subsequent union with Christ. The scene is divided diagonally, with the haloed figure of Christ looking down from the top left towards Beatrice, enclosed in a crescent moon and surrounded by stars. The central angel holds a sundial, as yet unfinished, but which in a preparatory drawing indicates the number nine, the hour of Beatrice's death. In the drawing Rossetti also inscribed along the line of the diagonal the concluding words of Dante's *Divine Comedy*: 'L'AMOR QUE MVOVE IL SOLE E L'ALTRE STELLE' – 'the love which moves the sun and the other stars' (*Paradiso*, xxxiii, l.145). Despite the realistic representation of the figures, the patterned background is unusually stylised, and it has been suggested that another artist may have intervened in this section of the panel. Some areas remain unfinished: for example, the crescent moon enclosing the Head of Beatrice was to have been inscribed with lines from *La Vita Nuova*: 'QVELLA BEATA BEATRICE CHE MIRA CONTINVAMENTE NELLA FACCIA DI COLVI' – 'That Blessed Beatrice who continuously gazes at Him.' The lines carry on into Christ's halo: 'QVI EST PER OMNIA SAECVLA BENEDICTVS' – 'Who is blessed throughout eternity.'

DANTE GABRIEL ROSSETTI 1828–82
Arthur's Tomb 1860

Watercolour 23.5 x 36.8 (9 ¼ x 14 ½)

Presented by the National Art-Collections Fund 1916

Rossetti's first Arthurian subject was taken from book XXI of Malory's *Morte d'Arthur*:

And whan queen Gwenyver understood that kynge
Arthure was dede ... she wente to Amysbyry. And there
She lete make herselff a nunne, and wered whyght
Clothys and blak ...Than sir Launcelot was brought
Before here: than the queen seyde to all tho ladyes.
'Thorow thys same man and me hath all thys warre be
wrought ... thorow oure love that we have loved togydir
ys my moste noble lorde slayne ... therefore, sir
Launcelot, I require the and beseche the hartily ... that
Thou never se me no more in the visayage' ...
[Launcelot]:
'madame, I praye you kysse me, and never no more'.
'Nay', sayd the queen, 'that shal I never do, but absteyne
you from suche werkes.'
And they departed ...
(E. Vinaver, *The Works of Sir Thomas Malory*, 1962
pp.873, 876, 877)

Rossetti heightens the impact of the scene by visualising it taking place over Arthur's tomb, underlining his obsession with the theme of illicit love and connection with death. There are a number of symbols which, in a neat typological recasting of the scene, liken it to the temptation in the Garden of Eden – in the left corner are a snake and an apple, and the incident takes place under an apple tree, the tree of temptation. But unlike Eve, Guinevere stands firm against her tempter, having seen the damage that giving in can bring. She pushes Lancelot away from her and also from the effigy of Arthur, which he profanely smothers. Along the tomb are earlier scenes from the story: on the left Arthur and Guinevere knight Lancelot, while on the right the Holy Grail appears to the Knights of the Round Table.

This is a replica of the first version of the watercolour which Rossetti made for Ruskin in 1855. The subject of new resolve and spiritual rebirth might be related to Holman Hunt's *The Awakening Conscience* (no.12).

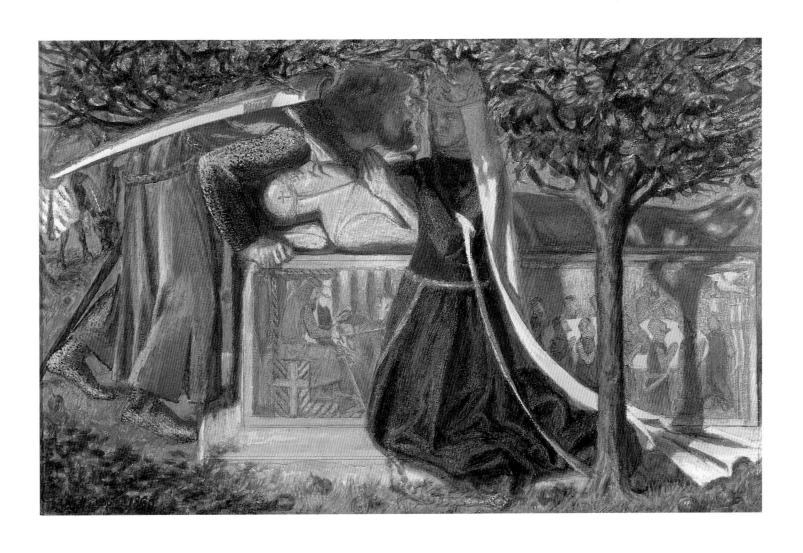

Arthur Hughes 1832–1915
Aurora Leigh's Dismissal of Romney
('The Tryst') 1860

Oil on board 39.4 x 31 (15 ½ x 12 ¼)

Bequeathed by Beresford Rimington Heaton 1940

Ellen Heaton, a patron of Rossetti, commissioned this painting for £30 on the recommendation of Ruskin, who told her that Hughes was 'quite safe – *every*-body will like what he does … his sense of beauty is quite exquisite' (*Sublime and Instructive. Letters from John Ruskin…*, ed. Virginia Surtees, 1972, p.175). It was Ellen Heaton who dictated the subject, based on the long narrative poem *Aurora Leigh* (1856) by her friend Elizabeth Barrett Browning. Aurora, an orphan raised by her aunt, aspires to be a poetess. On the morning of her twentieth birthday she rejects a marriage proposal from her cousin, Romney Leigh. She chooses to devote herself to her vocation in defiance of Romney, who disparages her verses and wants her to dedicate herself instead to his philanthropic causes to alleviate poverty. Aurora tells him that what he loves 'Is not a woman, Romney, but a cause: You want a helpmate, not a mistress, sir. A wife to help your ends; in her no end!' Hughes depicts the moment of Romney's rejection, while Aurora holds a book of her poems that he has found and made fun of. The white lilies represent Aurora's virginal status, and allude to her future single life, devoted to her art. The poem is not autobiographical, nor is it simply a treatise on the rights of women: it also examines pressing contemporary concerns surrounding poverty and the failures of utopian socialism. The narrative's resolution comes with both Aurora and Romney realising that they have taken a too limited view of humanity – she through her commitment to her art and her rejection of love, and he through trying to alleviate only the physical condition of the poor.

Hughes had a difficult time with his patron, who wished him to show an earlier moment before Aurora has decided on her rejection; she also objected to Aurora's turquoise dress, which Hughes had chosen to match the landscape instead of the white one mentioned in the poem. But Ruskin defended him and Ellen Heaton was reconciled to the picture enough to commission another.

Hughes appears to have used himself as the model of Romney, and his wife Tryphena for Aurora.

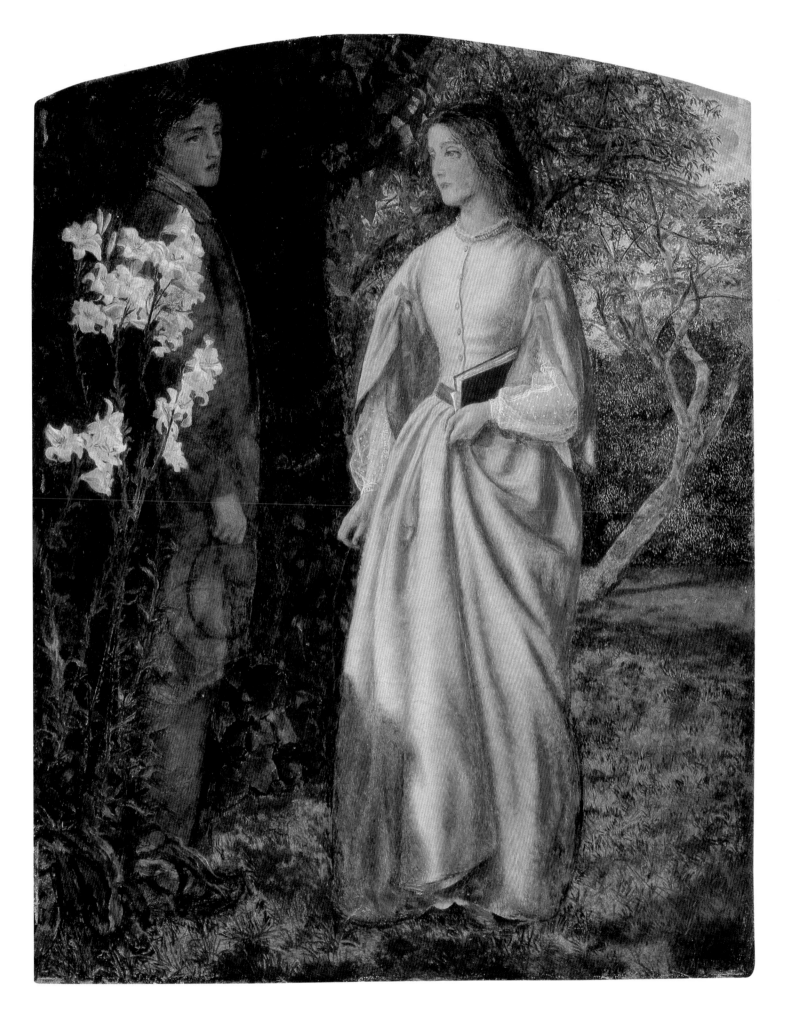

Edward Coley Burne-Jones 1833–98
Sidonia von Bork 1560 1860

Watercolour and bodycolour 33.3 x 17.1 (13 ⅛ x 6 ¾)

Bequeathed by W. Graham Robertson 1948

Sidonia is the evil anti-heroine of the Gothic shocker *Sidonia von Bork, die Klosterhexe*, a novel set in the sixteenth century, which charts the destruction of the house of Pomerania. Men fall hopelessly in love with the irresistibly beautiful and limitlessly cruel Sidonia before she crushes them using supernatural powers; she is eventually burnt as a witch aged eighty. Published in 1847–8, the book was claimed by its author, the Swiss clergyman Wilhelm Meinhold (1797–1851), to be a true story which he had discovered in an original manuscript, a traditional foible of Gothic novels. It was quickly translated into English, by Oscar Wilde's mother, and appeared in 1849 as *Sidonia the Sorceress*. Burne-Jones may have been introduced to the book by Rossetti, who had a 'positive passion' for the novel, according to his brother William, and Gabriel himself wrote to William Allingham that *Wuthering Heights* was 'the first novel I've read for an age, and the best, as regards power and sound style for two ages, except *Sidonia*' (*The Letters of D.G. Rossetti*, ed. Oswald Doughty and J.R. Wahl, Oxford 1965–8, I, p.224). Swinburne, too, was deeply fascinated by the story, for Sidonia fitted the Rossetti circle's love of both the supernatural and the archetypal *femme fatale*.

In Burne-Jones's watercolour Sidonia, aged twenty, contemplates her next act of malevolence. In his preface Meinhold claims to have seen a portrait of Sidonia, 'evidently of the school of Louis Kranach', and Burne-Jones follows certain details of the description such as 'a gold net … drawn over her almost golden hair … in her hand she carries a sort of pompadour of brown leather … her eyes and mouth are not pleasing, notwithstanding their great beauty – in the mouth, particularly, one can discover an expression of cold malignity'. In fact, Burne-Jones appears to have modelled Sidonia partly on Rossetti's mistress Fanny Cornforth, and this may have been an allusion to complaints about her manipulative abilities. Crawling over Burne-Jones's signature in the corner, the spider relates to Sidonia's powers of ensnarement. Burne-Jones abandoned Meinhold for Sidonia's elaborate strap-work dress, which looks like a mass of writhing snakes. For this the inspiration was a menacing portrait of Isabella d'Este by Giulio Romano he had seen at Hampton Court, and from this he also adopted the device of figures seen in the background through a doorway.

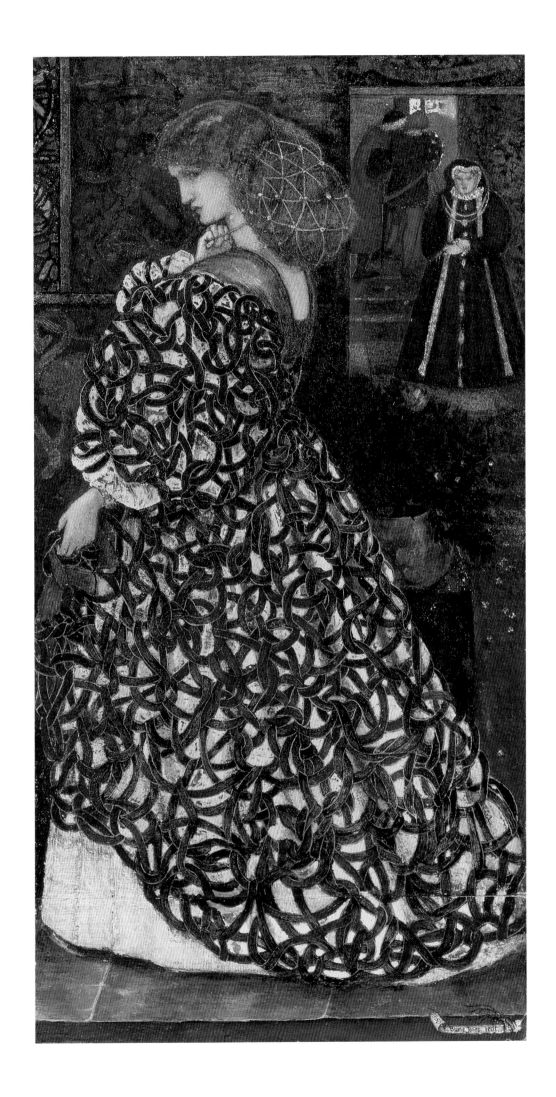

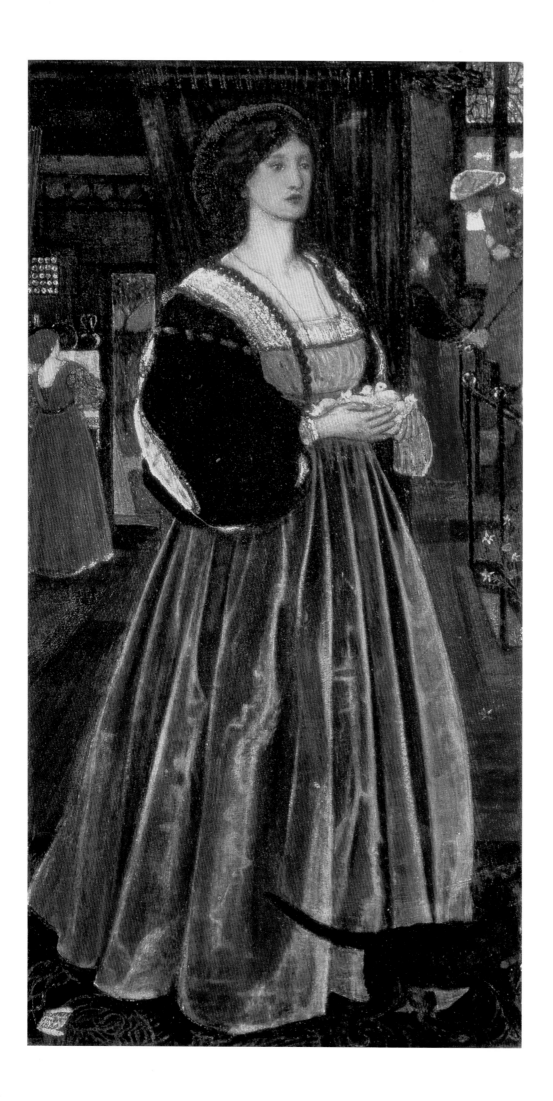

EDWARD COLEY BURNE-JONES 1833–98
Clara von Bork 1560 1860

Watercolour and bodycolour 34.2 x 17.9 (13½ x 7)

Bequeathed by W. Graham Robertson 1948

Whereas Fanny Cornforth was the model for Sidonia, for Clara Burne-Jones turned to his fiancée, Georgiana Macdonald. Clara von Dewitz marries Sidonia's high-minded cousin, Marcus von Bork, and is as good as the central character is evil. Meinhold describes her as 'intelligent, courageous, and faithful, with a quiet, amiable disposition, and of most pious and Christian demeanour'. Burne-Jones demonstrates her character by portraying her protecting a group of fledglings from a malevolent cat, who is clearly the witch Sidonia's familiar. Clara has an open facial expression, and is turned towards the viewer, in contrast to Sidonia, who is shown turned half away and with a scheming look. Despite saving Sidonia when she is caught out, Clara suffers a terrible end: Sidonia gives her a potion which simulates death, and she is buried alive. The two characters of Sidonia and Clara seem to embody the polarities of Victorian female stereotypes: on the one hand the virtuous but dull image of perfection; on the other, the rapacious *femme fatale*, exciting and alluring but ultimately destructive – each archetype as misogynistic as the other.

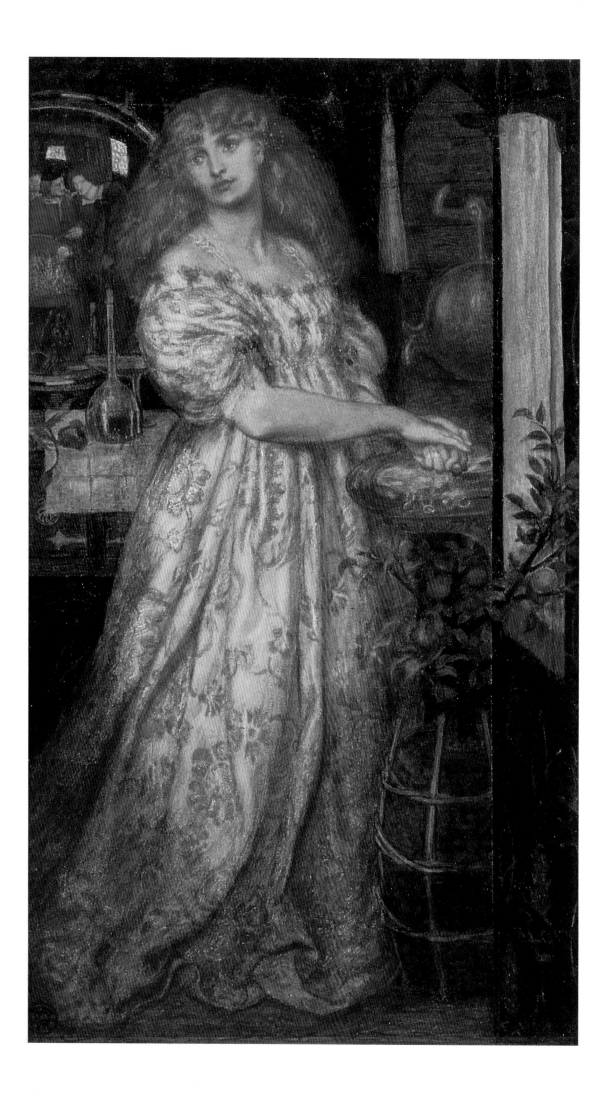

38

Dante Gabriel Rossetti 1828–82

Lucrezia Borgia 1860–1

Pencil and watercolour 43.8 x 25.8 (17 ¼ x 10 ⅛)

Presented in memory of Henry Michael Field by Charles Ricketts through the National Art- Collections Fund 1916

Rossetti began work on this subject in 1860 at a time when he was especially interested in the history of the notorious Borgia family. In his watercolour Lucrezia Borgia washes her hands after poisoning her husband, Duke Alfonso Bisceglie. She is aided in the crime by her father, Pope Alexander VI, and the reflection in the mirror shows him assisting the Duke to walk, thereby ensuring that the poison thoroughly infects his entire body. Burne-Jones was painting the evil heroine Sidonia von Bork (no.36) in the same year, and the two pictures have a very similar format. Each has a common source in the portrait of Isabella d'Este at Hampton Court, which Rossetti and Burne-Jones saw together. Many years after finishing the watercolour, Rossetti revised the details of Lucrezia's face. On the table in the background stands the carafe of wine with which she has done her wicked work, and beside it sits a poppy, a symbol both of the drug and of death.

The orange tree is intentionally ironic: orange blossom is the conventional decoration for the bride at a wedding and is a symbol of purity and innocence; the orange itself, seen here, is said to be an emblem of fruitfulness and hope. Lucrezia's act of washing her hands is also a reference to Pontius Pilate, and casts her husband in the role of a sacrifice. Rossetti had a life-long fascination for the subject of *femmes fatales* and temptresses, and it is in this context that Lucrezia must be seen. She is successful because of her beauty and physical allure, and also because of men's weak inability to resist her.

As well as being best known as a notorious poisoner, Lucrezia Borgia (1480–1519) was an important Renaissance patron of the arts. Born in Rome, she was the daughter of Rodrigo Borgia, later Pope Alexander VI, and sister of Cesare Borgia. Lucrezia's father arranged three marriages for her for political reasons.

FREDERICK SANDYS 1829–1904
Oriana 1861

Oil on panel 25.1 x 19 (9⁷⁄₈ x 7¹⁄₂)

Purchased with assistance from the Abbott Fund 1984

Sandys took the subject for this picture from an early poem by Tennyson, 'The Ballad of Oriana', published in the 1857 Moxon edition of his works. In the poem Oriana stands on the wall of a castle, watching her betrothed in a battle below. An arrow meant for the knight strays, killing her instead. Sandys does not attempt to illustrate Tennyson's poem, but refers obliquely to just one line of the ballad: 'She stood upon the castle wall.'

Sandys became acquainted with the Pre-Raphaelites in 1857 and was much respected by them, although he always remained on the fringes of the group and later quarrelled bitterly with Rossetti, who accused him of plagiarising his pictures. Holman Hunt made two illustrations to 'Oriana' for the Moxon Tennyson, but they bear no stylistic similarities to Sandys's painting.

The artist's interest in fifteenth-century Flemish painting, particularly that of Rogier van der Weyden and Jan van Eyck, is apparent in the minute observation of the sitter's skin, hair and clothing, and in the detailed background landscape. Sandys toured Belgium and Holland the year after painting *Oriana*. The bridge with a castle in the background, which suggests a European setting, was actually based on Bishop's Bridge in the artist's native Norwich. The same bridge also figures in *Autumn*, which Sandys was probably working on at the same time as *Oriana*.

The texture of rich fabrics, such as the brocade in the cloak, had a recurring fascination for Sandys. The Clabburn family, internationally renowned shawl manufacturers, lived in Thorpe, near Norwich, and patronised the artist; *Oriana* was in the collection of William Houghton Clabburn until his death in 1889. He probably bought the painting when it first appeared at the Royal Academy in 1861. Sandys' only other exhibit that year was a portrait of Mrs Clabburn, painted in 1860.

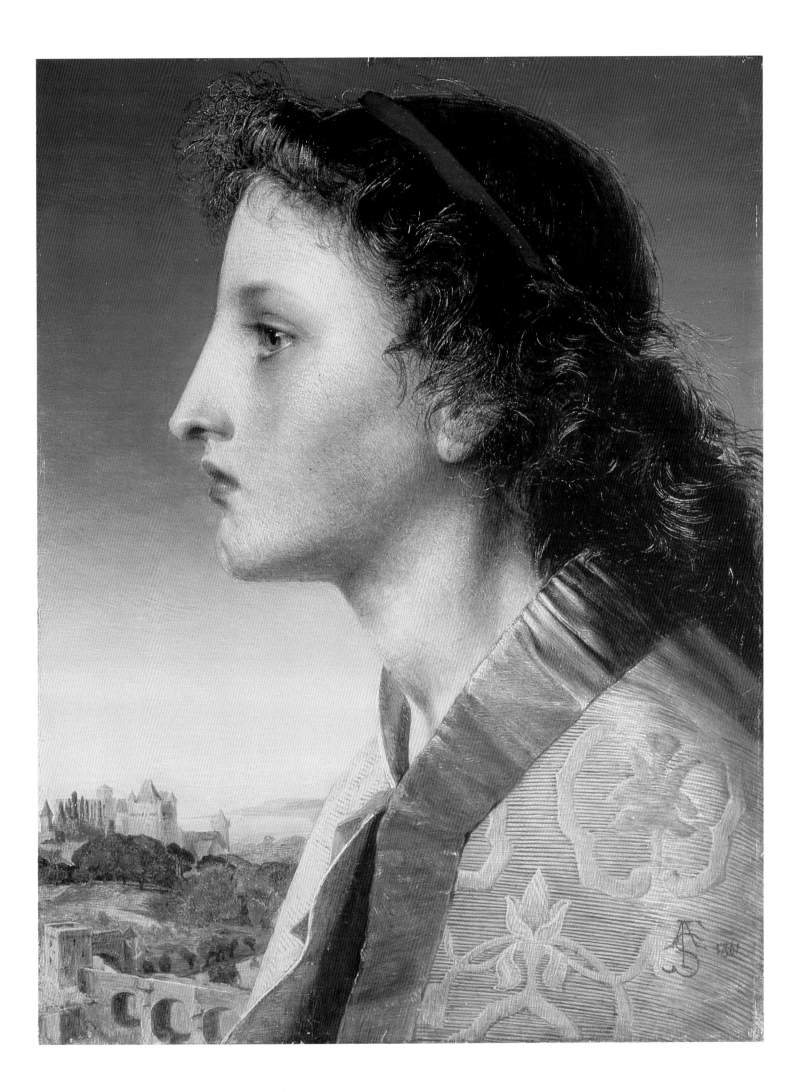

Edward Coley Burne-Jones 1833–98
The Annunciation and the Adoration of the Magi 1861

Oil on canvas triptych
108.6 x 73.7 (42¾ x 29), 109 x 156 (42⅞ x 61⅜),
108.6 x 73.7 (42¾ x 29)

Presented by G.H. Bodley in memory of George Frederick Bodley 1934

Burne-Jones owed one of his most important early commissions to a complaint in the *Ecclesiologist*. This religious journal pointed out the lack of focus on the altar in the Church of St Paul's in West Street, Brighton, which had been designed by Richard Cromwell Carpenter and built between 1846 and 1848 in a restrained Gothic Revival style. The architect George Frederick Bodley, who was on friendly terms with Burne-Jones, was commissioned to provide a reredos in response to the *Ecclesiologist* but, as Georgiana Burne-Jones recalled, he 'unselfishly suggested the church should have a painted altarpiece instead ... and that Edward should be the artist employed' (*Memorials*, I, p.124). Having completed the triptych shown here, Burne-Jones painted a second version which made the figures more prominent so that they could be seen from afar in the large church, and this was the one used.

For the prime version Burne-Jones employed his friends as models. The Virgin is Jane Morris, and kneeling before her is her husband William. Swinburne appears on the right as a shepherd, playing bagpipes – traditional rustic instruments, but also perhaps a reference to his Border origins, although Northumbrian pipes do not have a mouthpiece. Behind him is Burne-Jones himself as another shepherd; the kneeling king in armour is the Italian organ-grinder and artist's model, Ciamelli, and the handsome black king is also likely to have been a professional model. Joseph may perhaps be Ford Madox Brown. The figure on the far left holds holly and mistletoe, long-standing Christmas emblems, but also links to earlier pagan traditions.

The Adoration is flanked by a pair of panels which show the event which foreshadowed it, the Annunciation. On the left the Angel Gabriel kneels and raises a hand in benediction, while on the other panel Mary is shown with the white lily which symbolises her purity. Between Mary and Gabriel is bush of pink roses, symbols of love but also an attribute of the Virgin, one of whose titles is 'The Mystical Rose'. Behind them is a tree bearing fruit, which refers to the act of creation and fertility.

Burne-Jones worked on the triptych at the same time as Rossetti was making his *Seed of David* triptych for Llandaff Cathedral. The two were on close terms and their pictures are similar in subject, overall conception and in their richness of detail and symbolism.

The triptych had an unusual history. It was given to the executors of Burne-Jones's recently deceased patron, Thomas Plint, in return for money the artist had received in advance for work not yet undertaken. What happened next is unclear, but according to one account the picture was sold by Plint's family to a man who poisoned himself within a year, the third owner shot himself two years later and the painting was sold together with a bundle of stair rods for £7 to a builder. By a strange coincidence the builder was working for George Frederick Bodley who, recognising it, bought it for £50 (Ronald Parkinson, 'Two Early Altar-Pieces by Burne-Jones', *Apollo*, Nov. 1975, pp.320–3). It was presented to the Tate by Bodley's son.

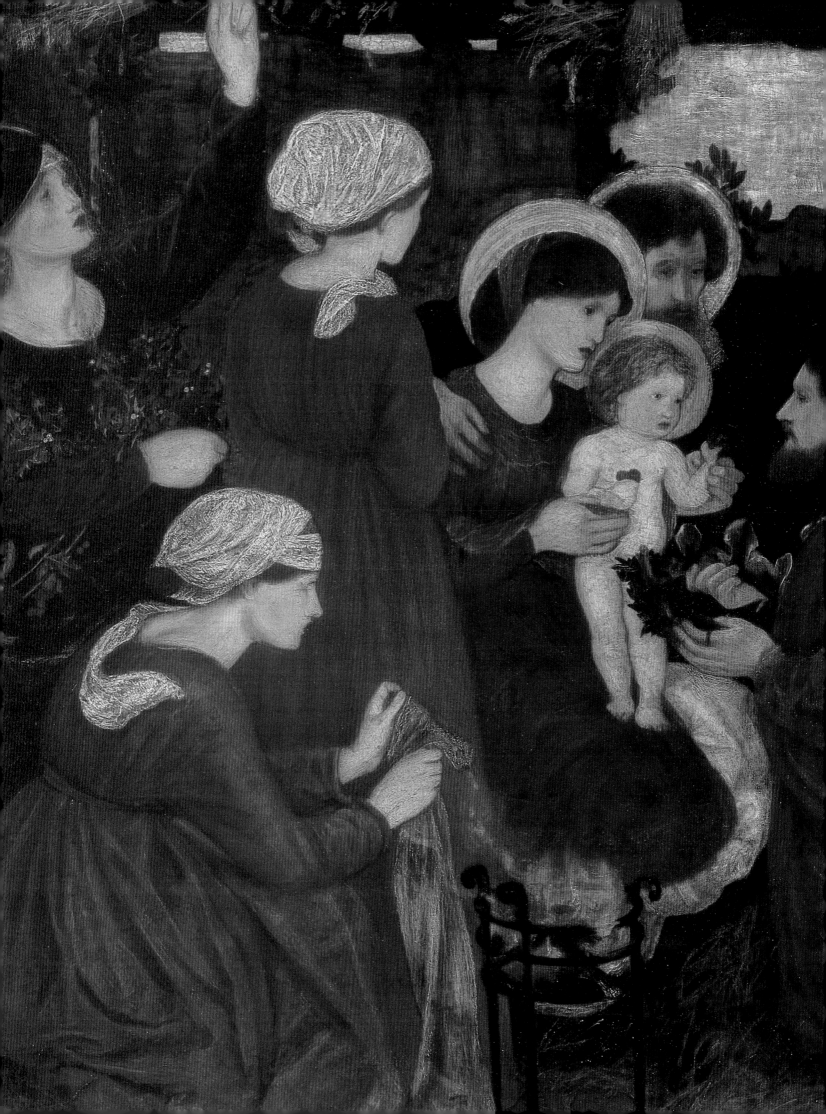

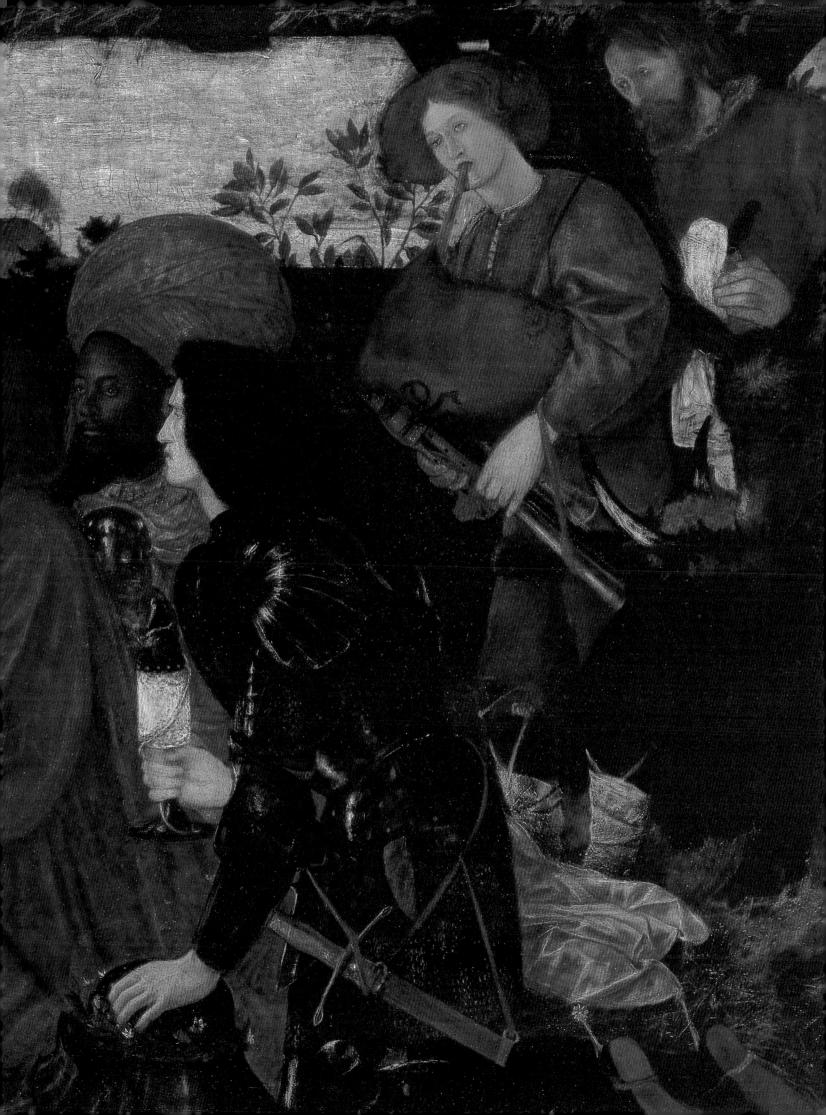

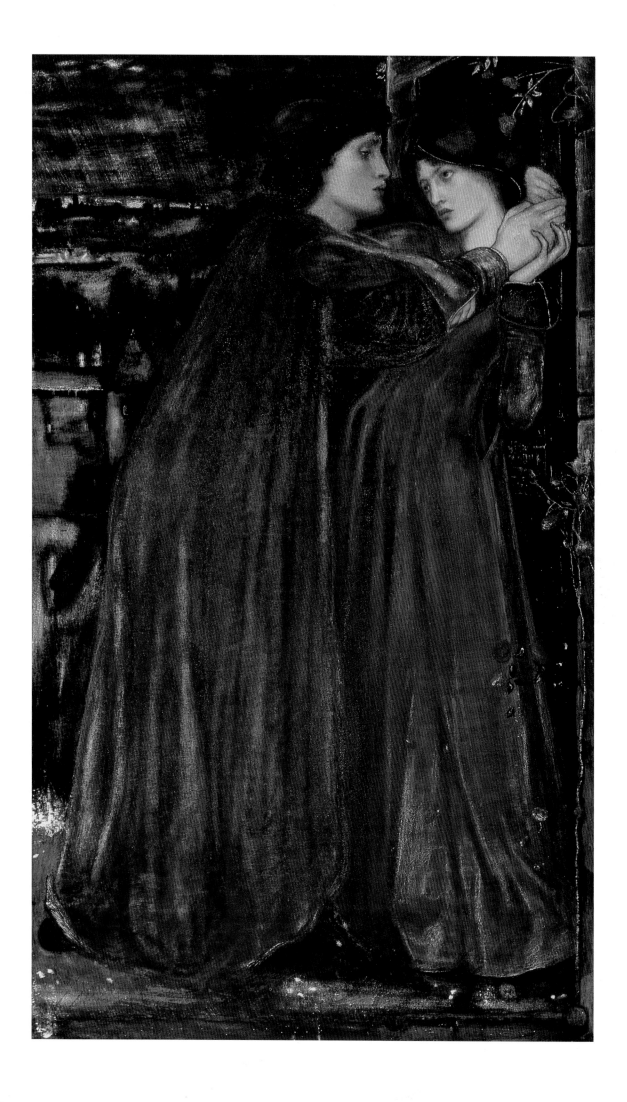

Edward Coley Burne-Jones 1833–98
Clerk Saunders 1861

Watercolour 69.9 x 41.8 (27 ½ x 16 ½)

Presented by Mrs Wilfred Hadley through the National Art-Collections Fund 1927

Among the Rossetti circle there was intense interest in ancient native folk ballads, particularly those collected by Sir Walter Scott and published as *Minstrelsy of the Scottish Border* (1802–3). The tragic story of Clerk Saunders and his sweetheart Mary Margaret was a favourite. In 1856 Elizabeth Siddall made a watercolour of the subject, and Swinburne rewrote the story for his own collection, *Ballads of the English Border*. Burne-Jones and Swinburne were close at this time, and it seems likely that they discussed the story. The moment Burne-Jones chose to portray is the fatal instant of choice, the decision leading to the violent climatic denouement of the story. Clerk Saunders, soaked to the skin on a rainy night, entreats Mary Margaret to let him come in to sleep. She repels him half-heartedly, and Burne-Jones vividly depicts in her expression and pose her mental struggle between discipline and desire. Saunders is discovered in her bed and, while spared by six of Mary Margaret's brothers, he is slain by the seventh. Scott's version of the ballad ends eerily with Saunders rising from his grave to appear at Mary Margaret's window to bid her goodbye; she asks him to kiss her in parting but he resists the temptation, telling her:

> My mouth it is full cold, Margaret,
> It has the smell, now, of the ground,
> And if I kiss your comely mouth,
> Thy days of life will not be long.

The models in Burne-Jones's watercolour appear to be William and Jane Morris; William Morris may also have designed their costumes.

Edward Coley Burne-Jones 1833–98
Woman in an Interior *c.*1861

Pencil and watercolour 22.5 x 31.8 (8⅞ x 12½)

Purchased 1924

Although the subject of this study remains unidentified, its handling and its focus on a single figure in an interior setting relates it to Burne-Jones's two watercolours illustrating the story of Sidonia von Bork (nos.36, 37). As in the portrait of Sidonia, Burne-Jones's model was most probably Fanny Cornforth, Rossetti's mistress (see no.32). Indeed, the subject of ripe feminine beauty and flowing red hair is clearly indebted to Rossetti, who in the 1860s had embarked on a series of abstracted or allegorical portraits of this type without narrative. The sitter in Burne-Jones's picture similarly looks out with a gaze that is at the same time introspective or self-absorbed, lost in thought or self-contemplation. The rich hanging in the background depicting fruit is very similar to the fabrics, tapestries and wallpapers that William Morris was to produce.

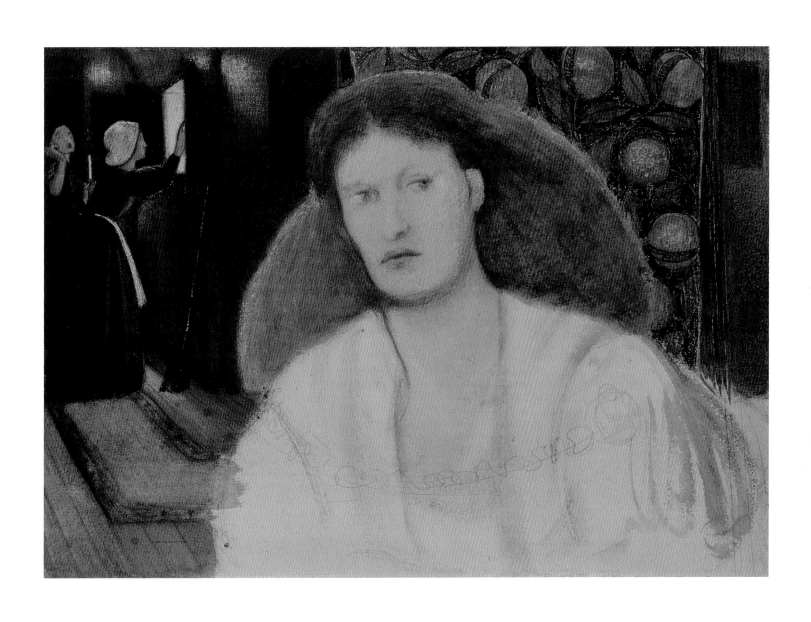

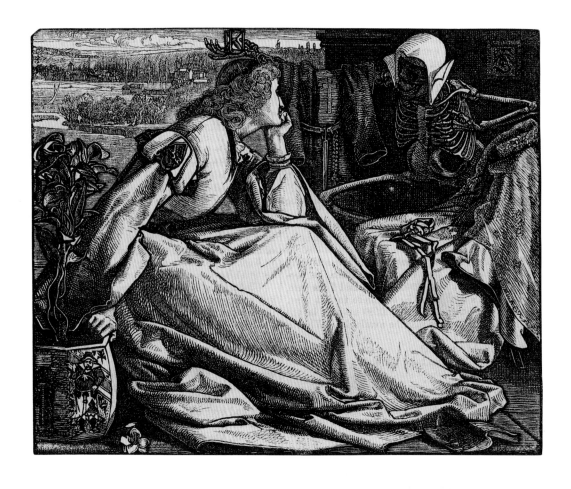

43
FREDERICK SANDYS 1829–1904
Until her Death 1862

Wood engraving and pencil 10.5 x 14 (4 ⅛ x 5 ½)

Presented by J.R. Holliday 1927

Sandys produced this plate as an illustration for the poem 'Until her Death' by Dinah Maria Mulock (1826–87), best known as the author of the novel *John Halifax, Gentleman* (1856). It was published in the Dalziel brothers' magazine *Good Words* in October 1862 (p.312). A highly fanciful poem, it speculates whether Death will come to the narrator 'soon or late' and if she will face him alone or loved; whatever, the event is of no consequence, however, because she has faith in the Resurrection. Sandys explained his illustration in a letter to the Dalziels:

> The poem ... is very beautiful but almost impossible fairly to illustrate. I have chosen to represent a fair maiden choosing the path she will pursue 'Until her Death'. Death himself is holding up a nun's dress and fitting on his own head her hood ... On a chair by his side is a brides dress, wreath and vail [*sic*], a child bauble and bells lying on it ... To all thoughtful purchases of Good Words this will be understood. For the rest it signifies nothing (quoted Betty Elzea, *Frederick Sandys 1829–1904: A Catalogue Raisonné*, 2001, Woodbridge, no.2.B.53).

Sandys's design was evidently inspired by Dürer's famous print *Melancholia* (1514), while the skeleton derives from Holbein's *Dance of Death* illustrations (1524–6). The unconcernedly relaxed pose of the woman and the inclusion of a Chinese pot and plant suggest Sandys's familiarity with the aesthetic compositions of Albert Moore and James McNeill Whistler.

ROBERT BRAITHWAITE MARTINEAU 1826–69
The Last Day in the Old Home 1862

Oil on canvas 107.3 x 144.8 (42¼ x 57)

Presented by E.H. Martineau 1896

The Pulleyne family has been forced to sell the ancestral home, Hardham Court, and its contents, thanks to the irresponsible behaviour of a feckless spendthrift. Typical of the social moralist subjects popular in Victorian art, the picture contains a number of visual clues which, when taken together, form an elaborate narrative. Family portraits and items of furniture bearing the initials of previous Pulleynes indicate that the family has a long pedigree. The miniature case in the father's hand and the sporting print in the left foreground tell us that he has gambled his inherited fortune away on horses. Lot numbers have been attached to various items of furniture and works of art and, together with the Christie's catalogue on the floor, they reveal that the family's possessions are soon to be sold. In the background a man is already gathering the objects that will be sent for auction. On the left an old woman, probably the grandmother, is giving a £5 note to the butler, who is clutching the keys to the house. A newspaper protrudes from the blotter beside her, with the word 'Apartments' clearly visible. The moral is clear: gambling only leads to debt, and the accumulated wealth of centuries can be lost in one generation. Despite the hopelessness of their situation, only the women in the family appear concerned; it is they who discharge the necessary duties and take responsibility. The man – who we learn from the sale catalogue is Sir Charles Pulleyne – raises a glass of champagne with his son, preferring to live for the moment. Sir Charles rests one foot carelessly on an antique chair and puts his arm around his son's shoulders. The implication is that he will pass his hedonistic lifestyle and gambling habit down to the next generation. The view out of the window, however, indicates that this family has reached the autumn of its life, and the bare branches of winter are tapping on the pane. The fire is low in the grate, and it will not be long before they are completely bereft. Indeed, this was not an infrequent occurrence in a period when the aristocratic landed families were declining in favour of a new class whose wealth was based on industry and manufacture rather than unprofitable ancient tithes and agriculture.

A pupil of William Holman Hunt, Martineau appears to have inherited his teacher's interest in social themes, as well as the Pre-Raphaelite taste for painstaking detail. The dark interior reflects the Victorian taste for heavy oak furniture and carved panelling, and yet the picture is also characterised by bright colour and contrasting patterns and textures. The richly carved mantel is based on that of the Great Chamber of Godinton Park in Ashford, Kent. This house was the seat of the Toke family from 1440 to 1895.

The 1860s saw the Temperance movement at its peak, and this adds another dimension to the picture, most notably in the offering of alcohol to the young boy. One of the key messages of Temperance campaigners was the role alcohol played in gambling recklessly and ultimate poverty and family collapse. This was a warning usually directed at the poor, but Martineau, who would have been aware of such arguments, here shows such phenomena crossing notional boundaries of class.

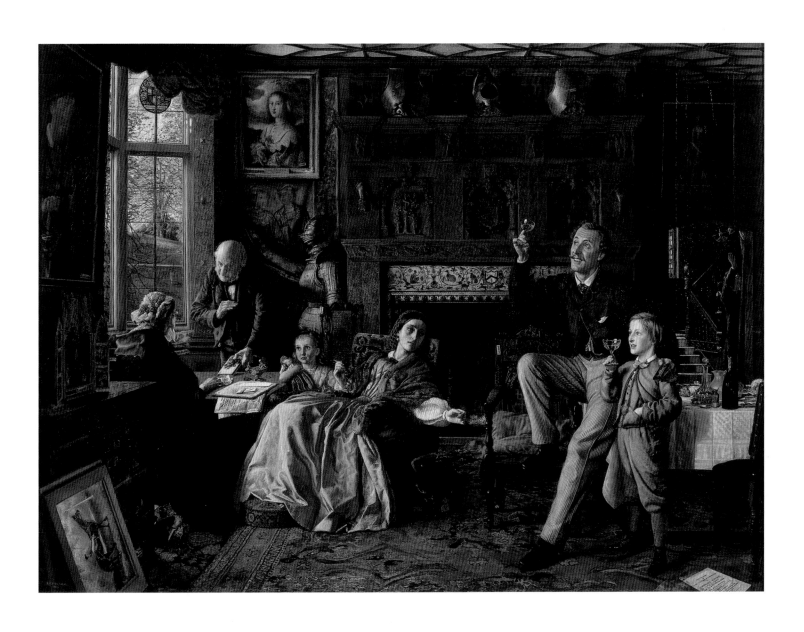

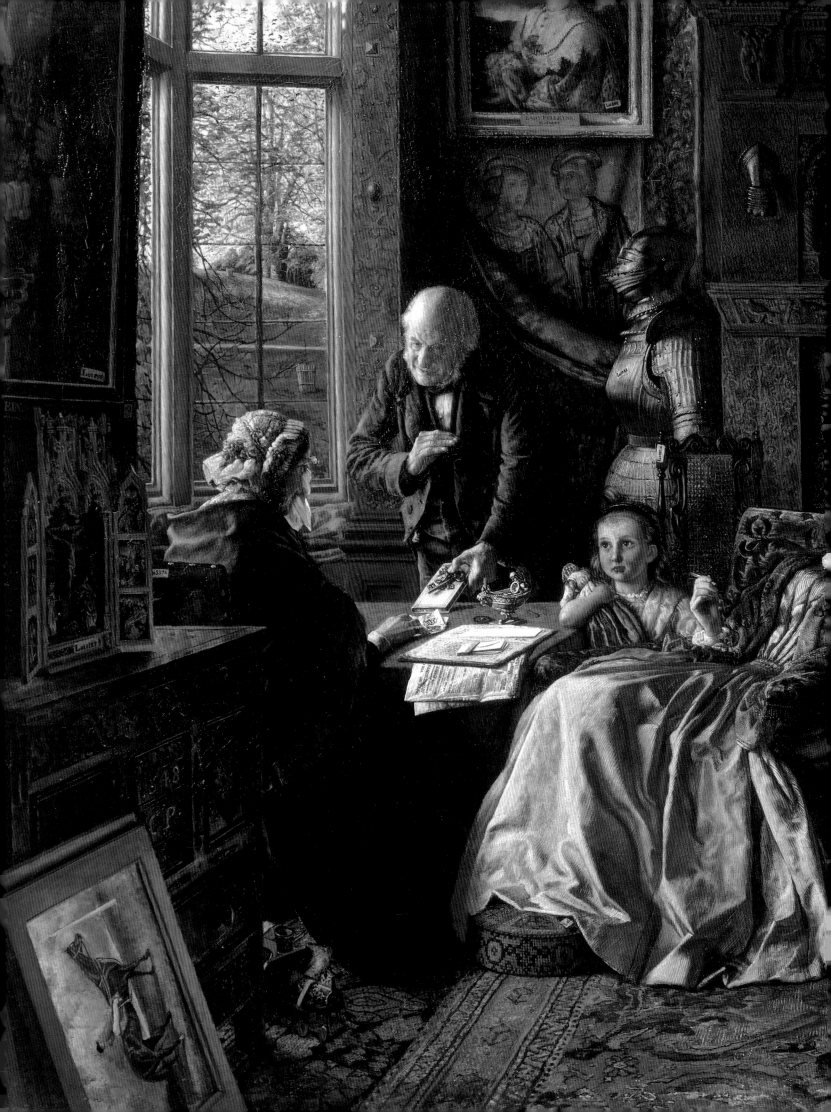

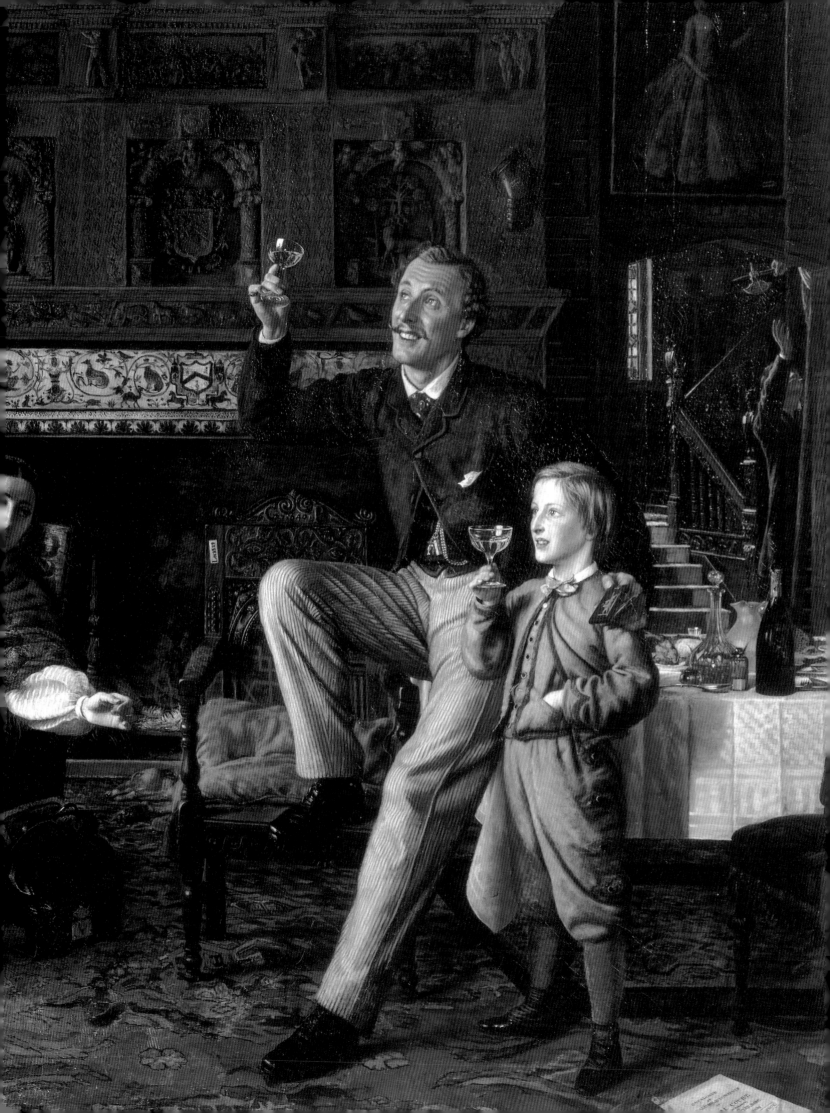

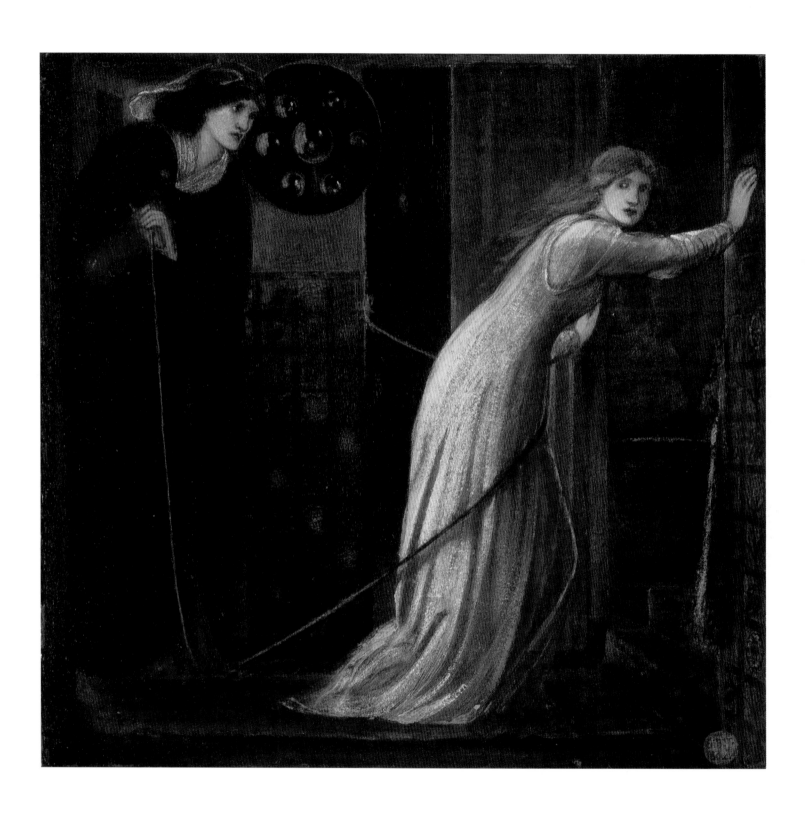

45

EDWARD COLEY BURNE-JONES 1833–98
Fair Rosamund and Queen Eleanor 1862

Pen and ink, watercolour, bodycolour and gum 26 x 27.3
(10¼ X 10¾)

Presented by J.R. Holliday through the National Art-Collections Fund 1923

Rosamund – 'Rosamund the Fair' – was Henry II's mistress who according to legend was poisoned by Queen Eleanor in 1177. To protect her, Henry had made Rosamund a house surrounded by an elaborate maze so that nobody could reach her. But Eleanor, 'by a clue of thredde', found her way through the labyrinth and despatched her rival. Burne-Jones shows the dramatic scene as Rosamund vainly tries to escape, but appears entangled in the thread which Eleanor holds.

Rosamund's story is one of the early ballads which enjoyed renewed popularity among those of the Pre-Raphaelite circle. Burne-Jones would visit the home of Peter Marshall, one of the partners in Morris & Co., to hear him sing border ballads; 'Rosamund the Fair' was one of the most popular among the circle. It inspired Burne-Jones to make several watercolours of the subject, and Arthur Hughes and Frederick Sandys also illustrated the story, while Rossetti, perhaps spurred on by Burne-Jones's pictures, treated the subject in a watercolour in 1861. Fresh impetus came from Swinburne's verse drama of 1860, which enacted the confrontation between Rosamund and the Queen.

DANTE GABRIEL ROSSETTI 1828–82
St George and the Princess Sabra 1862

Watercolour 52.4 x 30.8 (20 5/8 x 12 1/8)

Bequeathed by Beresford Rimington Heaton 1940

This shows another scene from a sequence of drawings Rossetti made chronicling the story of St George. Having killed the dragon, St George washes the blood from his hands in his upturned helmet. He watches through the window as a crowd, among whom one of the principal faces appears to be William Morris, carries the dragon through the streets in triumph. Lizzie Siddall modelled for Princess Sabra just a few days before taking an overdose of laudanum. She is shown in the disturbing act of kissing St George's bloodied hands.

The story of St George is an obvious allegory of the defeat of evil, but it is also a tale of the conversion of the Libyan king and his people to Christianity and the stamping out of pagan practice. Rossetti probably knew the detail of the tale from Thomas Percy's survey of medieval songs, ballads and romances, *Reliques of Ancient English Poetry* (1765). Burne-Jones started a cycle of decorative canvases based on the story, and William Morris treated it in part of his verse epic, *The Earthly Paradise*. In addition to his earlier watercolour of St George and the Princess (no.28), Rossetti himself made designs for a series of five stained glass windows in 1860–1. Evidently the tale held considerable fascination for him, and it is interesting to note the distraction of the two characters in *The Wedding of St George and Princess Sabra* (no.28) repeated again in this later watercolour. Instead of looking at each other, Princess Sabra looks at St George's hands or almost into herself, while he, staring at the procession, is separated and cut off from it. Washing his hands, an act iconographically usually associated with Pontius Pilate and seen elsewhere in Rossetti's work in his picture of Lucrezia Borgia (no.38), seems almost a guilty act of assuagement. It is as if, having made a sacrifice of the dragon, George has unleashed something terrible.

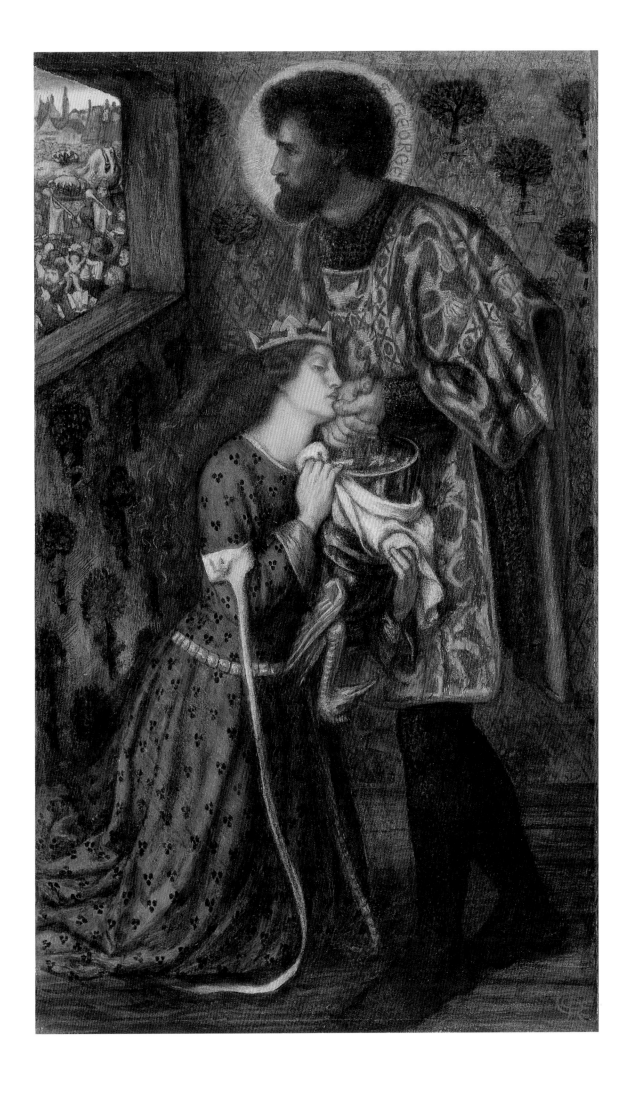

EDWARD COLEY BURNE-JONES 1833-98
Sigurd the Crusader 1862

Wood engraving 15.6 x 11.4 (6 ⅛ x 4 ½)

Purchased 1925

Sigurd is the hero of the Norse *Volsunga Saga*, the Scandinavian equivalent of *Siegfried and the Nibelungenlied*. Burne-Jones's tautly modulated design, in which the figures of Sigurd and Hinda fill the picture space, was the first he made in 1862 for the illustrated journal *Good Words*. This was a sixpenny weekly publication which had recently been taken over by the Dalziel brothers. The magazine took a serious and high moral and literary tone, and sought to bring original works of art to its readers from young and cutting-edge artists. It had been Holman Hunt who recommended Burne-Jones to the Dalziels, telling them:

> He is perhaps the most remarkable of all the younger men of the profession for talent, and will undeniably, in a few years fill the high position in general public favour which at present he holds in the professional world. He has yet, I think, made but few drawings on wood, but he has had much practice in working with

the point both the pencil and pen-and-ink on paper, and so would have no difficulty with the material (quoted Bill Harrison and Martin Waters, *Burne-Jones*, 1973, p.72)

Burne-Jones's first published woodcut, a medium in which he consciously had in mind medieval antecedents, was a great success. It accompanied the poem 'Sigurd the Crusader' by the Scots poet and journalist William Forsyth:

> Through smiles and tears, and
> Loving cheers,
> And trumpet notes of fame,
> Came King Sigurd, the Crusader –
> Like a conqueror he came,
> There stood the noblest of the land,
> The pride of many a hall,
> But the lovely lady Hinda's hand
> He kissed before them all.

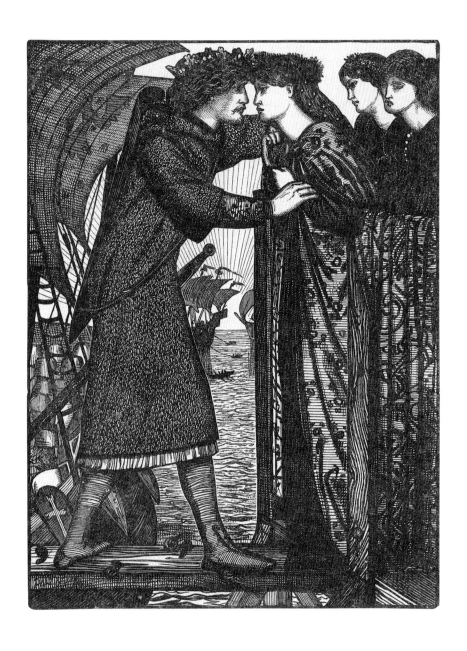

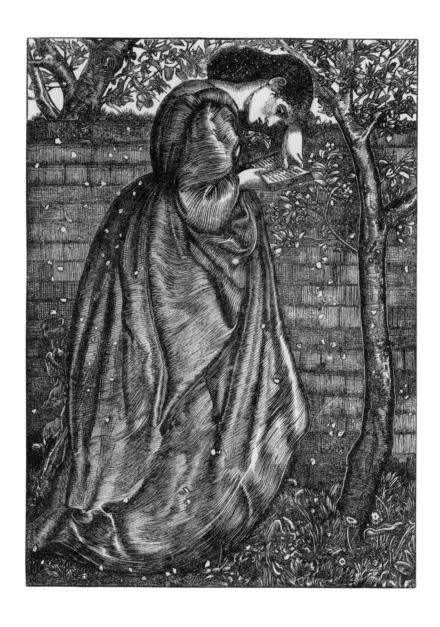

Edward Coley Burne-Jones 1833–98
Summer Snow 1863

Wood engraving 14.6 x 10.8 (5 ³/₄ x 4 ¹/₄)

Presented by Harold Hartley 1925

The second and last of Burne-Jones's contributions to the Dalziels' *Good Words* was accompanied by a melancholy anonymous poem:

Soft falls the summer snow,
On the springing grass drops light,
Not like that which long ago,
Fell so deadly cold and white,
This wears the Roses flash,
Faint, ere bloom hath quite foregone her,
Soft as maiden's timid blush,
With the looks she loves upon her.

So impressed were the Dalziel brothers by the design that they urged Burne-Jones to make a watercolour of it, which he duly did. The subject here is full of emotive mystery, and there is a prevalent mood of loss and longing. The model has some resemblance to Jane Morris. The act of reading seems in some way to relate to the illustration of a literary form, and addresses the way, perhaps, by which words summon visual images.

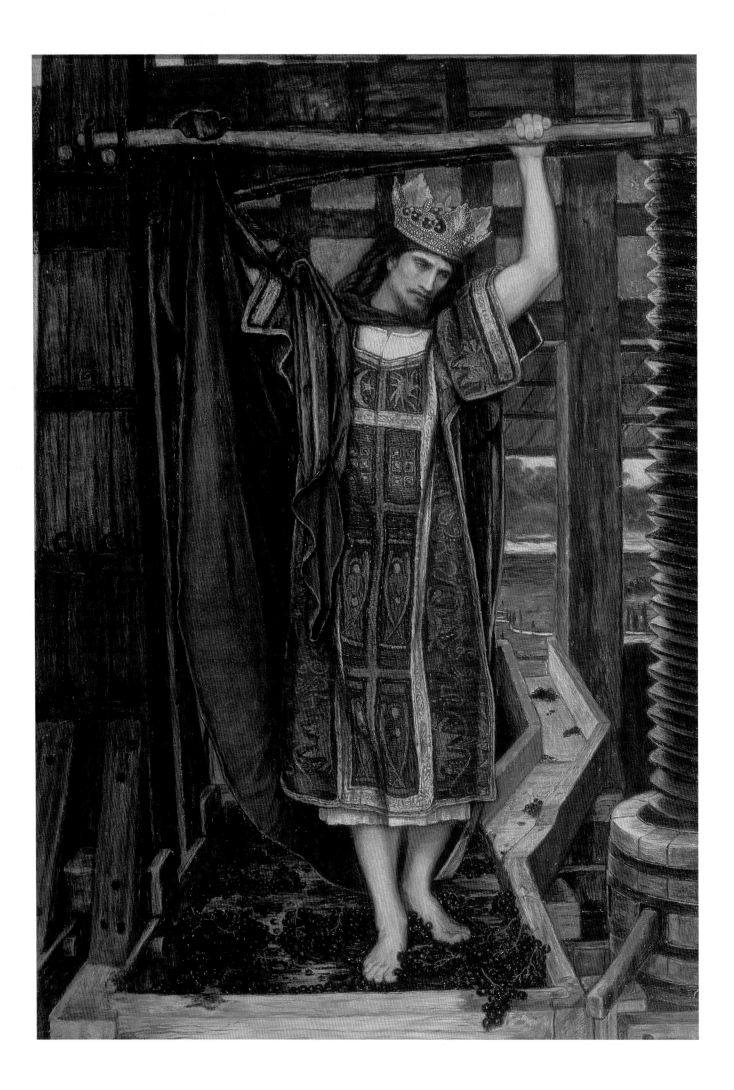

JOHN RODDAM SPENCER STANHOPE 1829–1908
The Wine Press 1864

Oil on canvas 94 x 66.7 (37 x 26 ¼)

Presented by Sir Henry Grayson Bt 1930

Christ wears the richly decorated raiment and crown of a king, although performing a humble yet sacramental task: the wine will be drunk in memory of his own blood during Communion. The position he takes holding the bar above stretches his body into a pose very similar to that of the Crucifixion, and the act of crushing can also seem to represent Christ's own physical breaking. It is an arresting and ambiguous characterisation, and one which perhaps seems to affirm the necessity of ordinary work to gain salvation.

One of Spencer Stanhope's early works, *The Wine Press,* was painted during his association with members of the Pre-Raphaelite Brotherhood and before he turned to painting allegories inspired by the Italian Renaissance in the style of Burne-Jones. Stanhope's niece, Anna Maria Wilhelmina Stirling, described the picture as 'perhaps the finest work he ever executed' and explained that the inspiration for it came from 'a visit to Varennes in his youth ... watching the treading of the winepress by the French peasants, he evolved this design' (A.M.W. Stirling, *A Painter of Dreams And Other Biographical Studies,* London 1916, p.335). The biblical subject derives from the lines inscribed on the frame, 'I have trodden the winepress alone', which are taken from the Book of Isaiah (63:3): 'I have trodden the winepress alone; and

of the people there was none with me: for I will tread them in mine anger, and trample them in my fury; and their blood shall be sprinkled upon my garments, and I will stain all my raiment.' This equates the symbol of the wine press with the notion of divine punishment, and elsewhere in this biblical passage God threatens mankind with death 'because His people have not helped in the battle against evil'.

The picture might, however, be understood as an example of biblical typology, a form of symbolism revived in the nineteenth century, in which divinely intended prefigurations of Christ's Passion and Crucifixion were identifiable in the events of the Old Testament. Biblical typology was frequently employed in Pre-Raphaelite painting, and the suffering of Christ on the cross is conveyed in the image of treading the wine press, for he both treads the press and is also crushed by it.

Comparisons were made by contemporaries between Stanhope's picture and Holman Hunt's famous image of Christ, *The Light of the World* (1851–3; fig.10). Both works portray Jesus in his offices as prophet, priest and king in their representation of the jewelled crown, the *ephod* or surplice worn by the Jewish High Priest, which is lined with crimson, and the white undergarment representing the spotless humanity of Christ.

SIMEON SOLOMON 1840–1905
Sappho and Erinna in a Garden at Mytilene 1864

Watercolour 33 x 38.1 (13 x 15)

Purchased 1980

Sappho is shown embracing her fellow poet Erinna in a garden at Mytilene on the island of Lesbos. Born at Lesbos in about 612BC, after a period of exile in Sicily, Sappho returned to the island and was at the centre of a community of young women devoted to Aphrodite and the Muses. Although Solomon believed Erinna to have been part of this community, we now know that she lived not on Lesbos, but on the Dorian island of Télos, and slightly later than Sappho, at the end of the fourth century BC. Sappho wrote nine books of poetry, of which only fragments survive. The principal subject of her work is the joy and frustration of love, and her most complete surviving poem is an invocation to the goddess Aphrodite to help her in her relationship with a woman. Sappho is shown crowned with laurels and with dark, Mediterranean, slightly androgynous features. She represents a 'masculine' foil to Erinna's seductive femininity, emphasised by the soft flesh tones, partially exposed breasts and shoulder. Their love for each other is underlined by the pair of doves seated above them. Sappho is identifiable through her traditional attributes: the lines of poetry and the musical instrument set to one side.

Simeon Solomon was a close associate of the Pre-Raphaelites and his work owes much to Rossetti and Burne-Jones. The influence of Rossetti, and more especially the poet Swinburne (1837–1909) – who was influenced in turn by Sappho's poetry – led him to explore the forbidden subjects of homosexuality and lesbianism. However, he was unable to conceal his own sexual preferences and on 11 February 1873 was arrested for propositioning a man in a public lavatory near Oxford Street. After his trial his former friends would have nothing to do with him, and he lived the life of an outcast on the margins of society, finally dying in the workhouse.

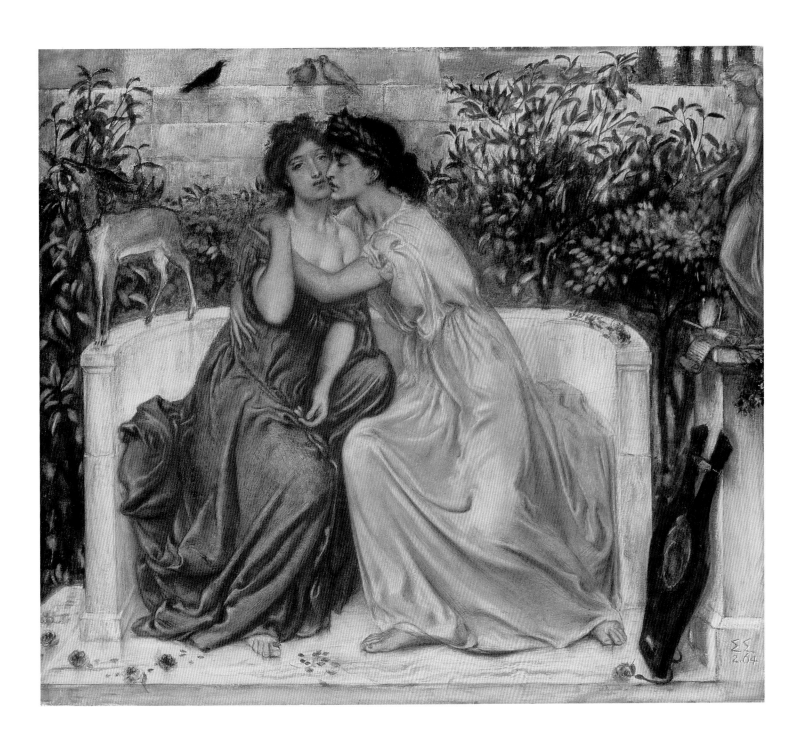

141

Dante Gabriel Rossetti 1828–82
How Sir Galahad, Sir Bors and Sir Percival Were Fed
with the Sanct Grael; but Sir Percival's Sister Died
by the Way 1864

Watercolour 29.2 x 41.9 (11¹/₂ x 16¹/₂)

Bequeathed by Beresford Rimington Heaton 1940

The magic and romance of Malory's tales of King Arthur in the *Morte d'Arthur* fascinated Rossetti, and the quest for the Holy Grail perhaps appeared to be a metaphor for striving towards artistic perfection or personal expression. Originally Rossetti had planned to use this design as one of the murals to decorate the Oxford Union, but he abandoned the idea and instead used it for this watercolour. Rossetti's friend the poet Swinburne posed for the figure of Sir Galahad. Galahad was able to attain the Grail because of his purity, and in view of Swinburne's decadent tastes and verses this may have been an ironic choice of model. The Angel of the Grail was based on Rossetti's dead wife Lizzie; the luminous lily represents her purity, while the dove both represents

the Holy Spirit and refers to one of Rossetti's pet names for her. Rossetti has in fact united the culmination of the Grail quest with an earlier incident in the tale when Sir Percival's sister gives her life to heal a woman who could only be saved by the blood of a virgin. This introduces to the picture the theme that the attainment of the Grail, representing purity and perfection along with spiritual salvation, can only be achieved through some sacrifice.

The picture is also remarkable for its composition which compresses the picture space so that there is little foreground and no recession; everything fills a central plane, and is decorated with rich colours and designs. These are deliberately medievalising devices reminiscent of illuminated manuscripts.

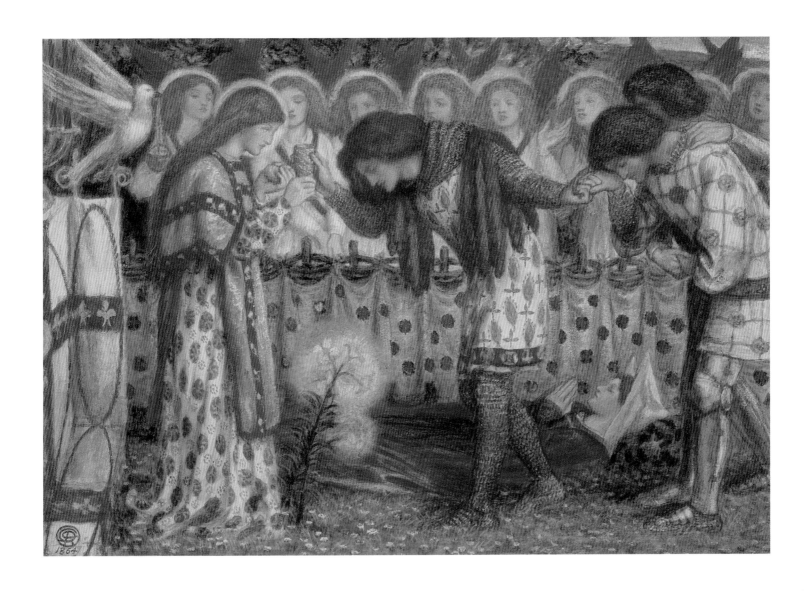

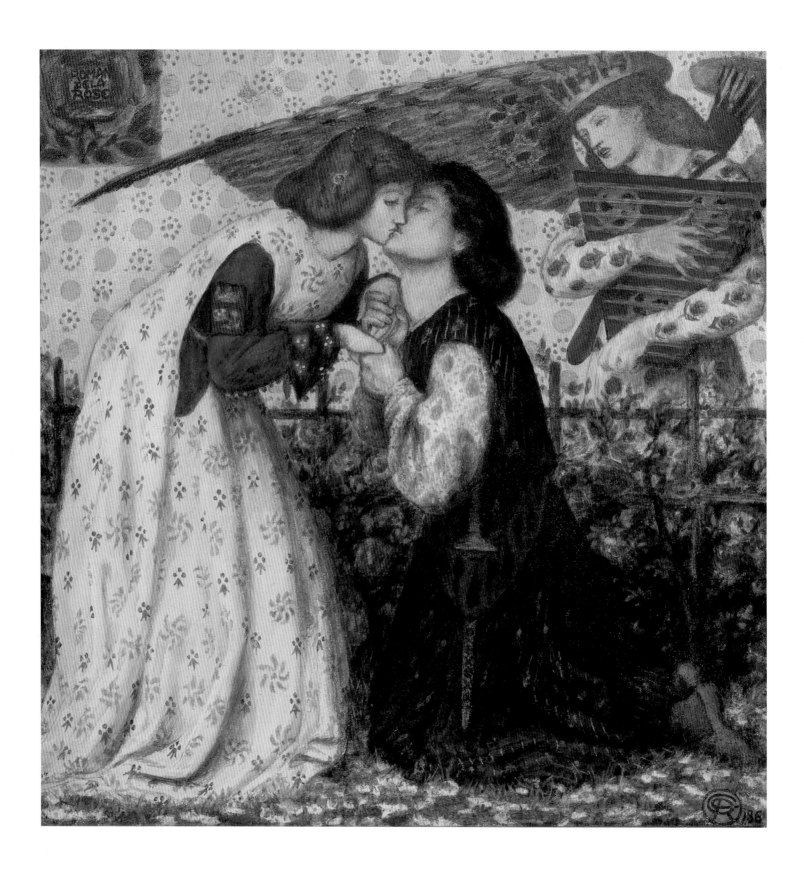

DANTE GABRIEL ROSSETTI 1828–82
Roman de la Rose 1864

Watercolour 34.3 x 34.3 (13 ½ x 13 ½)

Presented by Andrew Bain 1925

Rossetti's inspiration for this watercolour was the thirteenth-century French poem of the same name, by Guillaume de Lorris and Jean de Meun, which is a complex allegory about love and loss. The poem begins with an allegorical account of the lover's pursuit of his beloved. In a dream or vision he visits a beautiful garden where he sees a rosebud and is pierced by Cupid's arrow; the rest of the tale tells of his struggles and setbacks to win the rosebud before ultimate success. With its themes of the quest for ideal, perfect love and spiritual revelation it was a story bound to appeal to Rossetti.

The picture's shallow depth and its rich decoration are clearly inspired by medieval illuminated manuscripts, which Rossetti viewed in the British Museum and elsewhere. The rapt, embracing couple are typical of Rossetti's work at this time, their union blessed by the sweep of the angel's wing. The watercolour derived from an earlier design for the frontispiece of Rossetti's *Early Italian Poets*, a collection of his translations.

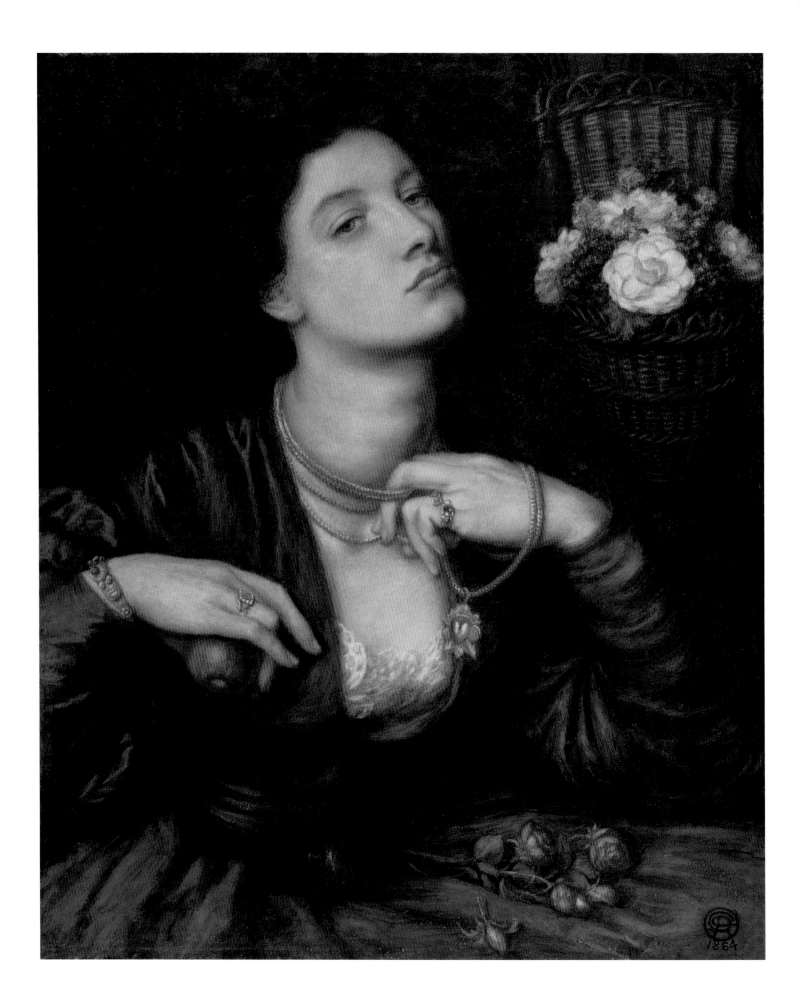

53
DANTE GABRIEL ROSSETTI 1828–82
Monna Pomona 1864

Watercolour and gum arabic 46 x 37.8 (18 ⅛ x 14 ⅞)

Presented by Alfred A. de Pass 1910

In 1859 Rossetti started working in a wholly new and original way. He painted *Bocca Baciata* (fig.11), a head and shoulders 'portrait' of his lover Fanny Cornforth (see no.32), and the first of what became a long series of subjectless ruminations on feminine beauty. These pictures of women, 'with floral adornments', as Rossetti's brother William described them, were self-contained objects of purposeless beauty in themselves, and entirely without moral or narrative. They were also explicit testimony to the power of sexual attraction and an embodiment of Rossetti's feelings of erotic yearning for the opposite sex. Holman Hunt immediately grasped the moral line which *Bocca Baciata* had crossed, and in a private letter to his patron Thomas Combe he wrote:

> I will not scruple to say that it impresses me as very remarkable in power of execution – but still more remarkable for gross sensuality of a revolting kind peculiar to foreign prints … I would not speak so unreservedly of it were it not that I see Rossetti is advocating as a principle the mere gratification of the eye and if any passion at all – the animal passion to be the aim of art … I disfavour any sort of sympathy with such notion (quoted Elizabeth Prettejohn, *The Art of the Pre-Raphaelites*, p.108)

The muse for *Monna Pomona* was Ada Vernon, a model who lived on the Kings Road not far from Rossetti's Chelsea house. The title means simply 'The Lady of the Apples' and alludes only to the daintily held apple in the picture, although perhaps also suggesting the Temptation and Fall, or Paris's award of the Golden Apple to the fairest of the Three Graces in Classical mythology. Rossetti has made his subject tilt back her head to give greater prominence to the throat, a part of the body for which he appears to have had a strong fascination. Her fingering of her necklace adds a deliberately calculated erotic frisson and emphasises the low cut of her dress. Such pictures were never exhibited in Rossetti's lifetime but instead sold to a circle of appreciative connoisseurs. This one was bought by Alexander Ionides, the leader of the Greek community in London.

54

FORD MADOX BROWN 1821–93
King René's Honeymoon 1864

Pencil, watercolour, bodycolour and gum arabic on card
27.6 x 18.6 (10⅞ x 7⅜)

Purchased 1917

This is a watercolour version of a subject Brown painted to decorate a gothic cabinet designed by John Pritchard Seddon which is now in the Victoria and Albert Museum. On Seddon's completion of the metal and inlaid work he commissioned the firm of Morris & Co. to produce painted panels for it which illustrated the fine and lesser arts. It was Brown's suggestion that the themes should be based around the honeymoon of King René, the father of Margaret, queen to Henry VI of England. René was titular King of Naples, Sicily, Jerusalem and Cyprus and a man renowned for his mastery of the arts, as recounted in Sir Walter Scott's novel *Anna von Gierstein* (1829). Ford Madox Brown contributed this design as symbolising 'Architecture', and René is shown considering plans for a new castellated house to be occupied by himself and his new bride. The other panels for the cabinet were painted by Burne-Jones, who depicted 'Painting' and 'Sculpture', and Rossetti, who treated the subject of 'Music'.

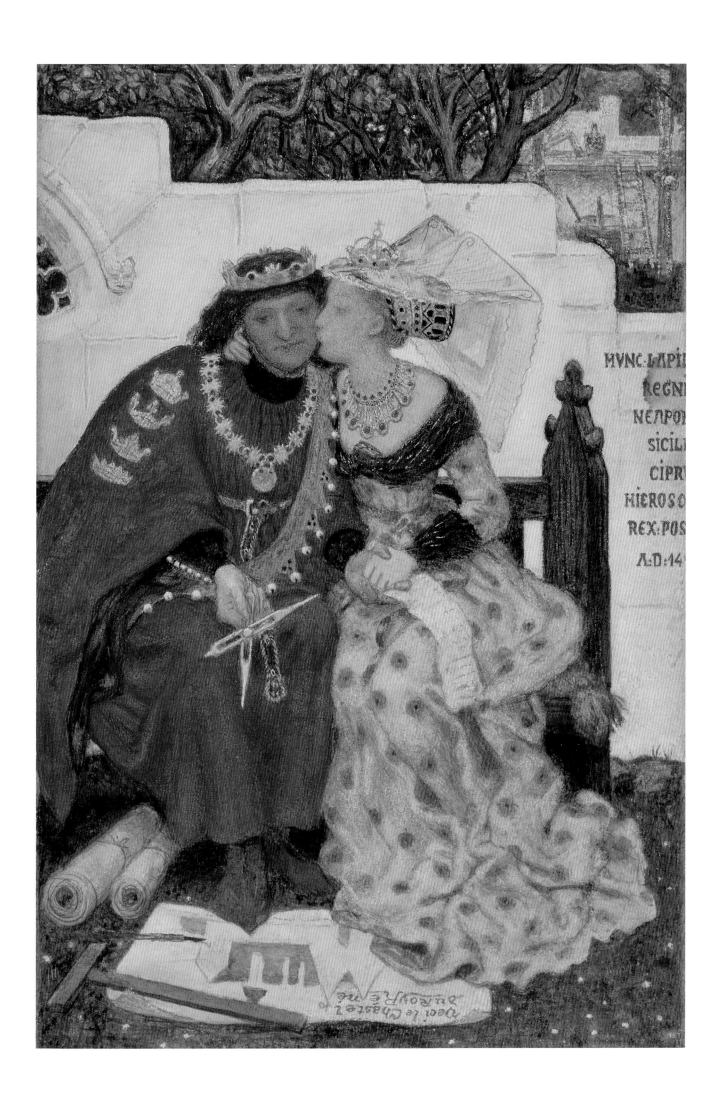

HVNC·LAPII

REGNI

NEAPO

SICILI

CIPRV

HIEROSO

REX·POS

A·D·14

150

55
FORD MADOX BROWN 1821–93
The Last of England 1864–6

Watercolour 35.6 x 33 (14 x 13)
Purchased 1916

Painted for George Rae of Birkenhead, an important patron of the Pre-Raphaelites, this is a watercolour replica of Brown's famous 1855 oil of emigrants leaving England. The theme was inspired by the departure of his friend Thomas Woolner for Australia in July 1852. Emigration was a considerable social phenomenon in mid-nineteenth-century Britain. Some left to staff the ever-growing Empire, but for many the choice was a more fundamental one between life and death. Following the Irish potato famine of the 1840s hundreds of thousands facing starvation left Ireland to go to America, Canada and elsewhere; and in Scotland others left in large numbers because of the unviable nature of the rural economy. In 1852 alone, the year Woolner left England, 369,000 people emigrated from Britain. Brown himself, hardly able to make a living from his art, was contemplating emigrating to India when he began work on *The Last of England*.

For the main focus of the picture he chose a middle-class couple; beneath her shawl the woman cradles a small baby, whose tiny fingers are just visible, grasping its mother's hand. Brown drew his own child for the picture, and the models for the figures were himself and his wife Emma, further personalising the subject-matter. The father's brooding expression betrays his anxiety and apprehension at the voyage ahead, while the mother's serene features seem to convey both her trust and her sense of resignation. Following the Pre-Raphaelite prerequisite for truth to nature, Brown painted the bulk of the oil version out of doors and asked his wife to sit in all weathers, even when there was snow on the ground.

The circular format is reminiscent of a Renaissance tondo, but it also serves to emphasise the couple's unity. Accompanying them in the boat are 'an honest family of the green-grocer kind', Brown wrote in the catalogue to his 1865 solo exhibition. Behind them is 'a reprobate', who 'shakes his fist with curses at the land of his birth, as though that were answerable for *his* want of success'. The rather comical-looking cabbages arranged around the boat are intended to indicate a lengthy voyage. In the distance, the White Cliffs of Dover are just visible, while at the back of the boat a cabin boy is selecting vegetables for dinner from a small lifeboat, which bears the ironic name of the ship, 'Eldorado'. Brown wrote further and revealingly of the subject:

It treats of the great emigration movement, which attained its culmination in 1852. The educated are bound to their country by closer ties than the illiterate, whose chief consideration is food and physical comfort. I have, therefore, in order to present the parting scene in its fullest tragic development, singled out a couple from the middle classes, high enough, through education and refinement, to appreciate all they are giving up, and yet dignified enough in means to have put up with the discomforts and humiliations incident to a vessel 'All one class' ... The husband broods bitterly over blighted hopes and severance from all that he has been striving for. (Ford Madox Brown, *Work, and other Paintings by Ford Madox Brown, at the Gallery, 191 Piccadilly*, exh. cat., London 1865)

WILLIAM BELL SCOTT 1811–90
The Eve of the Deluge 1865

Oil on canvas 32.4 x 44.5 (12 ¾ x 17 ½)

Presented by Miss Alice Boyd 1891

Like Rossetti, Scott was both a poet and a painter, and they first met in 1847 after the younger man wrote a letter praising Scott's recently published verse narrative *The Year of the World*. Scott came from an artistic background: his father was a successful engraver in Edinburgh, and he himself set up business in London as a 'painter-etcher'. His early works were rejected by the Royal Academy, but Scott came to be on friendly terms with a circle of painters that included William Powell Frith and Richard Dadd. After his introduction to Rossetti, and then to Woolner and Carlyle, he quickly became an intimate of the Pre-Raphaelite circle and contributed two of his poems to *The Germ* in 1850.

Scott's principal occupation was as Master of Newcastle School of Art and Design, an appointment which was set up by the Board of Trade to encourage aesthetic quality and integrity in the fine and manufacturing arts. He enjoyed a certain success in this role, always ready to encourage and learn from artisans and their craftsmanship. But in 1864 he left Newcastle to settle permanently in London; *The Eve of the Deluge* was painted the following year and shows a rich originality of design and subject-matter. From the shade of an Assyrian palace a group of decadents mocks Noah as he calmly enters the ark. There is an ominous cloud on the horizon, and the birds starting through the air strike a note of alarm. Scott's picture can be seen in the context of the new-found popularity of Hebraic subjects in the 1860s, in aesthetic circles a phenomenon embodied by Simeon Solomon's works. In many ways, Scott presents a vision of the two sides to moral choice, the sprawling figures who have taken the path of sensory indulgence contrasting with the orderly procession and discipline of Noah and his followers. Throughout the composition everything is treated in almost obsessive detail; indeed, in Scott's work both as a painter and a poet, it is fair to say that his conception often outstrips the execution. In later years, despite enduring friendship, there were moments of barely concealed irritation at the way the younger Rossetti outstripped him in both art and poetry, and his memoirs were unduly critical of him.

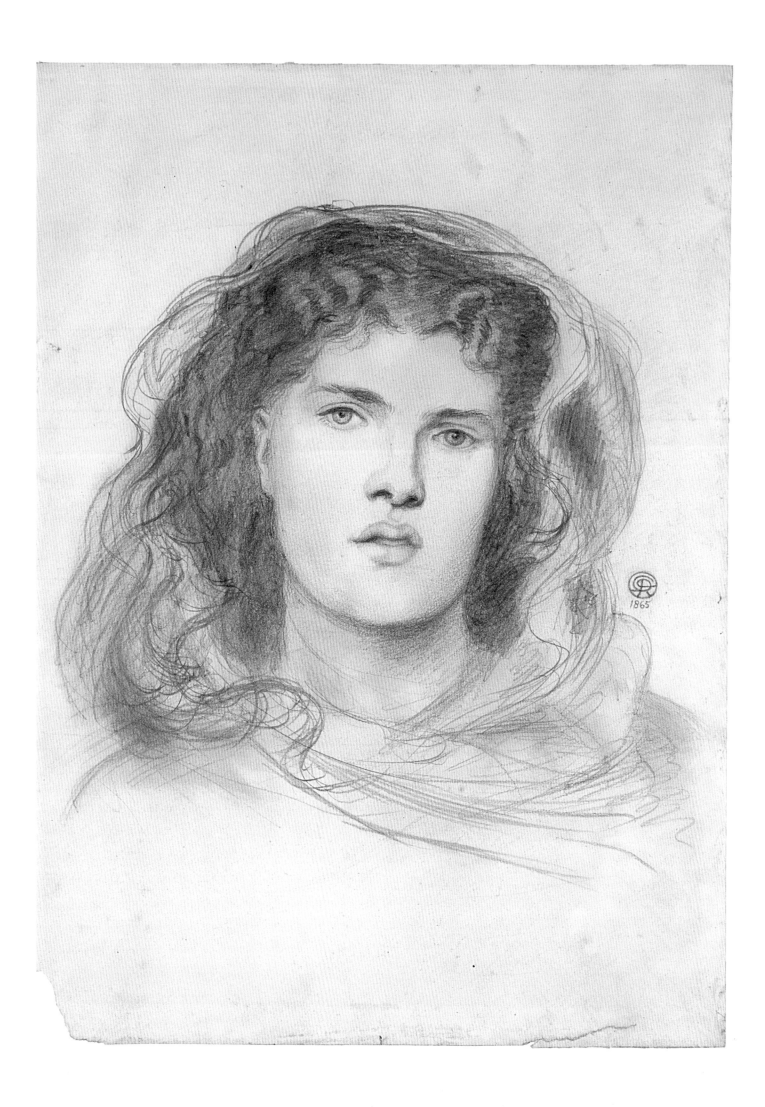

57

DANTE GABRIEL ROSSETTI 1828–82
Study for 'The Bride' 1865

Pencil 41.9 x 30.5 (16⁷/₈ x 12)

Bequeathed by J.R. Holliday 1927

Rossetti's theme is once again the overwhelming beauty of woman, and man's weakness and fascination in the face of it. This is a study for his famous oil *The Bride* (1865–6, *Tate*), inspired by the biblical Song of Solomon. It shows the bride pulling back her veil; looking straight out of the picture, she places the viewer in the role of her lover, gazing at her revealed beauty. This drawing is for one of the attendants ranged around the bride, each representing a different type of feminine beauty.

Rossetti inscribed the frame of the finished oil with lines from the Song of Solomon and Psalm 45:

> My beloved is mine and I am his (Song of Solomon 2:16)
> Let him kiss me with the kisses of his mouth: for thy
> love is better than wine (Song of Solomon 1:2)
> She shall be brought unto the King in raiment of
> needlework: the virgins her companions that follow her
> shall be brought unto thee (Psalm 45:14)

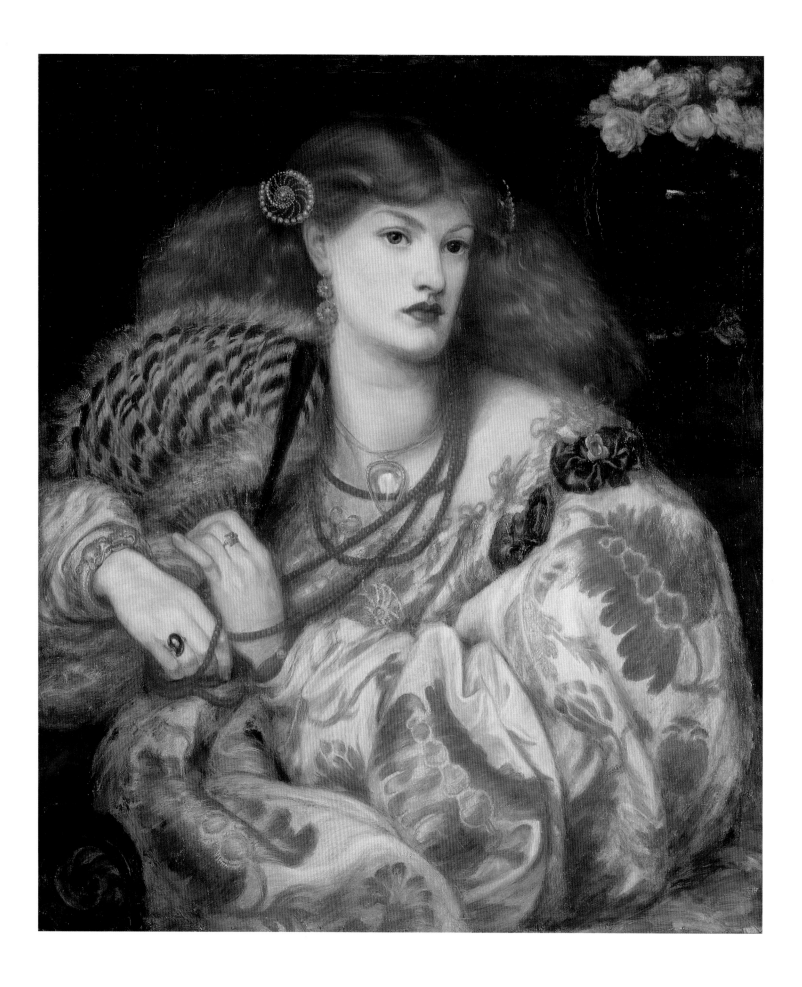

58

DANTE GABRIEL ROSSETTI 1828–82
Monna Vanna 1866

Oil on canvas 88.9 x 86.4 (35 x 34)

Purchased with assistance from Sir Arthur Du Cros Bt and Sir Otto Beit KCMG
through the National Art-Collections Fund

This is one of the best known of the series of decorative pictures of beautiful and sensual women which Rossetti made in the mid-1860s. The model is Alexa Wilding, whom Rossetti first saw whilst walking in the Strand. He was immediately struck by her beauty and her auburn hair and, after following her for some way, introduced himself to her and asked her to model for him. She refused, and it was not until he saw her again in the same area that he was able to persuade her; she sat for several of his major pictures of the mid-1860s. In *Monna Vanna* Rossetti heaps together dazzling surfaces and rich textures to create a vision of luxurious beauty. The spiral pearl clasp in her flowing auburn hair and the red coral necklace appear frequently in Rossetti's pictures of women. Along with the sweeping movement of her arms, the green rosettes on her shoulder and the floral earrings, they serve to accentuate the picture's circular composition. The heavily embroidered white and gold drapery is used in other pictures of this date. The enormous sleeve recalls Raphael's portrait of Giovanna of Aragon which Rossetti may have seen in the Louvre.

Originally Rossetti called the picture 'Venus Veneta' and intended it to represent 'a Venetian lady in a rich dress of white and gold, – in short the Venetian ideal of female beauty' (quoted in a letter dated 27 September 1866, *The Correspondence of Dante Gabriel Rossetti*, ed. Doughty and Wahl, Oxford, II, p.606). After the picture was finished he changed the title to *Monna Vanna*, denoting a 'vain woman', a name taken from Dante's *Vita Nuova* which he had translated in October 1848. Rossetti considered the painting to be one of his best works and declared it 'probably the most effective as a room decoration that I have ever painted'. But in 1873 he retouched the picture, lightening the hair and altering the rings which had been criticised for their clashing colours. He also changed the title to 'Belcolore', believing that the subject looked too modern for its previous title. Despite this, the painting continued to be known as *Monna Vanna*. It was first owned by the Cheshire collector William Blackmore, and later passed into the hands of George Rae of Birkenhead, one of Rossetti's most important patrons.

FORD MADOX BROWN 1821–93
The Coat of Many Colours 1867

Watercolour on paper laid down on panel 30.5 x 30.5 (12 x 12)

Bequeathed by J.R. Holliday 1931

Taken from Genesis 37:23, Brown first worked out the design for this subject in November 1863 for an engraving for the Dalziel brothers' epic *Bible Gallery*. In 1866 he started a big oil of the composition, and probably later the same year started this watercolour version. The picture shows Joseph's treacherous brothers telling their father about his death and holding up his blood-stained coat of many colours as evidence. Brown went into considerable explanation of the composition in the catalogue to his 1865 solo exhibition, writing:

> The cruel Simeon stands in the immediate foreground half out of the picture, he looks at his father guiltily and already prepared to bluster, though Jacob, all to his grief, sees no one and suspects no one. The leonine Judah just behind him, stands silently watching the effect of Levi's falsity and jeering levity on their father; Issacher the fool sucks the head of his shepherd's crook, and wonders at his father's despair. Benjamin sits next his father, and with darkling countenance examines the ensanguined and torn garment. A sheep dog without much concern sniffs the blood which he recognises as not belonging to man. A grand-child of Jacob nestles up to him, having an instinctive dislike for her uncles ... The ladder, which is introduced in a naturalistic way, is by convention the sign of Jacob, who, in his dream, saw angels ascending and descending by it.

Brown wanted to ensure the veracity of his image, and so made his usual diligent researches in the British Museum Library, and sketched the camel in London Zoo. For the background he borrowed a watercolour by his friend Thomas Seddon, *The Well of Enrogel*, painted in Palestine in 1854. Holman Hunt, with his first-hand knowledge of the Middle East, however complained that the dog in Brown's picture would be viewed as a 'defilement', but realising he had offended him, he quickly apologised by letter, citing other biblical justifications. When the first oil version was shown at Gambart's French Gallery it was somewhat poorly received, with the *Art Journal* judging: 'We cannot deny genius to this work. Yet why it should be quite so peculiar and repellent we cannot pretend to say ... As for the multitude we shall gratify the painter when we say that his picture is beyond them' (1866, pp.374–5).

The Bible was a long-standing source for painters of so-called history subjects, but Brown seems to have been fascinated by the potential of stories revolving around the different faces of human nature. His treatment of the story of Joseph can also be linked to the growing success of Simeon Solomon's early Hebraic pictures in the 1860s, with their mixture of mysticism, luxuriousness and ambiguity of subject.

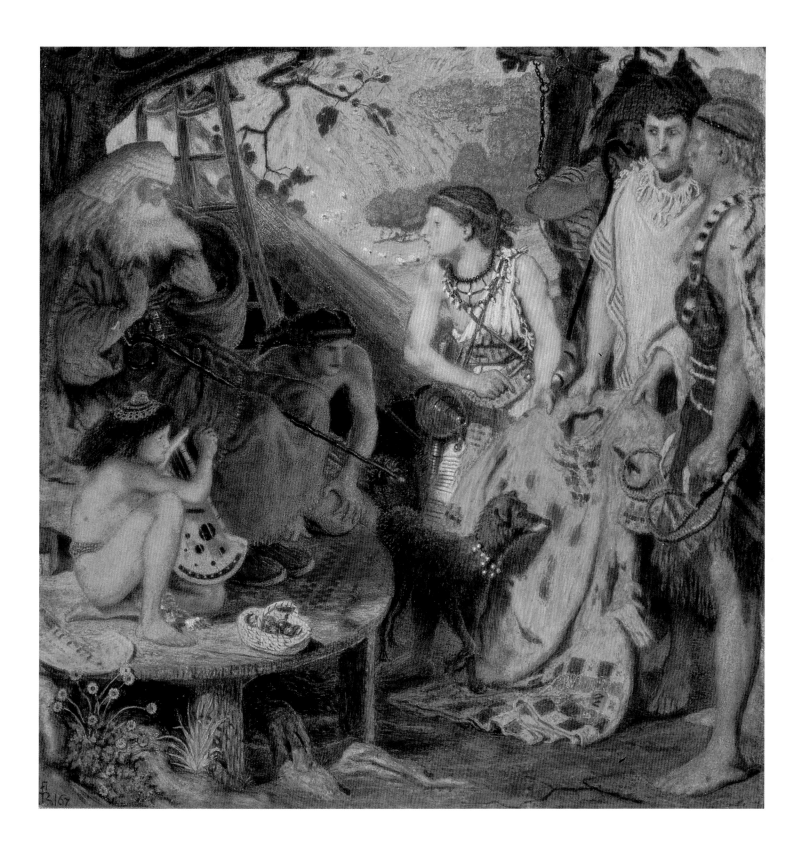

GEORGE PRICE BOYCE 1826–97
A Girl's Portrait, *c.*1868

Pencil, watercolour and scratching out 24.9 x 18.2 (9 ¾ x 7 ⅛)

Purchased with assistance from the Abbott Fund 1987

Boyce trained for several years as an architect, but in August 1849 he had a life-changing encounter with the landscapist David Cox whom he met sketching at Betws-y-Coed in Wales. 'This meeting', Boyce's friend Frederic Stephens wrote in his obituary of him, 'seems to have led to Boyce giving up architecture and taking to painting with characteristic single-mindedness and thoroughness' (*Athenaeum*, 13 February 1897, p.221). Plunging himself into his art, Boyce initially took lessons from Cox; perhaps at another art class he was introduced to Thomas Seddon, and through him may have been introduced to some among the Pre-Raphaelite circle. In 1849 he met Rossetti for the first time and the two remained close friends for over thirty years.

Watercolour landscapes were the mainstay of Boyce's work, expressed in a minutely detailed and highly distinctive style, which absorbed Pre-Raphaelite and Ruskinian beliefs in a keenly observed truth to nature. In the 1860s Boyce made a small group of highly-charged watercolour portraits of young women, most of them models who sat to Rossetti, such as Alexa Wilding and Ellen Smith. These intense, slightly ambiguous works may have been a response to Rossetti's immersion in making allegorical portrayals of feminine beauty, although Boyce's works, with their suppression of subject, suggest an affinity towards the abstraction of aestheticism. Indeed, he was on very friendly terms with James McNeilWhistler, who was at the centre of the aesthetic movement. In 1860 he recorded in his diary meeting for the first time in the National Gallery 'a gallicised Yankee, Whistler by name, who was very amusing, and with whom I walked part of the way home' (*The Diary of George Price Boyce*, ed. Virginia Surtees, Norwich 1980, p.29). Sadly the identity of the model in this watercolour is lost, and the title is that which Boyce's wife Augustine wrote on a label which was once attached to the back of the frame. Her gown appears oriental, and reflects the taste for *japonisme* which Whistler and his immediate circle took up in the 1860s. In 1862 Boyce had visited the International Exhibition in London, where he would have been able to admire the impressive contributions of the Japanese Court.

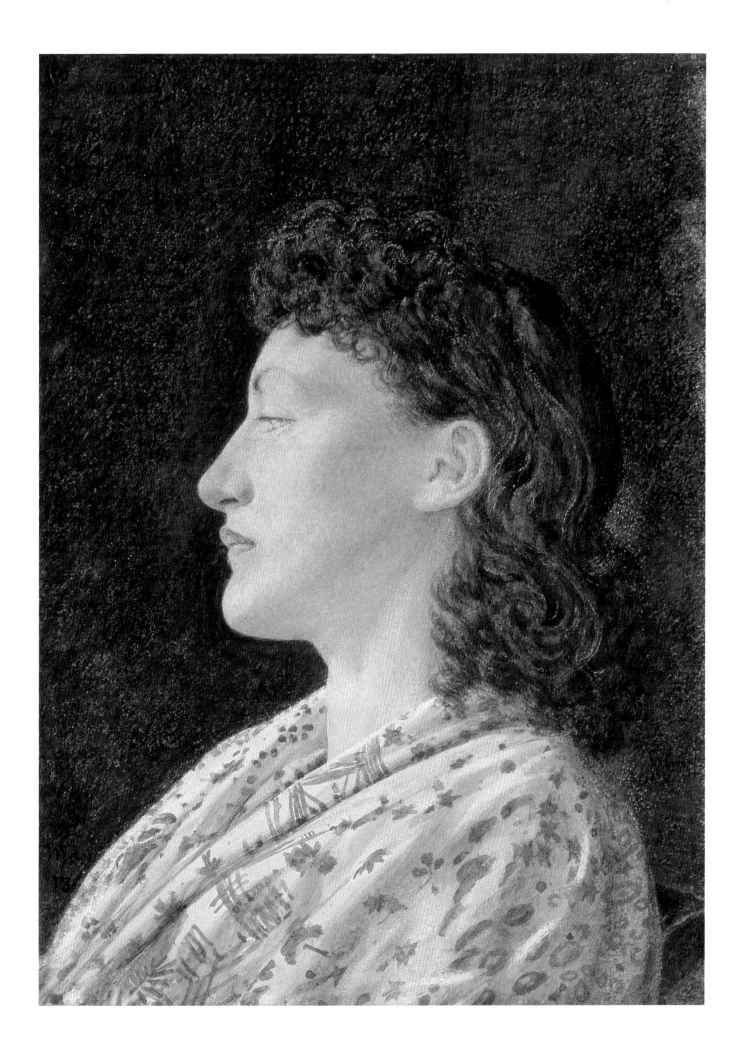

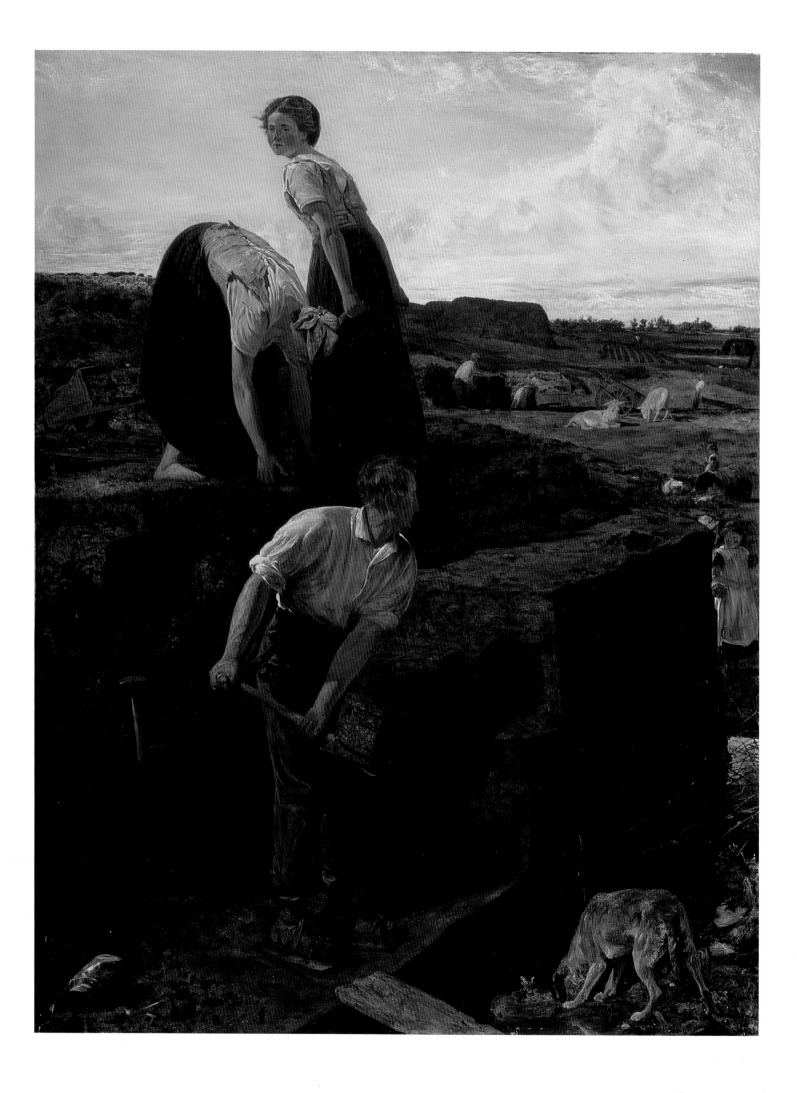

61

THOMAS WADE 1828–91
Turf Cutters 1869

Oil on canvas 90 x 70 (35½ x 27½)

Purchased 1996

Wade is a good example of a painter who apparently had little or no contact personally with the key Pre-Raphaelites but who nevertheless absorbed many of their aesthetic ideals and ways of working. As a young man he tried unsuccessfully to make a career in London, and is likely there to have seen works by Hunt, Millais and others. By 1861 he had returned home to Preston and sometime around the middle of that decade he met the Liverpool Pre-Raphaelite follower William Windus. Windus encouraged him, and Wade started submitting works to the Liverpool Academy which had a cadre of Pre-Raphaelite painters led by Windus and included James Campbell (see no.19).

Much of Wade's work showed working-life scenes or combined them with landscape, and *Turf Cutters* is an outstanding example of his abilities. The reflected light of the sun is captured with great subtlety and the multi-level composition is cleverly laid out to lead the eye round the picture. Although the title refers to turf, it appears that actually it is peat that is being cut, a fossil fuel staple for the poor. This is back-breaking work, and Wade contrasts the labours of the adults with the careless play of the half-hidden children.

Not a great deal is known about Wade's life, but his abilities were recognised by Ruskin, who bought one of his watercolours, and the Trustees of the Chantrey Bequest, who acquired another for the Victoria and Albert Museum in 1878. The *Art Journal* savaged him in 1870 by claiming that his meticulous style was 'an ultra example of the somewhat outrageous and defiant manner which are permitted to the supremely lawless Art of the present day' (1 June 1870).

Edward Coley Burne-Jones 1833–98
The Temple of Love c.1872

Oil on canvas 213.4 x 92.7 (84 x 36½)

Presented by the Trustees of the Chantrey Bequest 1919

The concept for Burne-Jones's allegory originated in William Morris's dramatic poem 'Love is Enough', begun in October 1871. Originally this was to be published along with woodcut illustrations by Burne-Jones but the project fell through. Burne-Jones had already made several of the designs, including one for *The Temple of Love* which was to serve as the frontispiece; at some stage, either before or after the book's cancellation, Burne-Jones evidently realised that the design would support fuller treatment as an ambitious painting in oils. Couched in deliberately archaic language, Morris's poem tells the story of 'A King whom nothing but Love might satisfy, who left all to seek Love, and, having found it, found this also, that he had enough, though he lacked all else'. Although this was a view that fitted perfectly Pre-Raphaelite anti-materialist beliefs, it also held deeply personal resonance for Burne-Jones who had ended his passionate affair with his mistress, Maria Zambaco, the previous year, to stay with his wife (see no.62).

In Burne-Jones's picture the king is Pharamond, shown with his lover Azalais being crowned in the House of Love. This is not an episode related in Morris's poem, and seems to have been an imaginative interpretation of Burne-Jones's own. In the background are grisaille panels based on other pictures by Burne-Jones which depicted famous lovers – Pyramus and Thisbe, Phyllis and Demophoön, and Orpheus and Eurydice. The principal source for the picture's design, both in general format and certain details such as the richly-coloured marbles and crisp folds of drapery, was Mantegna's *Madonna della Vittoria* which Burne-Jones had seen when he visited the Louvre. The pale colouring and chalky surface are also inspired by Mantegna, although they also owe a debt to Michelangelo whom Burne-Jones increasingly came to revere.

Despite working on the canvas spasmodically over an extended period it remained unfinished in Burne-Jones's studio. It was acquired from his Estate by the Trustees of the Chantrey Bequest and presented to the Tate in 1919.

65
EDWARD COLEY BURNE-JONES 1833–98
Desiderium 1873

Pencil 21 x 13.3 (8 ¼ x 5 ¼)

Presented by Sir Philip Burne-Jones Bt 1910

Filled with inspiration by the Renaissance frescoes he saw on his trip to Rome, Florence and Assisi in the autumn of 1871, the following year Burne-Jones embarked on a number of ambitious allegorical cycles, including the *Briar Rose* and *Cupid and Psyche* series. Another one was a group of illustrations of 'The Masque of Cupid', a subject which he took from Edmund Spenser's verse epic *The Faerie Queen* (1590). Originally Burne-Jones planned four life-size paintings devoted to 'The Vision of Britomart' but, perhaps
as a result of his development of the other projects, except for a series of study drawings this series remained unfulfilled despite his later return to it. The figure in this drawing is that of Amorous Desire, who is depicted, as in Spenser's description, blowing gently to awaken the sparks of passion:

> Twixt both his hands few sparks he close did strayne,
> Which and still he blew and kindled busily,
> That soone they life conceiv'd, and forth in flames did fly.

In Spenser's poem the character is male, but in Burne-Jone's drawing the figure is evidently that of a woman. While Burne-Jones was known for the deliberate androgynous blurring of masculine and feminine features in his work, there is likely to be another motive here.

The face of 'Desire' is unmistakably that of his mistress, Maria Zambaco, from whom he had reluctantly parted three years earlier. In casting her as the character who sparks amorous intent he was reflecting on the nature and passion of their relationship. The third book of *The Faerie Queen*, from which he took the subject, is concerned with Britomart's quest to find her ideal match, her future husband Arthegall. This, too, held great resonance for Burne-Jones, for after breaking finally with Maria he continued to be racked with guilt that he may have made the wrong choice and lost his one true love.

Presented to the Tate by Burne-Jones's son Philip in 1910, *Desiderium* was only the second of his works to enter the national collection, the first being *King Cophetua and the Beggar Maid*.

DANTE GABRIEL ROSSETTI 1828–82
Proserpine 1874

Oil on canvas 125.1 x 61 (49 ¼ x 24)

Presented by W. Graham Robertson 1940

Rossetti explained the subject of *Proserpine* in a letter to W.A. Turner, who bought a version of the picture in 1877:

> The figure represents Proserpine as Empress of Hades. After she was conveyed by Pluto to his realm, and became his bride, her mother Ceres importuned Jupiter for her return to earth, and he was prevailed on to consent to this, provided only she had not partaken of any of the fruits of Hades. It was found, however, that she had eaten one grain of a pomegranate, and this enchained her to her new empire and destiny. She is represented in a gloomy corridor of her palace, with the fatal fruit in her hand. As she passes, a gleam strikes on the wall behind her from some inlet suddenly opened, and admitting for a moment the light of the upper world; and she glances furtively towards it, immersed in thought.
> (W. Sharp, *Dante Gabriel Rossetti: A Record and Study*, London 1882, p.236)

The subject was suggested to the artist by William Morris, whose wife Jane was the model for this and many other works by Rossetti. Her own life bore similarities to that of the captive goddess, and the painting could be seen as much a portrait of Jane as a representation of Proserpine. By all accounts, Mrs Morris was not a happy woman and Morris was a cold husband. Jane enjoyed an intimate relationship with Rossetti which spanned decades, and Rossetti painted *Proserpine* while staying with the couple at Kelmscott Manor. Eight oil versions were made, most meeting with disaster of one sort or another. This, the seventh, was painted for the Liverpool shipping magnate F.R. Leyland, as a replacement for a previous version which was damaged in transit.

Various symbols contained in the painting include the pomegranate, which signifies captivity and marriage, and the incense-burner, the attribute of a goddess. The decorative quality of the picture is accentuated by the curve of the ivy spray, a symbol of clinging memory, which is echoed in Proserpine's arm and the rich folds of drapery. The painting is inscribed with the artist's signature and date on a scroll at lower left: 'DANTE GABRIELE ROSSETTI RITRASSE NEL CAPODANNO DEL 1874' ('Dante Gabriel Rossetti painted this at the beginning of 1874'). Rossetti wrote a sonnet for the painting, inscribing it in Italian on the picture and in English on the frame:

> Afar away the light that brings cold cheer
> Unto this wall, – one instant and no more
> Admitted at my distant palace-door.
> Afar the flowers of Enna from this drear
> Dire fruit, which, tasted once, must thrall me here.
> Afar those skies from this Tartarean grey
> That chills me: and afar, how far away,
> The nights that shall be from the days that were.
> Afar from mine own self I seem, and wing
> Strange ways in thought, and listen for a sign:
> And still some heart unto some soul doth pine,
> (Whose sounds mine inner sense in fain to bring,
> Continually together murmuring,) –
> 'Woe's me for thee, unhappy Proserpine!'

The frame, designed by Rossetti, is decorated with roundels which resemble a section through a pomegranate.

DANTE GABRIEL ROSSETTI 1828–82
Sancta Lilias 1874

Oil on canvas 48.3 x 45.7 (19 x 18)

Presented by Madame Deschamps in memory of Georgiana, Baroness
Mount-Temple 1909

This is an abandoned and cut-down first version of one of Rossetti's most important pictures, *The Blessed Damozel* (1875–8, Fogg Art Museum, Harvard). Whereas Rossetti's paintings often prompted verses, this is the only one to have derived from one of his poems. Started in 1848, the poem of the same title was first published in February 1850 in *The Germ*, but underwent continuous alteration until the final version of the text appeared in 1881. It tells of the yearning of a dead woman in Heaven for reunion with her still-living lover:

> The blessed damozel leaned out
> From the gold bar of Heaven;
> Her eyes were deeper than the depth
> Of waters stilled at even;
> She had three lilies in her hand,
> And the stars in her hair were seven.

In the painting, Rossetti shows the Blessed Damozel looking down upon her beloved, who is depicted below her in a predella. Behind her, pairs of lovers embrace, united once again in Heaven. This situation has a poignant parallel in Rossetti's own life through the death of his own wife Lizzie Siddall in 1862.

Rossetti may also have been influenced in his choice of subject by the thoughts and writings of the Swedish theologian Emmanuel Swedenborg (1688–1772). In *Conjugial Love* (1768) Swedenborg wrote that each man or woman has an ideal partner – a 'conjugial' partner – and that their union constitutes an eternal, sanctified love. However, Rossetti did not use Lizzie's features for either *Sancta Lilias* or *The Blessed Damozel*. Instead, probably at the suggestion of William Graham, who commissioned the work, he called upon the model Alexa Wilding. Even more significant, the women in the background of *The Blessed Damozel* were modelled on Jane Morris, perhaps denoting a dilemma in Rossetti's mind as to who his 'ideal partner' might be.

In Rossetti's poem the Damozel has seven stars in her hair. This is an oblique reference to the seven daughters of Atlas and Pleione, who were transformed into the seven stars of the Pleiades. In the picture Rossetti has included only six stars, since one of the stars, Merope, ashamed of her love for Sisyphus, a mere mortal, shined invisibly. Rossetti, condemned to a meaningless and relentless existence without Lizzie, perhaps identifies with Sisyphus, who was forced to roll a giant boulder eternally uphill. In the poem and the finished picture the Damozel holds three lilies, referring to both the Holy Trinity and the Annunciation. In *Sancta Lilias* – 'Sacred Lily' – Rossetti has substituted yellow irises, which belong to the lily family. In Classical myth Iris was the goddess of the rainbow, the bridge between Heaven and Earth. In the context of the picture, therefore, it may be intended to represent the link between Rossetti and Lizzie Siddall, between the earthly and the spiritual.

WILLIAM HOLMAN HUNT 1827–1910
The Ship 1875

Oil on canvas 76.2 x 97.8 (30 x 38 ½)

Presented by subscribers 1907

In November 1875 Holman Hunt married Edith Waugh, the sister of his dead wife Fanny. It was a match opposed by her parents and prohibited by English law, and their wedding took place in Neuchâtel in Switzerland. In December the newlyweds arrived in Jerusalem, Hunt's second visit to the Holy Land. It was a journey which must have filled him with some sense of trepidation, for it was on his previous attempt to get to Jerusalem; this was in 1866 that his wife Fanny had died. Upon his arrival, Hunt now set to work on *The Triumph of the Innocents*, a large-scale work which, although showing the Holy Family's Flight into Egypt, partly refers to spiritualism and the continuing presence of the dead. The idea of flight also matched Hunt's marital circumstance. Ill-fated, the picture caused him recurrent problems through his rash use of faulty canvas.

Perhaps as a salve to these frustrations, Holman Hunt started *The Ship* around the same time. It was presented to the Tate by subscribers in 1907 to mark his eightieth birthday at which time Hunt wrote to *The Times* explaining the painting's origins:

> It is now 30 years since I painted the picture. Deeply entranced by the poetry of a vessel traversing the globe under the immensity of stars, bearing its freight of

human joys and woes, I undertook the picture on a Peninsular and Oriental steamer ... I made elaborate studies both by night and day in preparation for the picture on board ship, and I painted it while still all was fresh in my mind, when arriving in Jerusalem (3 April 1907).

Hunt stated that it was partly inspired by Tennyson's *In Memoriam* (1850), and seems to match the lines:

> I hear the noise about thy keel,
> I hear the bell struck in the night,
> I see the cabin window bright,
> I see the sailor at the wheel!

Tennyson's poem is an expression of his grief at the loss at sea of Arthur Hallam, his sister's fiancée. In its themes of death and spiritual uncertainty it must have matched Hunt's mood as he inevitably ruminated on the extinction of his first marriage. But another source of inspiration may have come from Walt Whitman, a volume of whose poetry was published in London in 1868, edited by William Michael Rossetti. In *Leaves of Grass* Whitman recurrently uses the image of sailors crossing the seas as a metaphor for man's spiritual and emotional passage through life and the journey of the soul, themes which similarly engrossed Hunt.

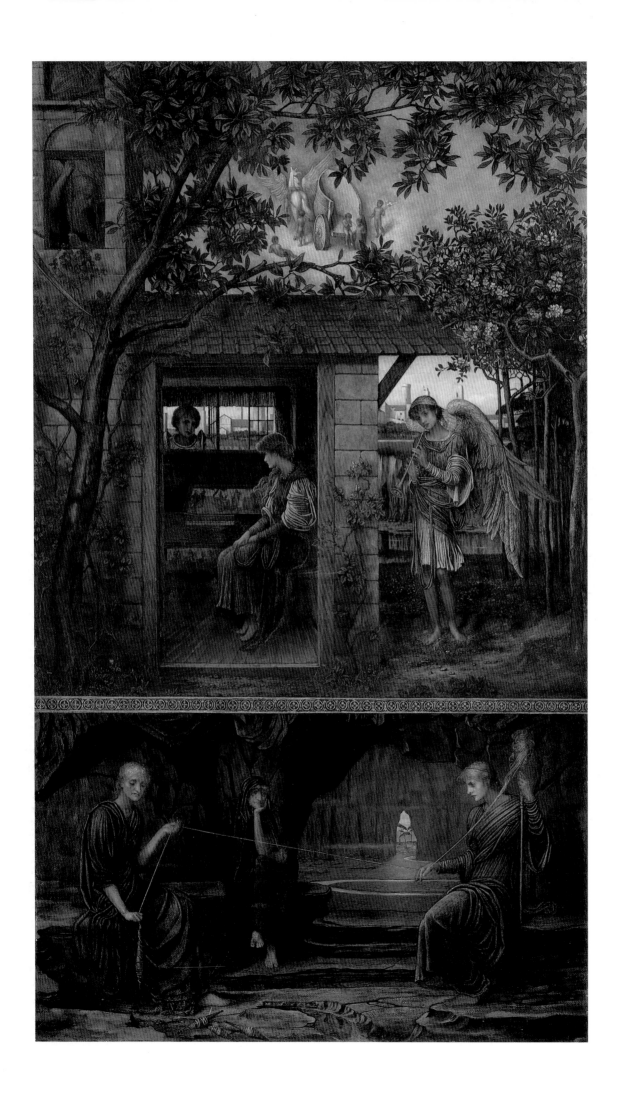

John Melhuish Strudwick 1849–1935
A Golden Thread 1885

Oil on canvas 72.4 x 42.5 (28 ½ x 16 ¾)

Presented by the Trustees of the Chantrey Bequest 1885

First exhibited in 1885 at the Grosvenor Gallery, a venue for cutting-edge British art, the picture was accompanied by the lines:

> Right true it is that these
> And all things else that under Heaven dwell
> Are changed of Time.

The theme of Time is dealt with in two related parts. Below, the three Fates are spinning the thread of life; their spindles show part gold and part grey threads, the gold to measure out the allotted span of a person's life. Above, a girl and her lover are talking, he peeping in through the casement. It is their happiness that is being determined by the Fates: a bell is tolling in a tower, symbolising the passing of time, Love's car is waiting in the sky and the figure of Love himself plays to them outside the door.

Strudwick was a pupil of Burne-Jones, whose influence is felt clearly in this picture. One of the generation of younger artists who grew up under Pre-Raphaelitism, he adopted their belief in serious subject-matter and turned it to produce allegories of time, love and the eternal choices of humanity. The elaborate frame and division of the picture derive from Renaissance art.

JOHN EVERETT MILLAIS 1829–96
Mercy: St Bartholomew's Day, 1572 1886

Oil on canvas 184.1 x 130.8 (72½ x 51½)

Presented by Sir Henry Tate 1894

Millais portrays an imaginary incident at the time of the St Bartholomew's Day Massacre in Paris on 24 August 1572, when thousands of Protestants were slaughtered by Catholics. The subject itself was not new for Millais as he had treated it in 1852 in his painting *A Huguenot, on St. Bartholomew's day refusing to shield himself from danger by wearing the Roman Catholic badge*. Here Millais had portrayed an ill-fated love-affair between a Catholic and a Protestant, where the staunch Protestant is shown refusing the Roman Catholic badge of a white cloth which will save him, offered by his Catholic lover. This act of refusal is an indication that he is prepared to die for his faith.

In *Mercy: St Bartholomew's Day* Millais shows the other side of the story involving the blind commitment of the Catholic who is prepared kill for his beliefs. Millais's painting follows closely the requirements laid down prior to the massacre by the Order of the Duke of Guise that Catholics had to follow: 'When the clock of the Palais de Justice shall sound upon the great bell at daybreak, then each good Catholic must bind a strip of white linen round his arm, and place a fair white cross in his cap'. In a gloomy interior, a man wearing a white armband, rosary beads around his neck, a crucifix fixed upon the brim of his hat and with his sword unsheathed, prepares himself for bloodshed. In the Christian spirit of forgiveness a nun begs for mercy on behalf of the hapless Protestants, but the man pulls her arm away and moves to follow the call to arms indicated by the friar who beckons from the open doorway. The passion flowers and roses placed in the foreground are overblown and withered; the passion flower was a symbol for the suffering of Christ and was often used in Victorian art to indicate a doomed love affair. Here, the wilting flowers indicate that the pious fervour of the Catholic will have a tragic end.

Millais viewed *Mercy* as a serious example of his late work, but it was not well-received. When it was shown at the Royal Academy in 1887 one critic declared that 'Sir John Millais disappoints expectations' and that his figures offered 'little else but meaningless violence of gesture' (*Magazine of Art*, 1887, p.272). Millais himself was disappointed with it and confessed to the artist Briton Rivière: 'I have done the picture … I am sometimes happy over it, but oftener wretched' (J.G. Millais, *The Life and Letters of Sir John Everett Millais*, 1899, II, p.196). Millais progressively abandoned the detailed, minute rendering of his early pictures in favour of a broader, more painterly style, which had little connection with Pre-Raphaelite principles.

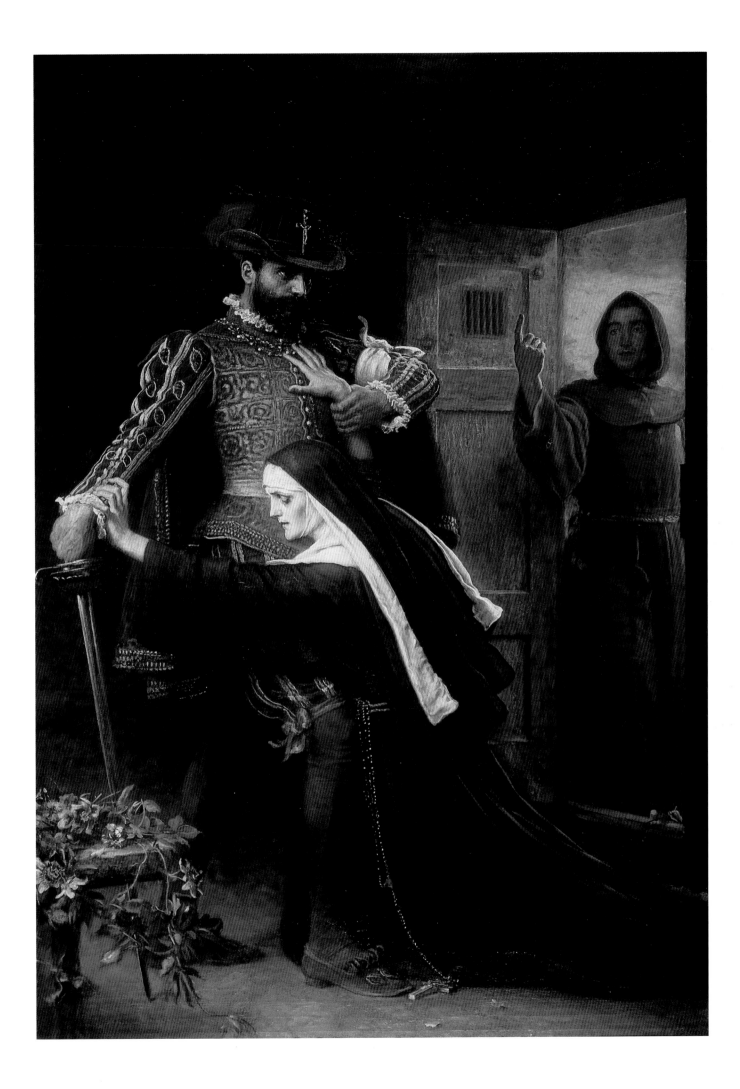

BIOGRAPHIES

Heather Birchall

The son of a wine merchant, Boyce initially trained as an architectural draughtsman. In 1849, following a meeting with the watercolourist David Cox, he decided to give up architecture for painting. During the next five years he was taught by Cox, whose influence is apparent in his early watercolours. In 1849 Boyce met Rossetti and, through him, Hunt and Millais. Boyce's generalised treatment of landscape soon gave way to minutely observed pictures in the manner of the Pre-Raphaelites. He kept a diary between 1851 and 1875 which provides an invaluable insight in to the lives and personalities of his Pre-Raphaelite friends. Encouraged by Ruskin, he went to Italy and painted architectural subjects in watercolour; shortly afterwards he travelled to North Africa accompanied by Frank Dillon and Egron Lundgren. Boyce was elected Associate of the Old Watercolour Society in 1864 and Member in 1878. He was also a founder member of the Hogarth Club, a private exhibition space, along with Burne-Jones and Frederic Leighton. In 1868 Boyce commissioned Philip Webb to build a house for him in Chelsea. There he became friends with James McNeil Whistler and his later studies of the Thames, painted at night and in subdued colours, anticipate Whistler's nocturnes.

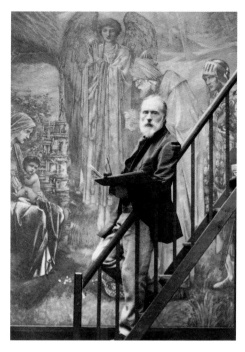

FORD MADOX BROWN
Born Calais 16 April 1821, died London 6 October 1893
Pencil drawing by Dante Gabriel Rossetti, 1852
National Portrait Gallery, London

EDWARD COLEY BURNE-JONES
Born Birmingham 28 August 1833, died Fulham 16 June 1898
Platinum print by Barbara Leighton, printed by Frederick Hollyer,
1890
National Portrait Gallery, London

WILLIAM SHAKESPEARE BURTON
Born London 1 June 1824, died London 26 January 1916
Self-portrait chalk drawing, 1899
National Portrait Gallery, London

Brown studied in Bruges and Ghent, and between 1837 and 1839 attended the Antwerp Academy under the historical painter Gustave, Baron Wappers. He settled in London in 1844 following his marriage to his cousin, Elizabeth Bromley. In the same year Brown competed unsuccessfully for the Westminster Hall Decorations. He travelled to Basle and Rome in 1845-6 and came in to contact with the German Nazarene painters led by Peter Cornelius and Johann Friedrich Overbeck. The meticulous detail and naturalism of Brown's early paintings, such as *Chaucer at the Court of King Edward III* 1851, 1867-8 (no.26), reflect the influence of these artists. Brown taught Rossetti for a few weeks in 1848 and thereafter became a mentor to the PRB. The aims and ideals of the Brotherhood are reflected in two of his most famous paintings, *Work* 1852, 1856-65 (fig.8) and *The Last of England* 1852-5 (see no.55). In his later period, Brown returned to the historical subjects of his earlier years. Through his friendship with Rossetti, he also began designing furniture and stained glass for the decorating firm Morris, Marshall, Faulkner & Co. His last major commission, received in 1878, was a series of murals for Manchester Town Hall.

Burne-Jones went to Exeter College, Oxford, in 1853 destined for the priesthood. There he met William Morris who was to become his lifelong friend. Through reading Ruskin, Burne-Jones realised his ambition was to become an artist and contacted Rossetti at the Working Men's College in London. They shared a flat in Red Lion Square and worked together on the Morte d'Arthur wall paintings for the Oxford Union Debating Hall. In 1862 Burne-Jones accompanied Ruskin on a trip to Italy. Two years later he was elected Associate of the Old Watercolour Society, becoming a Member in 1868. At this time his work was regarded with suspicion by critics, the *Art Journal* of 1869 describing his painting *The Wine of Circe* 1863-9 as 'extremely disagreeable'. Burne-Jones stopped exhibiting until the opening of the Grosvenor Gallery in 1877. At this exhibition he established his reputation as England's most influential artist and began to attract many pupils and imitators including Robert Bateman and Walter Crane. Towards the end of his career Burne-Jones was awarded many European honours, including the Légion d'honneur. He accepted a Baronetcy in 1894. Burne-Jones was an influential figures in the Arts and Crafts Movement and helped in the production of stained glass, embroidery, illustrated books and furniture for Morris's firm, Morris, Marshall, Faulkner & Co.

The son of William Evans Burton, the actor and dramatist, Burton studied at the Government School of Design, Somerset House, and finally at the Royal Academy Schools. From the age of twenty he exhibited at the Royal Academy where he won a gold medal in 1851 for *Delilah Begging the Forgiveness of Samson in Captivity*. His best-known Pre-Raphaelite picture, *The Wounded Cavalier* 1855-6 (see no.63), was described as 'one of the finest works ever painted in England under the Pre-Raphaelite influence'. Exhibited at the Royal Academy in 1856, the subject and meticulous accuracy of the painting created a sensation. Ruskin eulogised in his *Academy Notes*, 'His work is masterly, at all events, and he seems capable of the greatest things'. However, the following year his painting *A London Magdalene* was rejected by the Academy. During the 1880s Burton gave up painting, affected by ill health and lack of recognition, but was persuaded to take it up again about 1900. Burton's later works, such as *King of Sorrows* and *The World's Gratitude*, are primarily religious and symbolist in subject-matter.

JAMES CAMPBELL
Born Liverpool 1828, died [unknown] 1893

CHARLES ALLSTON COLLINS
Born Hampstead 25 January 1828, died London 9 April 1873
Drawing by John Everett Millais, 1850
Ashmolean Museum, Oxford

WALTER HOWELL DEVERELL
Born Charlottesville, Virginia 1 October 1827,
died London 2 February 1854
Drawing by Holman Hunt, 1853
Birmingham Museums & Art Gallery

The son of a Liverpool insurance clerk, Campbell entered the Royal Academy schools in 1851 following a brief period as a probationer at the Liverpool Academy Schools. In 1852 he began exhibiting at the Liverpool Academy and was elected a member in 1856. Campbell quickly secured patronage from wealthy locals such as John Miller of Liverpool and George Rae of Birkenhead. Most of Campbell's small pictures are representations of the lives of the respectable lower middle classes and artisans in Liverpool, for example *Waiting for Legal Advice* 1857, or images drawn from the life of the urban poor. His genre subjects are characterised by their meticulous detail and restrained use of colour. After the exhibition of *The Wife's Remonstrance* 1858, Ruskin commented: 'Campbell is unredeemably under the fatal influence which shortens the power of so many Pre-Raphaelites — the fact of loving ugly things better than beautiful ones'. In 1862 Campbell moved to London and turned to a broader style of painting. Commissions, however, were not forthcoming and he eventually returned to Liverpool where, due to his failing eyesight, he was forced to give up painting.

Collins was the son of the artist William Collins RA and younger brother of the writer Wilkie Collins. He showed an early gift for art and was admitted to the Royal Academy Schools. He first exhibited there in 1847 with two portraits. At the Royal Academy Collins became friends with Millais who put his name forward for membership of the PRB. Despite the support of Hunt, Stephens and Rossetti, Millais's proposal was rejected by Woolner on the grounds that Collins's work was not sufficiently 'Pre-Raphaelite'. Collins's best known picture, *Convent Thoughts* 1850–1 (see no.14), was painted near Oxford and shows a level of detail and accuracy that is almost unprecedented in Pre-Raphaelite painting. The 'thoughts' of the nun are evident from the passion flower that she is holding, symbolic of the Crucifixion. Collins shared the High Church faith of Thomas Combe who purchased the painting from the 1851 Academy exhibition. In the late 1850s Collins gave up painting and devoted the rest of his life to literature. He completed two novels, two travel books and several essays. In 1860 he married Kate, the younger daughter of Charles Dickens, and became a regular visitor to Dickens's home at Gad's Hill Place near Rochester in Kent.

Deverell came to London with his family when he was two years old. Until 1852 they lived at Somerset House where his father worked as Secretary to the Government School of Design. At the age of sixteen Deverell started work in a Westminster solicitor's office. Determined to become an artist, he began to attend Sass's drawing school where he met Rossetti. In 1846 Deverell entered the Royal Academy Schools and exhibited his first painting there a year later. A year after being appointed assistant master at the School of Design, he discovered Elizabeth Siddall working in a milliner's shop in Leicester Square. She modelled for his masterpiece, *Twelfth Night* 1849–50 (see no.2). Exhibited at the National Institution in 1850, this was his first work painted in the Pre-Raphaelite style. Deverell joined Rossetti, Hunt and Millais in reviving the Cyclographic Club and contributed to the Pre-Raphaelite journal, *The Germ*. When Collinson resigned from the PRB, Deverell's name was suggested but his membership was never confirmed. One year before his early death at the age of twenty-six, Deverell exhibited *A Pet* at the Liverpool Academy. This was purchased by Millais and Hunt for £80 and was later owned by Burne-Jones.

ARTHUR HUGHES

Born London 27 January 1832, died Kew 23 December 1915

Photograph by Lewis Carroll, 1863

Tate Archive

WILLIAM HOLMAN HUNT

Born London 2 April 1827, died London 7 September 1910

Photograph by David Wilkie Wynfield, 1860s

National Portrait Gallery, London

ROBERT BRAITHWAITE MARTINEAU

Born London 19 January 1826, died London 13 February 1869

Photograph by W.E. Debenham

The Maas Gallery, London

At the age of fourteen Hughes began studying art under Alfred Stevens at the School of Design in Somerset House. The following year he entered the Royal Academy Schools where he exhibited his first work in 1849. Hughes became interested in Pre-Raphaelitism after reading the journal of the PRB, *The Germ*, in 1850. That year he met its main contributors, Hunt, Rossetti and Brown. The first major Pre-Raphaelite picture he exhibited was *Ophelia* (exh. RA 1852), revealing both a Pre-Raphaelite enthusiasm for Shakespearean subjects and a Ruskinian attention to detail. Although Hughes always remained on the periphery of the movement, he painted some of the most familiar Pre-Raphaelite paintings, including *April Love* 1855–6 and the *Long Engagement* 1854–9. These pictures, about the hardship of young love in Victorian times, were later replaced by Arthurian legends, perhaps due to his work on the Oxford Union murals in 1857. Like his earlier work, *The Brave Geraint* 1860 and *Knight of the Sun* 1860 are characterised by their brilliant colour and microscopic detail. He continued to exhibit at the Royal Academy until 1908. Hughes was a prolific illustrator, contributing to the illustration of Allingham's *Music Maker* in 1855 and other major books and periodicals.

Between 1839 and 1843 Hunt worked as an office clerk. At the same time, against the wishes of his parents, he attended drawing classes under the portrait painter, Henry Rogers. He entered the Royal Academy Schools in 1844, at the third attempt. Through his friendship with Millais and Rossetti he helped to form the Pre-Raphaelite Brotherhood in 1848. Influenced by his reading of Ruskin's *Modern Painters* in 1847, he began to paint in meticulous detail directly from nature. From 1854 Hunt made several visits to Egypt and Palestine to paint Biblical scenes. *The Scapegoat* 1854–5, painted on the shores of the Dead Sea, is an example of his painstaking efforts to paint an authentic landscape. On his return to England, Hunt contributed a number of illustrations to the Moxon Tennyson (see no.29). He continued to contribute pictures to the Royal Academy exhibitions and, later, the Grosvenor and New Galleries. His major later works include *The Triumph of the Innocents*, 1876–87 and *May Morning on Magdalen Tower*, 1888–91. Unlike Millais and Rossetti, Hunt adhered to the Pre-Raphaelite principles throughout his lifetime. In 1905 his history *Pre-Raphaelitism and the Pre-Raphaelite Brotherhood*, emphasising his role as the intellectual leader of the Pre-Raphaelite Movement, was published.

Martineau was educated at University College School in London and then went on to study law. Perhaps encouraged by his mother, who was a talented amateur watercolourist, he abandoned the legal profession and became a pupil in the school of F.S. Cary in 1846. Two years later Martineau entered the Royal Academy Schools. In 1851 he met Hunt who became his friend and tutor. They shared a studio in Chelsea c.1851–2 and later at 14 Claverton Street, Pimlico. Martineau made his début at the Royal Academy with *Kit's Writing Lesson* 1852 (no.9). This was followed by other small genre and historical pictures, including *Katherine and Petruccio* 1855 and *The Last Chapter* 1863. His most successful picture, *The Last Day in the Old Home* 1862 (no.44), was exhibited at the International Exhibition in 1862 where it aroused much discussion. Such moralising modern-life subjects were popular among Martineau's patrons, who included James Leathart and Sir Thomas Fairbairn. Martineau was working on another important picture, *Christians and Christians*, when he died at the age of forty-three. The following year an exhibition of his pictures was held at the Cosmopolitan Club in Berkeley Square.

JOHN EVERETT MILLAIS

Born Southampton 8 June 1829, died London
13 August 1896
Albumen print by Herbert Watkins, late 1850's
National Portrait Gallery, London

DANTE GABRIEL ROSSETTI

Born London 12 May 1828, died Birchington-on-Sea,
Kent 9 April 1882
Photograph by Lewis Carroll, 1863
National Portrait Gallery, London

FREDERICK SANDYS

Born Norwich 1 May 1829, died London 25 June 1904
Photograph by Frederick Hollyer, c.1890
The Maas Gallery, London

Millais came to London from Jersey with his parents in 1838, entering Sass's drawing school the same year. A child prodigy, he enrolled at the Royal Academy Schools in 1840, their youngest ever pupil. He exhibited his first work, *Pizarro Seizing the Inca of Peru*, in 1846 at the age of sixteen. He met Hunt at the Royal Academy Schools and, together with Rossetti, formed the PRB. Following the ferocious attack on his painting *Christ in the House of his Parents* 1849–50 (see no.4), exhibited at the Royal Academy in 1850, Ruskin wrote to *The Times* defending the young artist. In 1853 Millais accompanied Ruskin and his wife, Effie, to Glenfinlas in Scotland. He and Effie fell in love and, following the annulment of her marriage to Ruskin, were married in 1855. From this period Millais abandoned painting with such pedantic attention to detail and began to produce more saleable works in a looser style. Millais's reputation as a fashionable society painter led to numerous commissions for portraits, his most notable sitters including Gladstone, Disraeli and Carlyle. At the same time Millais produced illustrations for many popular magazines and books. In 1885 he became the first English artist to be made a Baronet. He died in 1896, a few months after being elected President of the Royal Academy.

Rossetti was the son of an Italian political refugee and Dante scholar, and brother of the poetess Christina Rossetti. Educated at King's College School, London, he entered Sass's drawing academy in 1841, obtaining admission to the Royal Academy Schools in 1845. Dissatisfied with their teaching methods, he left the RA and studied for a short time under Ford Madox Brown. In 1849 he exhibited *The Girlhood of the Mary Virgin* at the Free Exhibition in Hyde Park, his first painting inscribed with the acronym PRB. Following the harsh criticism of his next painting, *Ecce Ancilla Domini!* 1849–50 (fig.4), Rossetti stopped exhibiting publicly and began to sell his paintings direct to collectors. In 1850 he met Elizabeth Siddall who modelled for many of the watercolours that he produced during the 1850s inspired by his reading of Dante and Malory's *Morte d'Arthur*. Siddall died from an overdose of laudanum in 1862, two years after their marriage. Later that year Rossetti moved to 16 Cheyne Walk and returned to painting in oil. The faces of his favourite models during the 1860s, Alexa Wilding and Jane Morris, can be seen in his numerous allegorical female portraits.

Sandys received his initial training from his father, a minor Norwich artist. He was later educated at the Government School of Design in Norwich where he attracted the patronage of the Revd James Bulwer, who commissioned him to make several architectural and antiquarian drawings. In 1851 Sandys moved to London and began to exhibit at the Royal Academy. He started to associate with the Pre-Raphaelite painters and poets following the publication of his lithographic print *The Nightmare*, a caricature of Millais's painting *Sir Isumbras at the Ford* which had attracted critical attention at the 1857 Royal Academy exhibition. The faces of Rossetti, Millais and Hunt were substituted for those of the girl, the knight and the boy respectively. Sandys made his most important contribution to the Pre-Raphaelite Movement through his illustrations for wood-engraved magazines including *Once a Week* and *The Cornhill*. Their technical accomplishment led to Rossetti's remark that Sandys was the 'greatest living draughtsman'. Sandys continued to exhibit at the Academy until 1886 and at the Grosvenor Gallery after 1877. His most notable paintings include *Oriana* 1861 (no.39), *Morgan le Fey* 1863–4 and *Medea* 1866–8. From 1880 Sandys devoted himself to portraiture and began to execute portrait drawings in crayon on blue paper.

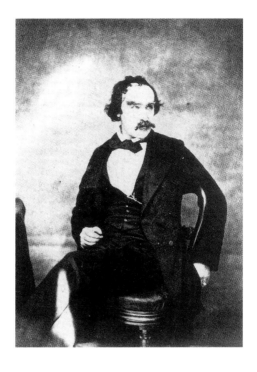

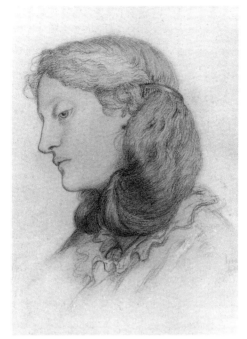

WILLIAM BELL SCOTT
Born Edinburgh 12 September 1811, died Penkill,
Strathclyde 22 November 1890
Photograph, 1861
National Trust, Wallington

ELIZABETH SIDDALL
Born London 25 July 1829, died London 11 February 1862
Pencil drawing by Dante Gabriel Rossetti
Private Collection

SIMEON SOLOMON
Born London 9 October 1840, died London
14 August 1905
Pencil drawing self-portrait, 1859
Tate

Scott initially received tuition from his father, the Edinburgh engraver Robert Scott. He continued his studies at the Trustees' Academy in Edinburgh before moving to London in 1837. In London he quickly formed friendships with several painters and writers including Frith, Dadd and Leigh Hunt. Scott painted genre and history subjects which he exhibited at the British Institution from 1841 and the Royal Academy from 1842. Failing to secure any patrons in London, Scott accepted the Mastership of the Government School of Design in Newcastle upon Tyne, which he took up in 1843 and held for twenty years. In 1857 Scott was invited by Sir Walter and Lady Pauline Trevelyan to paint a series depicting the History of Northumbria for their home, Wallington Hall, Northumbria. The final and most famous picture of the series, *Iron and Coal: The Industry of the Tyne*, is reminiscent of Ford Madox Brown's *Work* 1852–65 (fig.8) and is one of the best-known depictions of the Industrial Revolution. Scott is best known as a poet, publishing his first volume of poems in 1838. In 1875 he dedicated his *Poems* to Rossetti, Swinburne and Morris.

Siddall was the daughter of a cutler and ironmonger from Sheffield. There are no details of her early education, but at the age of twenty she was working in a milliner's shop near Leicester Square. There she was 'discovered' by Walter Deverell who introduced her to the PRB. Siddall began work as a professional model, appearing notably in Millais's *Ophelia* 1851–2 (fig.15). From 1852 she received tuition from Rossetti, whom she finally married in 1860. Siddall's literary and religious paintings and drawings were admired by Ruskin who agreed to give her £150 a year in return for any work she might produce. In addition he provided her with enough money to visit Paris and Nice. In 1857 Siddall made her exhibition début at the Pre-Raphaelite Salon at Russell Place. Included in the exhibition was one of her most important works, *Clerk Saunders* 1857, taken from the eponymous ballad by Walter Scott. In 1857 Siddall visited Sheffield where she attended the local art school. Following the birth of a stillborn daughter in 1861, she suffered from depression and died of a laudanum overdose the following year.

Solomon was the son of a prominent member of the Jewish community in London and brother of the artists Abraham and Rebecca Solomon. He entered the Royal Academy Schools at the age of fourteen and in 1860 exhibited his first major work there, *The Mother of Moses*. The artist's devotion to his faith is evident from the numerous drawings and paintings he produced of Jewish life and ritual. These pictures, characterised by their Pre-Raphaelite attention to detail and love of rich colour, brought him to the attention of Rossetti and Burne-Jones. Under the influence of his friend Algernon Swinburne, Solomon replaced Hebraic themes with images of Hellenic, androgynous figures. In 1872 Solomon exhibited for the last time at the Academy, *Judith and her Attendant*. The following year he was arrested and convicted for homosexual offences and subsequently cut off by his family and friends. His career in ruins, Solomon tried to earn money as a pavement artist in Bayswater. During this period he also produced numerous drawings and pastels of mythological and biblical figures. Solomon ended up an inmate in St Giles's Workhouse in Holborn where he later died of heart failure.

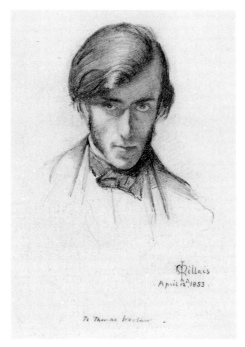

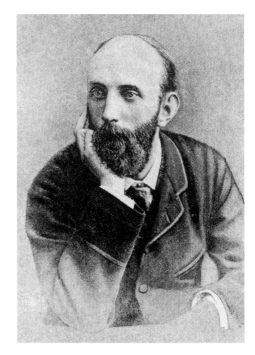

JOHN RODDHAM SPENCER STANHOPE
Born Yorkshire 20 January 1829, died Florence
2 August 1908
Photograph by Lewis Carroll, 1857
National Portrait Gallery, London

FREDERIC GEORGE STEPHENS
Born London 10 October 1828, died London 9 March 1907
Pencil drawing by John Everett Millais, 1853
National Portrait Gallery, London

JOHN MELHUISH STRUDWICK
Born London 6 May 1849, died London 1937
Photograph, Art Journal, 1891
Tate Archive

The son of Yorkshire landed gentry, Stanhope decided his vocation was to be an artist while studying at Christ Church, Oxford. He moved to London in 1850 where he received tuition from G.F. Watts. Through Watts he met Rossetti and Burne-Jones and collaborated with them on the decoration of the Oxford Union debating hall in 1857. The influence of the latter can be seen in his painting *Love and the Maiden* 1877, which was exhibited in the opening exhibition of the Grosvenor Gallery in 1877. Stanhope exhibited similar allegorical and mythological subjects at the Royal Academy and Dudley and New Galleries. Along with Brown, Hunt and Rossetti, he was one of the founder members of the Hogarth Club which was aimed at non-academicians. Due to ill health, Stanhope settled permanently outside Florence in 1880. His villa became a popular destination for artists, writers and collectors, including Burne-Jones, William Morris and Stanhope's niece and pupil, Evelyn de Morgan. Stanhope was one of the first British painters to revive the Italian technique of tempera painting and much of his later work is in this medium. He later helped found the Society of Painters in Tempera.

Stephens entered the Royal Academy Schools in 1844 on the nomination of Sir William Ross, who lived in Fitzroy Square near to the Strand Union Workhouse, where Stephens's parents worked as master and mistress. At the Academy he befriended Hunt, Millais and later Rossetti and Madox Brown. Famously handsome, he modelled for many of their paintings including Ferdinand in *Ferdinand Lured by Ariel* 1849–50 by Millais. In 1848 Stephens was nominated for membership to the PRB by Hunt. He exhibited two portraits at the Royal Academy before realising his true vocation as an art critic. After contributing an article on Italian painting to *The Germ* in 1850, Stephens began writing for a number of periodicals including *Crayon* and the *London Review*. In 1861 he became editor of the *Athenaeum*, a post he held until 1901. Stephens combined his writing with teaching at the University College School. In addition he was secretary of the Hogarth Club, founded in 1858 by Madox Brown, Rossetti and others. Stephens wrote numerous books, including monographs on Edwin Landseer, William Mulready and Laurence Alma-Tadema. He amassed a large collection of prints and drawings at his house in Hammersmith Terrace, where he died in 1907.

Strudwick studied at the South Kensington and Royal Academy Schools where he received encouragement from the Scottish artist, John Pettie. In the early 1870s he worked as a studio assistant for both Spencer Stanhope and Burne-Jones. His first and only picture exhibited at the Royal Academy, *Song Without Words* 1876, shows the influence of these artists in the pedantic attention to detail and rich and glowing colour. The following year he exhibited at the Grosvenor Gallery and New Gallery. Strudwick's mythological and Arthurian works attracted the patronage of William Imrie of the White Star Shipping Line and the shipowner George Holt. The latter commissioned a number of paintings, including *Oh, Swallow, Swallow* 1893–4, and *Love's Palace* 1891–3, now in the collection at Sudley House. George Bernard Shaw eulogised: 'you sometimes remember a Strudwick better than you remember even a Burne Jones of the same year'. Strudwick lived all his adult life in Hammersmith with his wife, Harriet Reed, and one daughter. He was described in his obituary in *The Times* as 'a beautiful old man ... a charming personality, exceedingly kind to young artists'.

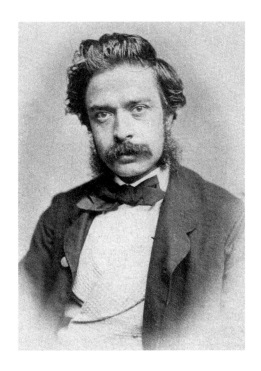

THOMAS WADE
Born Clifton, Lancashire 1828, died Windermere 1891
Photograph, c.1860–70
The Harris Museum and Art Gallery, Preston

HENRY WALLIS
Born London 21 February 1830, died Croydon
20 December 1916
Photograph

THOMAS WOOLNER
Born Hadleigh, Suffolk 17 December 1825, died London
7 October 1892
Pencil drawing by Dante Gabriel Rossetti, 1852
National Portrait Gallery, London

Little is known of the early training and education of Wade and he is rarely mentioned in Pre-Raphaelite literature. In 1861 he was living in Preston, Lancashire, where he earned a living as a portrait painter. Encouraged by the Liverpool Pre-Raphaelite artist William Windus, whom he met in the mid-1860s, Wade began to produce images of the hardships of working-class life in Lancashire. The pictures he sent to the Royal Academy between 1867 and 1890, including *A Stitch in Time c.*1868 and *The Poacher's Home* 1868, are social realist depictions of English cottage life. At this time he was a committee member for a number of charity exhibitions held to support the education of the working classes. In 1879 Wade moved to Windermere where he remained until his death. His exhibits at the Royal Academy from that period were primarily Cumbrian, Scottish and Welsh landscapes; these demonstrate an attention to detail and use of colour that is reminiscent of Ford Madox Brown.

Wallis studied at F.S. Cary's Academy and in 1848 entered the Royal Academy Painting School. He continued his studies in Paris in the atelier of M.G. Gleyres and the Académie des Beaux-Arts before returning to England. Wallis exhibited extensively throughout his lifetime at the Royal Academy, British Institution and Old Watercolour Society. The influence of the Pre-Raphaelite artists is evident in his most famous picture, *Chatterton c.*1855–6 (see no.25), which was painted in the actual attic in Gray's Inn where the young poet died in 1770. *The Stonebreakers*, exhibited at the Royal Academy in 1858, was proclaimed by Ruskin 'picture of the year' and was one of the last pictures by Wallis in Pre-Raphaelite style. His most important patron during this period was the Leeds stockbroker T.E. Plint. In 1858 Wallis eloped with the wife of the novelist and poet George Meredith and thereafter gave up painting seriously. In later life he travelled to Italy and Egypt, painting watercolours of the local landscape. Wallis wrote voluminously on Italian, Egyptian and Persian ceramics and amassed a significant collection of such objects.

Woolner trained under William Behnes and in 1842 entered the Royal Academy Schools. His earliest surviving work, *Puck* 1845–7, was noticed by Hunt for its Shakespearean theme and naturalism and secured his admission to the PRB in 1848. Woolner contributed poetry to *The Germ* in 1850, two years before emigrating to Australia having failed to secure any sculptural commissions. His move inspired Brown's well-known painting *The Last of England* 1852–5 (see no.55). Gold prospecting proved no more lucrative and Woolner returned to London in 1854. He gradually began to receive commissions for idealised sculpture of imagined subjects, for example the life-size group *Constance and Arthur*, and portrait statues. Woolner's best-known sitters include Carlyle, Gladstone and Tennyson. The portrait of the latter was greatly admired and secured his reputation. The New Sculpture eclipsed Woolner's realist style but demand for his sculpture remained high. From 1870 he received numerous commissions for public monuments of notable figures such as Palmerston and Landseer. In 1871 Woolner was elected Associate of the Royal Academy, becoming a full member in 1874. Three years later he was appointed its Professor of Sculpture but resigned after two years.

SELECT BIBLIOGRAPHY

Anne Clark Amor, *William Holman Hunt: The True Pre-Raphaelite*, London 1989

Tim Barringer, *The Pre-Raphaelites: Reading the Image*, London 1998

J.B. Bullen, *The Pre-Raphaelite Body: Fear and Desire in Painting, Poetry and Criticism*, Oxford 1998

Oswald Doughty and John Robert Wahl, *The Letters of Dante Gabriel Rossetti*, 4 vols., Oxford 1965–7

Ellen Harding (ed.), *Re-framing the Pre-Raphaelites: Historical and Theoretical Essays*, Aldershot 1996

William Holman Hunt, *Pre-Raphaelitism and the Pre-Raphaelite Brotherhood*, 2 vols., London and New York 1905

Debra N. Mancoff (ed.), *John Everett Millais: Beyond the Pre-Raphaelite Brotherhood*, London and New Haven 2001

Jan Marsh and Pamela Gerrish Nunn, *Pre-Raphaelite Women Artists*, exh. cat., Manchester City Art Gallery 1998

Jan Marsh, *Dante Gabriel Rossetti: Painter and Poet*, London 2000

Leslie Parris (ed.), *The Pre-Raphaelites*, exh. cat., Tate Gallery 1984

Leslie Parris (ed.), *Pre-Raphaelite Papers*, London 1984

Marcia Pointon (ed.), *Pre-Raphaelites Re-Viewed*, Manchester and New York 1989

Elizabeth Prettejohn, *The Art of the Pre-Raphaelites*, London 2000

Elizabeth Prettejohn, *Rossetti and his Circle*, London 1997

Benedict Read and Joanna Barnes, *Pre-Raphaelite Sculpture: Nature and Imagination in British Sculpture 1848–1914*, London 1991

William Michael Rossetti, *Dante Gabriel Rossetti: His Family Letters, with a Memoir*, 2 vols., London 1895

Virginia Surtees (ed.), *The Diaries of William Price Boyce*, Norwich 1980

Virginia Surtees (ed.), *The Diary of Ford Madox Brown*, London and New Haven 1981

Malcolm Warner (ed.), *The Pre-Raphaelites in Context*, San Marino 1992

Andrew Wilton and Robert Upstone (eds.), *The Age of Rossetti, Burne-Jones & Watts: Symbolism in Britain*, exh. cat., Tate Gallery, London 1997

Stephen Wildman and John Christian, *Edward Burne-Jones: Victorian Art-Dreamer*, exh. cat., Metropolitan Museum of Art, New York 1998

PHOTO CREDITS

INDEX